Arts Education in Action

Collaborative Pedagogies for Social Justice

Edited by
Sarah Travis
Jody Stokes-Casey
Seoyeon Kim

COMMON THREADS

An anthology from the
University of Illinois Press

Library of Congress Control Number: 2020945844
ISBN 978-0-252-08565-9 (paperback)
ISBN 978-0-252-05254-5 (e-book)

Contents

Abstract

Arts education creates a transformative impact when artists, educators, and students actively engage in addressing social injustices. *Arts in Action: Collaborative Pedagogies for Social Justice* is made up of articles related to intersections of social justice goals with visual arts, music, theater, dance, and literature education from University of Illinois Press journals including *Bulletin of the Council for Research in Music Education, Feminist Teacher, Journal of Aesthetic Education, Journal of American Ethnic History, Visual Arts Research*, and *Women, Gender, and Families of Color*. This collection weaves together scholarly inquiry, theory, and practice around social justice arts education for educators interested in confronting inequities, discrimination, and other forms of oppression through the arts.

Introduction

Sarah Travis, Jody Stokes-Casey, and Seoyeon Kim

Arts educators who envision society's transformation through the dissolution of oppression as one of their core purposes have adopted the term *social justice arts education*. Such pedagogical intentions are connected to correcting injustices that result from inequitable social opportunities and unjust social conditions tied to a wide range of factors related to identity such as race, ethnicity, nationality, religion, class, ability, gender, and sexuality. In social justice arts education, visual arts, music, dance, theater, and literary arts, among other arts, intersect with critical education paradigms to address social injustices.

This collection is made up of articles related to intersections of social justice goals with visual arts, music, theater, dance, and literature education from University of Illinois Press journals including *Bulletin of the Council for Research in Music Education*, *Feminist Teacher*, *Journal of Aesthetic Education*, *Journal of American Ethnic History*, *Visual Arts Research*, and *Women, Gender, and Families of Color*. It weaves together scholarly inquiry, theory, and practice around social justice arts education for educators interested in confronting inequities, discrimination, and other forms of oppression through the arts.

Embedded within the term *social justice* are the ideas of a cooperative society and shared civic responsibility. In developing this collection, collaboration was fundamental. Through selecting articles that address arts education and social justice, we, the editors, shared authority, labor, and our unique perspectives to produce a resource for fellow educators. The articles in this compilation can be deployed as active partners in the hands of teachers interested in engaging topics of social justice in their

curriculum. These selections represent a synergy of diverse scholars, educators, and artists working toward social justice through arts education. Through inquiry, they highlight the importance of critically reflective and inclusive pedagogy in educational contexts. They provide pedagogical theory and practical tools for building a social justice orientation through the arts.

We begin the compilation with seminal articles that offer frameworks to define the role of arts education in addressing social justice issues. In "Art Education in Civil Society" from *Visual Arts Research*, Elizabeth Delacruz (2005) provides a commentary on civil society in relation to art education. Delacruz conceptualizes civil society as "elements and social arrangements between people and society that exist outside the state's reach or instigation" and that have the potential to address social injustices. Delacruz calls upon art educators to actively engage social injustices, stating that "art education can play a vital role in the development of communal identity, compassion toward others, and civic engagement." In "Social Justice and Art Education" from *Visual Arts Research*, Elizabeth Garber (2004) explains how social justice intersects with art education and how "social justice education brings together the goals and perspectives of feminist, multicultural, disability rights, environmental, community based, critical pedagogy, social reconstruction, and visual culture art education." Garber asserts that "social justice education can . . . be thought of as guiding students to know themselves and their worlds, and to live and act as part of community and society as critical citizens."

Artists and educators often engage literary, poetic, and performative practices within social justice arts education. In "'Plotting' the Story of Race: Pedagogy Challenges in History and Literature" in the *Journal of American Ethnic History*, Amritjit Singh (2012) advocates using literary devices such as story and plot in teaching about and challenging historical master narratives about race in the United States. Singh concludes, "literary works can provide an effective lens to a more human and pulsating version of events to grasp, a pedagogical approach that becomes even more critical when issues of race and ethnicity, class and gender, are woven into the story." In "Utopian Performatives and the Social Imaginary: Toward a New Philosophy of Drama/Theater Education" from the *Journal of Aesthetic Education*, Monica Prendergast (2011) advocates for theater's potential to make spaces for "moments of deep empathy and intimate dialogue" that inspire re-envisionings of society. In "Disability, Hybridity, and Flamenco *Cante*" from *Women, Gender, and Families of Color*, Seema Bahl (2015) uses personal narrative to explore intersections of race and disability through performance, stating, "This essay examines my flamenco singing and performance from an intersectional perspective—in particular, the way that I express my racialized and disabled subjectivity onstage through *cante*."

In constructing curriculum and pedagogy, arts educators have the responsibility to incorporate equitable and culturally relevant practices. In "Beyond Participation: A Reflexive Narrative of the Inclusive Potentials of Activist Scholarship in Music Education," published in the *Bulletin of the Council for Research in Music Education*, Tuulikki Laes (2016) reflects on the complexities of activist narrative research into "inclusive, activist music education through unique policy and pedagogy solutions: promoting their students' musical agency *beyond* therapeutic care" for students with disabilities. In "Companion-able Species: A Queer Pedagogy for Music Education" from the *Bulletin of the Council for Research in Music Education*, Elizabeth Gould (2013) promotes a conceptual queering of the music education curriculum to challenge how we teach, introduce, and accept difference in the classroom, asking, "How might we interact with each other, enacting a pedagogy based not on a discourse of inclusion situated in terms of identities that necessitate exclusion, but one holding each other in regard, meeting face to face, as companion-able species?" In "(Re)Constructing Cultural Conceptions and Practices in Art Education: An Action Research Study" from *Visual Arts Research,* Joni Boyd Acuff (2014) describes how she guides art educators in "critically examining issues of oppression, cultural subjugation, unequal resources, and the systemic disparities that sustain economic inequity via art." Acuff underscores the importance of a "critical multicultural *art* education," stating that "in order for art teachers to comprehend, become invested in, and enact effective critical multicultural art education, they must first understand how they are affected by and implicated in maintaining oppression."

Social and political topics can often be difficult to confront within educational institutions, but such confrontation is a necessary component of social-justice-oriented education. In "Art, Native Voice, and Political Crisis: Reflections on Art Education and the Survival of Culture at Kanehsatake" from *Visual Arts Research,* Elizabeth J. Saccá (1993) describes the intersection of art, culture, social justice, and education in the context of a Mohawk community. Saccá argues that despite the difficulty in confronting trauma and oppression through art education, "art teachers who recognize the political forces working against art, community, environment, and creative work provide a great hope for the survival of all cultures." In "Affinity, Collaboration, and the Politics of Classroom Speaking" from *Feminist Teacher*, Kirstin Hotelling and Alexandra Schulteis (1997) advocate for "affinity politics, as an alternative to identity politics . . . shared concerns and strategies rather than by fixed identificatory markers" as a strategy for discussing difficult subject matter. Stephanie Springgay (2010) writes about the educational and activist impact of learning to knit with her students and the complexities of embodiment, touch, and collaboration in her article "Knitting as an Aesthetic of Civic Engagement: Re-conceptualizing Feminist Pedagogy through Touch," also from *Feminist Teacher*. Springgay contends

that while "activist art has commonly been understood to be an art form that carries political content," art as civic engagement manifests "whereby art is based on social relationships that make culture and creativity a central part of civic life," just as Delacruz advocated in the first article in this collection.

The arts intertwine with life to form the fabric of human experiences. Active attention to this interconnectedness between the arts and experience can, when combined with a social justice approach to education, amplify impact in addressing inequities, discrimination, and other forms of oppression. Many of the articles in this collection describe the importance of collaboration and civic engagement between artists, educators, students, and communities. Because art is active and a medium of activism, the arts in education can mobilize students to be active practitioners of social justice. It is our hope that you, fellow educator, are willing to seek to understand perspectives different from your own and to promote a more just world for ourselves, our students, and our communities. Through this work, we recognize that the arts weave us together as we follow the threads of our expression. Let's make things better, together.

References

Acuff, J. B. (2014). (Re)Constructing cultural conceptions and practices in art education: An action research study. *Visual Arts Research, 40*(2), 67–78.

Bahl, S. (2015). Disability, hybridity, and flamenco *cante*. *Women, Gender, and Families of Color, 3*(1), 1–18.

Delacruz, E. (2005). Art education in civil society. *Visual Arts Research, 31*(2), 3–9.

Garber, E. (2004). Social justice and art education. *Visual Arts Research, 30*(2), 4–22.

Gould, E. (2013). Companion-able species: A queer pedagogy for music education. *Bulletin of the Council for Research in Music Education, 197,* 63–75.

Hotelling, K., & Schulteis, A. (1997). Affinity, collaboration, and the politics of classroom speaking. *Feminist Teacher, 11*(2), 123–132.

Laes, T. (2016). Beyond participation: A reflexive narrative of the inclusive potentials of activist scholarship in music education. *Bulletin of the Council for Research in Music Education, 210–211,* 137–151.

Prendergast, M. (2011). Utopian performatives and the social imaginary: Toward a new philosophy of drama/theater education. *The Journal of Aesthetic Education, 45*(1), 58–73.

Saccá, E. (1993). Art, native voice, and political crisis: Reflections on art education and the survival of culture at Kanehsatake. *Visual Arts Research, 29*(57), 80–88.

Singh, A. (2012). "Plotting" the story of race: Pedagogy challenges in history and literature. *Journal of American Ethnic History, 32*(1), 7–23.

Springgay, S. (2010). Knitting as an aesthetic of civic engagement: Re-conceptualizing feminist pedagogy through touch. *Feminist Teacher, 20*(2), 111-123.

Art Education in Civil Society

Elizabeth Delacruz

In the wake of September 11, 2001, the *Journal of Cultural Research in Art Education* devoted a special issue to the potential of art to foster world peace. Throughout that special issue art educators were unified in their belief that art education can make a difference in an increasingly complex, interconnected world. Lewis Lankford asked that art teachers become more self-conscious about incorporating the development of humaneness into their curricula (2002). In Lankford's view, to be humane is to demonstrate kindness, tolerance, and compassion. Building on her work with Melanie Davenport, Enid Zimmerman argued that art education needs to establish links between local communities, national concerns, and international issues (2002). Similarly, in a 2004 special issue of *Visual Arts Research* devoted to diverse populations, Doug Blandy and Julia Kellman emphasized the need to broaden approaches to art education in order to address the economic, social, psychological, technological, and public health problems of globalization. Blandy and Kellman saw engagement with the arts as essential to having an informed and reflective citizenry. In his commentary for *Visual Arts Research*, Blandy continued a thesis that he and Kristin Congdon developed nearly two decades ago, that art education should foster democratic notions (1987). Arguing that educational institutions should be places where young people and adults learn about and make meaningful connections to the material culture, stories, and experiences of others, Blandy established a link between art education and civil society (2004).

The idea that art education should foster civil society merits further consideration. This commentary examines contemporary writings about civil society, and adds to Blandy's discussion of the concept in relation to goals for art education.

|

From *Visual Arts Research*, Vol. 31, No. 2 (2005), pp. 3–9.

What Is Civil Society?

Civil society is a notion with a long history. Varying conceptions about civil society have been set forth in the writings of Aristotle, Jean-Jacques Rousseau, Thomas Hobbes, Georg Wilhelm Friedrich Hegel, Karl Marx, Carl Schmitt, John Dewey, Hannah Arendt, Jurgen Habermas, Michel Foucault, Alexis de Tocqueville, Parker Palmer, Robert Putnam, and Edward Said (to name only a few). Over the last 200 years, philosophers and political scientists have used the term *civil society* to designate those elements and social arrangements between people and society that exist outside the state's reach or instigation. In many of those writings "the state" meant European monarchies, or oppressive communist, fascist, and totalitarian regimes (Geremek, 1998). In recent writings, civil society often refers to civil rights alliances that challenge both repressive governments worldwide and corrupt trans-national corporations (Boyte, 2002; Rieff, 1999), although much broader definitions also abound. Civil society is conceptualized in contemporary discourse as "that sphere of voluntary associations and informal networks in which individuals and groups engage in activities of public consequence, and includes widely varying kinds of voluntary associations: churches, neighborhood organizations, cooperatives, fraternal and sororal organizations, charities, unions, parties, social movements, and interest groups" (Sirianni & Friedland, n.d.). Broad definitions may also include hospitals, schools, governmental agencies, and the family among institutions contributing to civil society, although some writers argue that the term civil society is inappropriately used to refer to all not-for-profit, non-governmental, third sector[1] organizations (such as non-profit service providers and industry associations) (Korten, 2000). Helmut Anheier, editor of the new *Journal of Civil Society* concludes "civil society is a contested concept, with little agreement on its precise meaning" (2005, para. 1). Despite varying and contradictory definitions, values underlying notions of civil society cohere around related political and social concerns: honesty, fairness, transparency, safe-guarding public health and security (Bryun, 2005); inclusiveness, social justice, and sustainability (Korten, 2000); democracy and citizen empowerment (Boyte, 2002; Bridges, 2002b); and a critical examination of the nature and impact of globalization (Anheier, 2005). Extrapolating from these discussions and from Blandy's 2004 commentary in *Visual Arts Research*, a succinct, operational, and inclusive definition of civil society may be offered here as *that realm of private voluntary associations and public agencies or institutions working toward the public good*. Writing for the Civic Practices Network, Henry Boyte[2] summarizes elements of a contemporary, vitalized civil society.

> I am convinced that we need bold, savvy, and above all political citizens and civic institutions if we are to tame a technological, manipulative state, to transform an increasingly materialistic and competitive culture, and to

address effectively the mounting practical challenges of a turbulent and interconnected world. Political citizens require, in turn, a politics that is based on the assumption of plurality, widely owned by citizens, and productive. (2002, para. 1)

Co-opted by both liberal and conservative political parties within the United States, notions of civil society have been framed in public discourse either as an antidote to eroding public trust in government, schools, commerce, and religion, or as a necessary step toward ending the so-called welfare state and a return of the development of civic virtues and moral responsibilities to individuals, families, and communities (Miller, 1999). Responding to efforts to transfer the responsibilities of the social welfare of the citizens of a country from the government to volunteers and community groups, journalist and author David Rieff warns of what he sees as a post-cold war era of "privatization of democracy building" (1999, para. 2). Such transference, in Rieff's view, is tantamount to saying, "Let's give up on the state's ability to establish the rule of law or democracy through elections and legislation, and instead give civic associations—the political equivalent of the private sector—a chance to do their thing" (1999, para. 2). Boyte argues that what is left out of discussions of citizenship from both the left and the right is "the concept of the citizen as a creative, intelligent, and, above all, 'political' agent in the deepest meaning of the word, political—someone able to negotiate diverse views and interests for the sake of accomplishing some public task" (2002, para. 10).

Is Civil Society Declining in the United States?

Social critics have observed an erosion of civil society in the United States, brought about by the expansion of governmental and corporate control and influence in private life, a narrowing of the voluntary sector to service and advocacy (Sirianni & Friedland, n. d.), the ascendance of single issue politics (Miller, 1999), and social fragmentation (Boyte, 2002). Boyte observes the decline over the course of the 20th century of available common public spaces for the development of local relationships, particularly as local schools moved away from being social centers for their towns and cities (2002). Schools once were publicly shared places in their communities and neighborhoods, in which people gathered for reading groups, evening classes, debates, elections, cooperative extension services, club meetings, potluck dinners, picnics, performances, immigrant resources and services, and civic renewal activities (Boyte, 2002). We now live in an age of locked-down buildings, restricted access to public school resources, one-way service providers, gated communities, privatized resources, and information overload (Boyte, 2002). These changes have resulted in what Boyte terms the "phenomenology of powerlessness" (para. 102), a sense of

disengagement, ineffectualness, and alienation. Boyte further argues that higher education has contributed to this sense of powerlessness.

> Today, much of our research culture is detached from the problems and currents of the larger society. Much educational experience of our students teaches a narrow view of problems as discrete and disconnected. Service or even service learning does not necessarily address this problem at all. More generally, we also often teach the kind of innocence and irresponsibility that grows from cultivating the stance of outside critics, not engaged actors. (para. 102)

A purported decline of charitable giving and membership in voluntary social and civic-minded associations in the United States has been contested, however, as some observers have noted a shift from membership in older established civic-minded organizations to newer, different, local and international ones. These include establishment of stronger networks within neighborhoods, providing resources and assistance within personal friendships (Miller, 1999), and the recent proliferation of internet-based social, cultural, and political coalitions and communities. U.S. citizens are forming looser, intermittent, informal associations instead of maintaining long-term memberships in traditional establishments (Miller, 1999). Blandy's and Kellman's example of the youthful, in-your-face, techno-savvy DIY (Do-It-Yourself) movement (2004), shows just how different contemporary organized approaches to fostering civil society are, compared to only a generation ago. David Korten, writer, activist, and president of the People-Centered Development Forum, describes the emergence of self-organizing worldwide alliances of political action groups, comprised of individuals coming together from varied backgrounds and nationalities to pursue common issues (2000). Starting in the 1990s, massive organized protests were staged by global alliances of citizen activists to disrupt meetings of the World Bank, the International Monetary Fund, and the World Trade Organization, and to draw public attention to the destructive forces of global corporate hegemony (Korten, Perlas, & Shiva, 2002). Notably, the seventy thousand protesters who converged at a 1999 meeting of the World Trade Organization in Seattle included a broad coalition of people of faith, labor movements, environmentalists, youth, indigenous peoples, peace and human rights activists, feminists, farmers, gay and lesbian rights groups, sustainable agriculture advocates, food safety groups, and other interests (Korten, 2000).

While some civil society activists have been strongly and overtly hostile toward corporations and governments, others have adopted more academic approaches to the study and advancement of civil society, hosting research forums and engaging in inquiry, dialogue, critique, and dissemination of ideas and insights about relationships between civil society, governments, and corporate sectors. The 1991 conference *The Idea of Civil Society* sponsored by the National Humanities Center in Research

Triangle Park, North Carolina (Connor, 1998) and the work of the Center for Democracy and Citizenship at the University of Minnesota are two of many examples of academician approaches to the development of civil society.[3] The United Nations Foundation for International Partnerships (UNFIP) engages a business-like approach based in diplomacy and coalition building. The UNFIP brings together representatives of large multi-national corporations, governments, private foundations, civil society organizations, and academia to work toward achievement of its Millennium Development Goals and provides funding for local initiatives worldwide that fulfill those goals (UNFIP, 2004).[4] Taken together, local, national, and trans-national civil society associations utilize a variety of strategies—civil disobedience, political action, scholarly inquiry, diplomacy, and civic projects—to achieve their aims of the development of ethical public policy, citizen engagement, and public work.

Civil Society and Public Work

For Boyte, public work is an essential component of civil society (2002). Public work is defined by Center for Democracy and Citizenship as "sustained, visible, serious effort by a diverse mix of ordinary people that creates things of lasting civic or public significance" (2001, para. 1). Public work is full of tensions and conflicts, as people in diverse communities, from multi-cultural societies, or from different parts of the globe bring varying experiences and worldviews to problems of mutual concern (Boyte, 2002; Bridges, 2002a). Worldviews, or "life narratives" as Thomas Bridges, professor of Philosophy at Montclair State University calls them, are the life stories, myths, and metaphors that explain both the origins and possible futures of a particular group of people and embody their memories, histories, values, and beliefs about themselves (2002a). Life-narratives are maintained within particular communities, and communitarian identity and solidarity is achieved through the sharing of these narratives (Bridges, 2002b). Communities differentiate themselves from other communities and maintain their particularistic value systems through their collective life narratives (Bridges, 2002b).[5]

Understanding the manner in which individuals with different life experiences and worldviews connect and interact is central to the advancement of public work, the cultivation of civic friendship, and the promotion of world peace (Boyte, 2002; Bridges, 2002a). Civic friendship is the bond that forms between persons from differing communities precisely to the degree that they are able to go beyond distinguishing and separating themselves from others on the basis of biological, economic, and cultural aspects fundamental to communitarian identity *and* at the same time to the degree that individuals' communitarian worldviews and value systems may be maintained within such relationships (Bridges, 2002b). Civic partnerships rely on this kind of friendship. Effective civic partnerships involve mixtures of individuals

with diverse backgrounds who are grounded in their own sense of identity with a particular community but who also understand and care about the values and life circumstances of others (Bridges, 2002b), who are able to negotiate and connect their different life histories and interests, who trust one another (Biandy, 1999), and who come together to solve public problems and create outcomes of broad public benefit (Boyte, 2002). Public work, in this sphere, must also be informed by knowledge about the political dimensions of citizen engagement, which includes an understanding of the dynamics of power relations between individuals and organizations within particular settings (Boyte, 2002).

How Can Art Education Foster Civil Society?

Art education can play a vital role in the development of communal identity, compassion toward others, and civic engagement. The arts allow young people to formulate and convey personal meanings and values about life (Delacruz, 1995; Efland, Freedman, & Stuhr, 1996; Wilson & Wilson, 1982), and to bond with one another within their own school and community settings. The study of varied art forms of diverse peoples provides a means by which meaningful connections between individuals with differing cultural experiences, values, and interests may be developed (Delacruz, 1992, 1995; Daniel & Delacruz, 1993; McFee, 1996; Stuhr, 1994). In this view, art educators may provide both a special *place* within their schools and the *means through which* the development of student identity, connectedness to others, and intercultural understanding are nurtured (Delacruz, 1995; Zimmerman, 2002). Art education may advance understanding and compassion toward diverse people and cultural groups around the world, but only to the degree that art education is informed by a "critical emancipatory culturally diverse art curriculum" (jagodzinski, 1999, p. 319). Art education theory and practices must engage the study of cultural, psychological, structural, and historical aspects of power relationships between diverse peoples (jagodzinski, 1999); must seek to instill in students a sense of social justice (Garber, 2004); and must teach students how to work toward social change based on our democratic ideals of equity (Biandy & Congdon, 1987; Delacruz, 1995, 1996a, 1996b; Efland, et al., 1996), freedom from want or fear, and full civic participation for all people. Cultivation of a sense of social justice and development of requisite expertise for effective civic work have been among the goals of social reconstructionists' orientations to education since the 1960s, and as I and many others[6] have argued elsewhere, work toward social justice is a moral mandate for art education.

An orientation to art education as activist, community-oriented, and globally connected is currently taking form in schools and universities throughout the world, through service learning lessons, school-community collaborations, civic projects,

and internet-based alliances; and intriguing approaches to engaging art students in public work are emerging. But an activist and outward-looking view of art education remains on the periphery, and our involvements in civic projects (beyond student art exhibits strategically placed in select community sites) are scattered and intermittent. Social reconstruction is a formidable task for art education, and political action aimed at social change is slow, messy, and difficult work (Delacruz, 1996b; Boyte, 2002). Tradition, inertia, resistance to change, and reactionary backlash are compounded by tightened community and school budgets, increased focus on student performance on standardized tests, and teacher, administrator, and staff overload.

Research, advocacy, and critique in art education academic discourse problematize issues of both national and worldwide concern, and allow us to focus, debate, and clarify our beliefs and values about the goals of art education in contemporary life. But academic discourse, offered at a safe distance and absent substantive engagement in public work, is itself problematic (Boyte, 2002). Schools must become public and political spaces for "productive, pluralist, public activity," and universities must provide leadership in developing "bolder, more confident, and more political citizens" (Boyte, 2002, para. 103). If we agree that art education should foster civil society, then our mission in higher education includes development, implementation, and study of effective, feasible, and sustainable models, lesson ideas, and strategies for engaging students, K-16, in personally meaningful and socially relevant learning experiences—experiences that promote civic friendship and include civic work—while at the same time maintaining our identity as art education and reaffirming our place in public education.

Author Acknowledgment

The author thanks Kristin Congdon for her suggestions on an earlier draft of this commentary.

Notes

1. "Third sector" refers to voluntary associations of individuals and groups working for the common good. "It is distinguished from the public activities of government because it is voluntary, and from the private activities of markets because it seeks common ground and public goods" (Sirianni & Friedland, n. d., para. 1). The term "third sector" is sometimes used synonymously with "civil society."

2. Harry C. Boyte is founder, Senior Fellow, and Co-director of Center for Democracy and Citizenship, at the Hubert H. Humphrey Institute for Public Affairs, University of Minnesota, Minneapolis-Saint Paul.

3. More than a university based scholarly institute, the Center for Democracy and Citizenship engages in public works in the greater Twin Cities Minnesota area, and uses these public works to teach and learn about citizen civic engagement.

4. The UNFIP has established four priority areas derived from UN Millennium Development Goals (MDGs): children's health; population and women (with a focus on adolescent girls); environment (including biodiversity, energy, and climate change); and peace, security, and human rights.

5. This is not to say that "life narratives" are monolithic or static. Individual and community identities and narratives are complex, multidimensional, polyvocal, situational, and they change over time.

6. Numerous earlier writings about the moral underpinnings of multicultural and intercultural art education offered in the 1970s and 1980s by June McFee and Rogena Degge, Laura Chapman, Karen Hamblen, Vincent Lanier, jan jagodzinski, Doug Blandy, and Kristin Congdon inform a contemporary vision of civil society. For concise discussions of these writings in relation to the social reconstructionist movement in education, see Delacruz, 1990, 1992, and 1995.

References

Anheier, H. (2005). On-Line Commentary about the *Journal of Civil Society*. Retrieved from http://www.tandf.co.uk/journals/titles/17448689.asp

Blandy, D. (1999). Response to Bernard Young's essay, A viewpoint on multicultural art education at the millennium: Where to now? *Journal of Multicultural and Cross-cultural Research in Art Education* (17), 66–67.

Blandy, D. (2004). Commentary: Folklife, material culture, education, and civil society. *Visual Arts Research* (Issue 58), 3–8.

Blandy, D., & Congdon, K. G. (Eds.). (1987). *Art in a democracy*. New York: Teachers College Press.

Blandy, D., & Kellman, J. (2004). Editorial: A special issue on diverse populations. *Visual Arts Research* (Issue 58), 1–2.

Boyte, H. C. (2002). *A different kind of politics: John Dewey and the meaning of citizenship in the 21st Century*. Retrieved from the website of the Civic Practices Network Center for Human Resources, Heller School for Advanced Studies in Social Welfare, Brandeis University, Waltham, MA. http://www.cpn.org/crm/contemporary/different .html

Bridges, T. (2002a). *Civic freedom and its discontents*. Retrieved from the website *Philosophy and Civil Society: Inventing Postmodern Civic Culture*. Upper Montclair, NJ: Montclair State University. http://www.civsoc.com/nature/nature5.html

Bridges, T. (2002b). *Civic friendship, communitarian solidarity, and the story of liberty*. Retrieved from the website *Philosophy and Civil Society: Inventing Postmodern Civic Culture*. Upper Montclair, NJ: Montclair State University. http://www.civsoc.com/nature/nature10.html

Bryun, S. T. (2005). Civil society transcends right-left gap. *The Christian Science Monitor*, September 15, 2005. Retrieved from http://www.csmonitor.com/2005/0915/p09s01 -coop.html

Center for Democracy and Citizenship (2001). *The concept and philosophy of public work*. Retrieved from the website of the Center for Democracy and Citizenship at http:// www.publicwork.org/1_2_philosophy.html

Connor, R. (1998). *Introduction: The idea of a civil society*. Retrieved from the website of the Conference, *The Idea of a Civil Society*, held on November 1991 at the National Humanities Center, Research Triangle Park NC. http://www.nhc.rtp.nc.us:8080 /publications/civilsoc/civilsoc.htm

Daniel, V. A., & Delacruz, E. M. (1993). Art education as multicultural education: The under-pinnings of reform. *Visual Arts Research, 19*(2), 1–4.

Delacruz, E. M. (1990). Revisiting curriculum conceptions: A thematic perspective. *Visual Arts Research, 16*(2), 10–25.

Delacruz, E. M. (1992). Reconceptualizing art education: The movement toward multi-culturalism. In A. Johnson (Ed.), *Art Education: Elementary* (pp. 55–77). Reston, VA: National Art Education Association.

Delacruz, E. M. (1995). Multiculturalism and the tender years: Big and little questions. In C. M. Thompson (Ed.), *The Visual Arts and Early Childhood Learning* (pp. 101–106). Reston VA: National Art Education Association.

Delacruz, E. M. (1996a). An examination of approaches to multiculturalism in multicultural art curriculum products: Business as usual. *Journal of Aesthetic Education, 30*(1), 29–41.

Delacruz, E. M. (1996b). Multiculturalism and art education: Myths, misconceptions, and mis-directions. *Art Education 48*(3), 57–62.

Efland. A., Freedman, K., & Stuhr, P. (1996). *Postmodern art education: An approach to curricu-lum.* Reston, VA: National Art Education Association.

Garber, E. (2004). Social justice in art education. *Visual Arts Research, 59*(2), 4–22.

Geremek, B. (1998). *Civil society and the present age.* Retrieved from the website of the Con-ference, *The Idea of a Civil Society,* held on November 1991 at the National Humani-ties Center, Research Triangle Park NC. http://www.nhc.rtp.nc.us:8080/publications/civilsoc/geremek.htm

jagodzinski, j. (1999). Thinking through/difference/in art education contexts: Working the third space and beyond. In D. Boughton & R. Mason (Eds.), *Beyond multicultural art education: International perspectives* (pp. 303–330). New York: Waxmann Publishing Co.

Korten, D. C. (2000). *The civil society: An unfolding cultural struggle.* Keynote address at the Fourth International Conference of the International Society for Third-Sector Research in Dublin, Ireland. July 5, 2000. Retrieved from http://www.cyberjournal.org/cj/authors/korten/CivilizingSociety.shtml

Korten, D. C., Perlas, N., & Shiva, V. (2002). *Global civil society: The path ahead.* Retrieved from the website of The People-Centered Development Forum. http://www.pcdf.org/civilsociety/path.htm

Lankford, E. L. (2002). Nurturing Humaneness. *Journal of Cultural Research in Art Education* (19/20), 47–52.

McFee, J. K. (1996). Interdisciplinary and international trends in multicultural art education. *Journal of Multicultural and Cross-cultural Research in Art Education, 14,* 6–18.

Miller, D. W. (1999). Perhaps we bowl alone, but does it really matter? *The Chronicle of Higher Education,* July 16, 1999. Retrieved from http://www.civsoc.com/links/The%20Chronicle%20Research%20& %20Publishing%20July%2016,%201999.htm

Rieff, D. (1999). The false dawn of civil society. *The Nation* (February 22, 1999). Retrieved from http://www.thenation.com/doc/19990222/Riefff/

Sirianni, C., & Friedland, L. (n. d.). Civil Society. In Civic Dictionary. Retrieved October, 2005 from the website of the Civic Practices Network Center for Human Resources, Heller School for Advanced Studies in Social Welfare, Brandeis University, Waltham, MA. http://www.cpn.org/tools/dictionary/civilsociety.html

Stuhr, P. L. (1994). Multicultural art education and social reconstruction. *Studies in Art Educa-tion, 35*(3). 171–178.

United Nations Foundation for International Partnerships. (2004). *Mission statement and UN Millennium Development Goals*. New York: United Nations. Retrieved from http://www.un.org/unfip/

Wilson, M., & Wilson, B. (1982). *Teaching children to draw: A guide for parents and teachers*. Englewood Cliffs, NJ: Prentice-Hall.

Zimmerman, E. (2002). Intercultural education offers a means to promote tolerance and understanding. *Journal of Cultural Research in Art Education* (19/20), 68–80.

Social Justice and Art Education

Elizabeth Garber
University of Arizona

Social justice education brings together the goals and perspectives of feminist, multicultural, disability rights, environmental, community-based, critical pedagogy, social reconstruction, and visual culture art education. It is also related to socially responsive contemporary art and visual and material culture. This paper provides an overview of social justice in educational theory as a series of characteristics and emerging practice in art education, followed by problems encountered by implementing the theory. The subjects, the learners and the teachers, the means, and the outcomes are reviewed in social justice education. Issues in teaching social justice education arise from the ideological and economic contexts, the context of practice, and the student context. The paper concludes with four themes for instructing beginning teachers, themes that have developed from the author's practice: identity; understanding beyond ourselves; racism, sexism, and other forms of discrimination; and becoming political subjects.

In education, concern for social justice education brings together feminist studies, race and multicultural studies, disability rights, identity studies, environmentalism, community based, critical pedagogy, performance pedagogy, social reconstruction, visual culture, and other areas.[1] Uniting these educational theories and approaches relates education to a revisioning of the world as a more livable and joyous place for all, with a balance between humans, the environment, and other living beings.

In the art world, this direction has been ripening for the past two decades. Art writer Suzi Gablik (1991), in noting a growing cadre of contemporary artists

interested in "socially interactive" art (p. 7), promoted ideas of socially responsive art and building community through listening and what she calls "radical relatedness." She argued for art to be useful, not made for an aesthetic realm of contemplation or for rich collectors, but to "channel creativity onto the concrete social tasks that need doing—that is to say, toward the moral shaping of culture itself" (p. 142). Gablik has been a leader in revisioning the purposes of art as tied to social justice. Influential on Gablik's ideas, Arthur Danto (1986), in *The Philosophical Disenfranchisement of Art*, argued for art making to be in the service of bettering people's lives rather than directed towards the art world. In "The Artist as Ethnographer," Hal Foster (1996) called for the artist to change the technique of traditional artistic production and become a revolutionary worker against bourgeois culture. The artist is not in the same position as the worker, he noted, but must develop an equally critical approach to the means of production, while directing the work towards the interests of the working class.

Grant Kester (1999, 2002), interested in the interface of art and artists with viewers or participants, offers "dialogical or discursive aesthetics" as a model for art making that relates to community and social needs. Discourse is not only verbal conversation, but an attitude of exchange. Art exists in the discursive relationship established with the viewer, he argues. It grows out of a process of dialogue and collective exchange, the artist's active listening and empathetic identification, and a willingness to let the community influence art and artist. The art and its meaning occur outside the mind of the artist, and develop in the exchange between the artist and viewers, ultimately affecting the identities of both. Discourse changes the participants as well as the art outcome.

Gablik's (1991) book, *The Reenchantment of Art*, as well as essays in Suzanne Lacy's (1995) *Mapping the Terrain*, Nina Felshin's (1995) *But Is It Art?*, Carol Becker's (1994) *The Subversive Imagination*, Grant Kester's (1998) *Art, Activism, and Oppositionality*, and others offer analyses of many of the more well-known artists working today in this realm. An example of this type of art practice not as well-known in the United States is that of Lea and Pekka Kantonen. The Kantonens have been working with youth in indigenous and non-indigenous communities in Mexico, Lapland, Estonia, Slovakia, and Finland. The youth explore their own identities in relationship to place, eventually photographing themselves in their favorite places. Then through further discussions and negotiations, the youth and the artists select a limited number of these self-portraits as large-scale (approximately 24″ x 36″) photographs. The youth return to the place they were taken and, with the blow-ups in hand, are re-photographed. The result is a photograph within a photograph.

Although the result is striking, it is the process of working with the youth, and the educational institutions with which they are connected, that is central to their

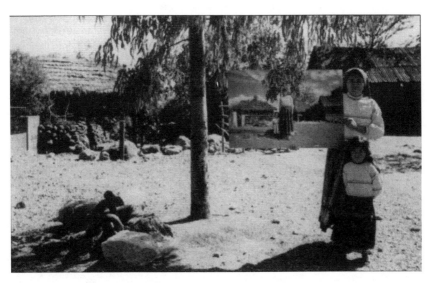

Lea and Pekka Kantonen, *Silvia Benitez: My Favorite Place*. San Miguel Huaistita, a Wirarika community in Jalisco, Mexico 1999–2002. Woman in the picture: Lorena Montoya de la Cruz. Child in the picture: Cesia Marbella Salvador Montoya. Photo: Silvia Benitez and Pekka Kantonen.

work. In addition to negotiating identity, place, and culture through the workshops with the youth, the Kantonens promote cultural exchange as they carry their collaborations with youth in one place to youth with another. They have even experimented with communications between groups of students in different places. The artists note the basis of cooperation as rooted in ethics and the importance of the process over the product. "Some things that Pekka and I, as artists, considered of minor importance, the young people have found more important and these are . . . represented in the end-products" (Kantonen, 2003, n.p.).

Proposals within art education for visual culture as a paradigm shift in the objects studied are founded in related beliefs that art education should be grounded in relevant, socially active learning. Tavin (2003), for example, in arguing for visual culture education, writes: "the analysis and interpretation of popular culture should engage students in confronting specific and substantive historical, social, and/or economic issues" and "challenges students to become politically engaged in real life issues" (p. 200). In linking visual culture to critical pedagogy, Tavin and other scholars (e.g., Duncum, 2002b; Freedman, 2003) radicalize the purposes and goals of art education, bringing them into the realm of socially responsive art and social justice education. This is an art education focussed not only on the relationship between culture and the arts, but on social change and social justice.

Characterizing Social Justice in Education

Social justice is a well-developed construct in the larger context of discourse within contemporary education. William Ayers and Therese Quinn (2000), editors of the social justice education series published by Teachers College Press, write that,

> Teaching for social justice might be thought of as a kind of popular education—of, by, and for the people—something that lies at the heart of education in a democracy, education toward a more vital, more muscular democratic society. It can compel us toward action, away from complacency. (p. vii)

Social justice education can also be thought of as guiding students to know themselves and their worlds, and to live and act as part of community and society as critical citizens, employing "the principles of justice, liberty, and equality" in creating a radical democracy (Giroux, 1991, p. 245). In the following paragraphs, I will adumbrate some of the main characteristics of social justice education as they affect the subject studied, conceptions of learners, means, and outcomes of teaching.

The Subjects Studied. The breadth of objects studied in schools widens in social justice education to include community arts, media, and popular culture literacies (Giroux & Simon, 1988, 1989a, 1989b; Grossberg, 1989; Kellner, 1991; McLaren, 1995; Shumway, 1989). This interest is resounding currently in art education as visual culture (Duncum, 1997, 2001; Freedman, 2000, 2003; Tavin, 2003) and material culture studies (Bolin & Blandy, 2003). Such interests are appropriate not only because the media and popular culture involve student knowledge, experience, and interests, but in order to help students investigate both the different ideological interests that construct these cultural products and the relationships between knowledge and social and historical constructs. Looking for what is absent as well as what is present, and learning to read these cultural products dialogically and dialectically, is part of such literacy. For example, Barrett (2003) has used a cover of *Rolling Stone* magazine featuring Destiny's Child, to engage college students in this kind of inquiry, and Tavin and Anderson (2003) have worked with elementary students to examine images and meanings in Disney animated films. Beyond popular visual culture, community murals (Garber, in press), designed and built environments (Chapman, 1978; McFee & Degge, 1980; Sproll, 1990), and crafts (Carpenter & Sessions, 2002; Lenz, 2002) are among the broadened subjects now considered as appropriate for study in art classes.

The Learners and the Teachers. In social justice education, students' interests, voices, and lives are now understood as part of the curriculum. Identity "takes shape within spaces both within and outside school," note Lois Weis and Michelle Fine (2000) in the introduction to their anthology *Construction Sites*. Educators "need to deepen their understandings of the many contexts that are meaningful to youth

if we are to engage with them intellectually and ethically" (p. xi). In art education, this interest in youth culture is taking shape through the study of visual culture (e.g., Duncum, 1997; Freedman & Schuler, 2002; Garber & Pearson, 1995; Grauer, 2002; Stokrocki, 2002). Students reclaim their voices as part of a process of empowerment, not as a means to acquire personal power over people or goods, but by learning how to resist oppressive power that subjugates or exploits themselves or other people. To resist requires a background of understanding of how power works, how "the production and organization of knowledge is related to forms of authority situated in political economy, the state, and other material practices" (Giroux, 1991, p. 253). Like the work artists such as the Kantonens do with youth, some art educators are working to engage youth in issues of identity and community. Springgay and Peterat (2002/2003), for example, look at the fashion show (traditionally thought of as a site of feminine gender construction) as a means for girls to explore identity, gender, and body knowledge through pleasure. Grauer (2002) has used teenagers' bedrooms as a site for discovering the role of corporate culture in shaping identity.

Teachers themselves need to be engaged as cultural workers and as intellectuals capable of reflecting on their situations and their roles in society (Aronowitz & Giroux, 1985; Simon, 1992). Teachers need to engage in open and critical dialogue, and to engage as critical citizens working for a democratically just society. They need to see themselves as agents of change, and to see the possibilities for change (Giroux

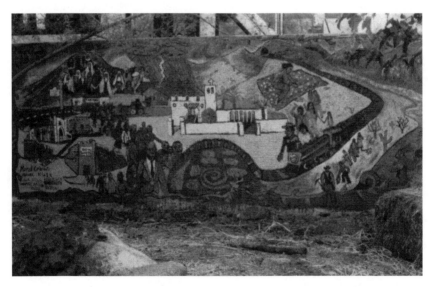

Tucson Arts Brigade and City of Tucson Youth Employment Program, *Seed for Life*. Dunbar Springs Community Garden, Tucson Arizona.

1991). To begin to do this, the sociology of education needs to be a foundation of their education. Central to this knowledge are the relationships between knowledge, culture, and power in schooling, as well as schooling as a form of social acculturation and social control. For example, "What counts as school knowledge? How is school knowledge organized? What are the underlying codes that structure such knowledge? . . . What kind of cultural system does school knowledge legitimate? Whose interests are served by the production and legitimation of school knowledge?" (Aronowitz & Giroux, p. 145). The importance of teachers seeing themselves as intellectuals—that is, as professionals able to conceptualize, design, and implement ideas and experiences in educating students—rather than as technicians implementing prepackaged content and instructional procedures, is crucial. In this view, teachers are able to determine content that validates their students while expanding their students' bases of understanding and experiences. Teachers' empowerment as leaders capable of contributing to a social change and social justice both inside and outside of schools provides a basis for belief in the possibility of social justice.

The Means. Critical inquiry that involves semiosis underpins how topics are explored and re-explored (Simon, 1992; Kincheloe & Steinberg, 1998). Critical inquiry is related to Freire's (1970/1993) notion of praxis, meaning that students learn to reflect and act on the world to transform it. Freire wrote that "knowledge emerges only through invention and reinvention, through the restless, impatient, continuing, hopeful inquiry human beings pursue in the world, with the world, and with each other" (1970/1993, p. 53). Freire emphasized burrowing into foundations, ideologies, and deeper meanings of what is taken for granted and unquestioned. Critical inquiry involves this digging into subtexts and underlying meanings. Only by uncovering these foundations can we see both how our social world and schooling are created and how, without these closer looks, schools recreate the social injustices of the world. With these understandings as bases, we can consciously work to change them.

An excellent example of the use of critical inquiry is Karen Keifer-Boyd's (1997) "politics of display" project involving pre-service art teachers in a critical inquiry of the museum. Based on the Museumism genre of art in which artists "'use museological practices to confront the ways in which museums rewrite history through the politics of collecting and presentation,'" (Corrin, 1994, p. 5, cited from Keifer-Boyd, 1997, p. 39), students examined how meaning is defined through museums and how only certain histories are presented. Students chose a museum site on the Internet and changed the meanings of art, artist, museum, audience, and art education through manipulating the virtual space using PhotoShop and HyperStudio computer programs. Based on Fred Wilson's *Mining the Museum*, in which he re-presented objects owned by the Maryland Historical Museum to show how the lives and accomplishments of blacks had been left out or diminished in the presentation of history and

how much of that history was of slavery and racism, Keifer-Boyd developed a list of strategies to expose taken-for-granted beliefs. For example, she suggested juxtaposing objects, repositioning them, asking what is left out, changing labels to redirect the meaning of the work, and making comparisons and metaphors. The idea was to understand that museums "(a) involve a relationship among power, representation, and cultural identity; (b) confirm belief systems; (c) display society's most revered beliefs and values; (d) are politically charged spaces; and (e) codify human experience" (p. 42).

An important premise of social justice education as critical pedagogy is to teach the languages both of critique and possibility (Giroux, 1991): that is to say, that critical thinking and reflection are accompanied by a sense of involvement and hope, a sense that each person can contribute to democracy and social justice, and make contributions to society that will positively affect social justice. As the above may imply, social justice involves helping students to consider ethical implications of their beliefs and actions. Freire made this clear in his work, which he based on ethical beliefs such as "oppression is wrong and one must develop ways to fight it," and "dialogue is not an end in itself but part of coming to know others," or "inter-subjective investigation." This doesn't mean that students' thinking and actions will be copies of what their teachers do, but that through thoughtful engagement with issues and situations, they will learn to question the status quo against their beliefs about a more just world. In Roger Simon's words,

> This will mean offering questions, analyses, visions, and practical options that people can pursue in their attempts to participate. . . . Required is practice rooted in an ethical-political vision that attempts to take people beyond the world they already know but in a way that does not insist on a fixed set of altered meanings. (Simon, 1992, p. 47)

Pam Taylor (2002a), contends that art educators should heed Estella Conwill Majozo's (1995) call to artists, that "Our relevance as human beings can be seen in the meaning of our acts as artists" (and as art educators). Taylor describes a service-earning project that she and her pre-service teachers completed (2002a, 2002b) in which they developed an "Empty Bowls" project to raise funds for a meals program in low-income housing communities. "Empty Bowls" was developed first in 1990 by Michigan high school art teachers who wanted to involve students in their communities to raise funds for a food drive. Since that time, their idea has spread internationally. Taylor argues that goals of service learning are to inspire a long-term commitment to community service, a sense of caring, a sense of hope, and a belief that through involvement we can make a difference. This project is an example of developing a sense of ethics in art education programs.

Also important means of social justice education include anti-discrimination pedagogies, where race, class, gender, age, abilities, nationality, cultural background, religion, and other factors that predefine people are explored consistently. They are explored as changing and diverse perspectives, not as a fixed set of attributes typifying all people of a certain group at all times. Students learn to think of diversity as a strength, and that no one way of being is the norm. An anti-racist/anti-discrimination pedagogy offers students opportunities to explore their positions on race and other types of discrimination, treating these positions not as expressions of individual perspective that are relative and equal, but are explored as "historical, cultural, and social practices that serve to either undermine or reconstruct democratic public life" (Giroux, 1991, p. 251). Forms of discrimination need to be analyzed in the specific ways in which they manifest, not only as general ideas. Different types of racism (individual, institutional, and cultural) are explored (Helms, 1984, 1990, 1995; Carter, 1997), and race is explored as an issue that includes Whites, and that they have a profound responsibility to engage.

An example of teaching art that incorporates anti-discrimination pedagogies is feminist art teacher Ms. Wolf, studied by Peggy Albers (1999). Ms. Wolf purposely engaged her middle school students in conversations about male and female artists to uncover biased assumptions. For example, she asked students what subject matter and emotions males and females draw, after finding that the subjects of most of her students' drawings fell into that commonly associated with their gender. She also engaged them in conversations about colors women and men use, and about the sexual orientation of artists based on subject matter. Wolf created several series of questions and activities to challenge students to think more deeply about their initial biased responses. For example, students examined a set of prints to predict the gender of the artist. The predictable results revealed to the students their sexist ideas, which Ms. Wolf then discussed with them in terms of why certain assumptions become accepted as the norm.

The Outcomes. The direction of this curricular work is towards students and teachers becoming border crossers (Congdon, Delgado-Trunk, Lopez, 1999; Garber, 1995; Giroux, 1991, 1992; Gomez-Peña, 1986, 1989, 1993, 2000). Border crossers are aware of various coordinates of difference and power and their specific limitations, and engage in the struggle for democratic change. Teachers guide students to look at their own cultural and social codes, and to engage these codes critically in order to work towards a more just society.

Roger Simon (1992) calls for schooling to have a "social imaginary" (p. 37) and Maxine Greene (2000) talks about the release of imagination as a means to act on behalf of our ethical beliefs and social consciousness. In art, this can be understood in part as what Suzi Gablik (1991) calls for, to put our creative imaginations towards social justice rather than only towards the expression, or liberation, of the self.

Problems in Social Justice Education

The characteristics of social justice education outline a vision of education that can make a difference for individuals, as well as in the conduct of social and political systems. It is visionary, and there are substantial hurdles to achieving it. These barriers can be divided into the *ideological context*, the *economic context*, the *context of practice*, and the *student context*. In this section, I will focus on major areas of concern in implementing social justice presented by each of these contexts.

The Ideological Context. David Sehr (1993) notes that historically there are two major competing ideological strains of democratic citizenship. The first, rooted in the political thought of Hobbes and Locke, the *Federalist Papers*, and Utilitarian Liberalism, is oriented towards privatization and the individual. Sehr notes,

> The democratic conception that flows from this tradition minimizes the role of ordinary citizens as political actors who can shape their own individual and collective destiny through participation with others in public life. Instead, it reinforces an egoistic individualism, and a glorification of materialism and consumerism as the keys to personal happiness and fulfillment. (pp. 5–6)

Its alternative, grounded in the work of Rousseau, Jefferson, Dewey, Mills, and feminist theory, holds participation of individuals in public life as a basic premise of democracy. Such participation arises from ideas of responsibility and caring for the good of the whole, not only for oneself. This understanding of democracy is grounded in a commitment to public participation and a respect for diversity and the equal participation of all social groups.

Similarly, Torres (1998) distinguishes between formal and substantive democracy. He puts forth four models of democracy based on the work of C. B. Macpherson.[2] These are:

1. *Protective democracy* which is based on the hegemony of a market economy "to advance market interests and to protect against the tyranny of the state";
2. *Developmental democracy,* which is based on elevating working-class people into rational beings who are "self-interested consumers and appropriators" and democratic participators;
3. *Equilibrium democracy* (or pluralist democracy), where apathy among the majority of citizens is crucial to a functioning democracy because participation "overloads the system with demands which it cannot meet"; and
4. *Participatory democracy*, in which socially equal and conscious individuals contribute to building "a sense of community, of association, of neighboring and joining." (Torres, 1998, pp. 146–147)

Substantive democracy is located in participatory democracy, or "public democracy," as Sehr (1993, p. 7) calls it, and in the goal of the social justice education. But it is

not the democracy, as Sehr points out, that is supported by corporations or many school boards. As many education theorists have pointed out (e.g., Apple, 1986; Osbourne, 1988; Simon, 1992), the ideas of corporate capitalism and consumerism guide decisions about schooling.

> Educational policies are being justified in relation to the interrelated goals of maintaining an internationally competitive economy, reducing the constant dollar value of government budget allocations to education, promoting economic and cultural partnerships between public schools and private corporations, narrowing the competency standards to which students and teachers will be held accountable, and, to ensure narrowed competencies, deskilling teachers within the search for prescriptive content and methods. (Simon, 1992, p. 36)

In the U.S., for example, we have increasing support of education by private corporations, through partnerships and through charter schools. We still have *Channel One*, a news program for teens spliced with high-powered advertising, broadcast into many high schools daily in exchange for free television sets. Most states have tied nationally standardized testing to diplomas, teacher pay, and/or state allotments for school funding.

As teachers in a privatized, individual-centered democratic society, we must be careful not to reduce "democracy to the equivalency of diverse interests" (Giroux, 1991, p. 246). This could mean the diffusion of struggles for rights across people of diverse backgrounds, heritages, and beliefs, as well as through the promotion of the individual at the cost of a substantial democracy of engaged people working together. Furthermore, we must consider how to balance the fact that we live in a formal, and not a substantive democracy with the goals of social justice education. It is indeed misleading to present students with the goals of social justice education without acknowledging and exploring the barriers presented by the model of formal democracy that currently exists.

The Economic Context. Jonathan Kozol (1992) argues in his book *Savage Inequalities*,

> Education offered to poor children should be at least as good as that which is provided to the children of the upper-middle class. If Americans had to discriminate directly against other people's children, I believe most citizens would find this morally abhorrent. (p. 207)

While democracy and equal opportunity are foundations of the belief system of North Americans and of our school systems, educational opportunity in U.S. education is not socially just. Kozol investigated the financing systems for education in several cities across the U.S. and found them grossly unequal. Wealthier districts will fight—all the way to the Supreme Court if necessary—to maintain their higher

spending levels. Based in what is called a foundation program, there is a formula that involves a local property tax on the value of homes and businesses for a school district. This means that wealthier districts raise more funds than poorer ones because taxes in wealthier districts generate more money. The state is supposed to provide funds to lift the poorer districts to a foundation level equal to that of the richest districts. The foundation, however, is set at a minimum level of subsistence, which is needed to provide a "'basic' education" (Kozol, p. 208), rather than setting it at the level of what it costs to run an upper-middle class district.[3] Kozol continues:

> The notion of a "minimum" (rather than a "full") foundation represents a very special definition of the idea of equality. It guarantees that every child has "an equal minimum" but not that every child has the same. (pp. 208–209)

Wealthier districts see it as their right to supplement the state aid given and raise the amount of spending per child, whereas poorer districts' supplement is much smaller.[4] A decade ago in San Antonio, Texas, when Kozol wrote his book, the per-pupil spending ranges varied from $2,000 to $19,000. The foundation level provided by the state was $1,477. What about school financing today? I looked at per-pupil expenditures in Tucson, where I live, and the Boston area. In Boston, they range from $5,000 figured in Attleboro, Haverhill, New Bedford, and Taunton ($6,000–7,000 if special education, bilingual, and occupational day costs are applied) to $12,781 in Cambridge ($14,084 with the higher expenditure pupil costs included). In Tucson, they range from $2,800 to $5,807 (including special education, bilingual, and occupational day costs). Although school financing is complex and these comparisons don't reflect the full complexity of financing, it is clear that economic advantages are guarded by middle- and upper-class parents and school boards in wealthier school districts. Kozol argued (1992),

> There is a deep-seated reverence for fair play in the United States, and in many areas of life we see the consequences in a genuine distaste for loaded dice; but this is not the case in education, health care, or inheritance of wealth. (p. 223)

The move to privatize education in the U.S. and to give tax vouchers to offset the cost of a private K–12 education are further advantages sought by wealthier U.S. Americans.

The Context of Practice. Goals can shift in the translation of theory to practice. Mentoring students' inquiry into social and economic structures that underlie art, education, and business practices, or guiding students' community involvement can get lost when completing the project. In visual culture art education, will the critical pedagogy goals that Tavin (2003) lays as the foundation of visual culture

education corrupt to incorporate the subject shift from art to visual culture and the learners' interests, but not the means and goals of social justice? This is happening before our eyes. Wales (2001), for example, describes teaching cartooning to his students. They explore *Peanuts* cartoonist Charles Schulz's biography and development of ideas, learn to develop characters, and draw them. In all fairness, Wales (and a host of other authors who have written about exploring visual culture with their students) does not cite social justice as a desired outcome, but such forays into visual culture in the current climate of change muddy the stated goals of visual culture education, which are in line with those of social justice education. In contrast, Tavin and Anderson (2003) take Disney to an elementary classroom where they actively address the principles Tavin (2003) advocates as means and outcomes of visual culture education. They worked with a group of elementary-aged children to deconstruct stereotypes presented in Disney movies. Beginning with having students define *stereotype*, they investigated various stereotypes (including racial, ethnic, and gender examples) from popular culture. The students critically examined characters in Disney movies, comparing them to the stereotypes studied, and later looked at non-stereotypical character representations in artworks by artists such as Edgar Heap of Birds and Jaune Quick-to-See Smith. Questions leading their discussions included: "Who are the main characters in the movie? What do they look like? How do they behave? Where does the action take place? How is local culture portrayed in *Aladdin*? How did Gaston, in *Beauty and the Beast*, treat Belle? If someone screamed at you and treated you badly, like in *Beauty and the Beast*, what would you do? Do the chihuahuas in *Lady and the Tramp* and *Oliver and Co.* have a particular accent? If the movie *Tarzan* takes place in Africa, where are the African people? Why do you think there are virtually no non-White people in a movie set in Africa?" (p. 34). From these discussions, students generated a long list of issues relating to race, gender, history, and violence. Then they proposed changes to Disney films to address these issues through studio activities such as movie posters, videocassette covers, and collage and assemblage shadow boxes accompanied by written statements.

It is common to extract from a teaching philosophy what appeals to a particular teacher. For example, projects to help youth excavate identity may stop at their individual identity without looking deeper into how they are not individuals unique from their culture, but in relation to their cultures and as outcomes of their cultures. It is easy to confuse education for social justice with a student-centered pedagogy, ignoring the languages of critique and possibility grounded in social justice, and the connection of what is learned to political and social structures. Additionally, to move from the warm and fuzzy comfort of learning about our communities or art from many cultures to learning about how value systems and socioeconomic structure are reflected in them is a substantial leap.

Jennings & Potter Smith (2002) found it relatively easy to shift their teacher-students' concepts of multicultural education to talk of a transformative approach, but implementation of that shift was much less successful. For example, a play about cultural diversity and a pen pal exchange were classroom practices resulting from a post-graduate class. Neither the play nor the exchange addressed structural inequality. Jennings and Potter Smith also found that while their teacher-students readily took to instructional strategies that encourage children to make meaning, and left behind the banking model of education (Freire 1970/1993), none of the teachers from the post-graduate course employed in their classrooms critical inquiry that underlies transformative pedagogy. In art education, Flavia Bastos (2002) studied socially conscious art teacher Leah Morgan, who made art relevant to her rural U.S. midwestern students, brought local artists into the school, and also introduced furniture design as a problem-solving exercise because of a local chair building business in the community. She grounded her teaching, in an exemplary manner, in the local arts and community, making her curriculum relevant to her students. But as Bastos notes, Morgan did not engage issues such as how the community's value systems or socio-economic structure were reflected in the locally produced art.

Even with experienced teachers who embrace its premises, it can be difficult to implement social justice education. Wanda May (1994) talked about the difficulty of being a teacher for social change, and even of using the imagination, inside many institutions. A professional community of support is important to teach emancipatory education. It is not possible, she argued, to achieve emancipatory education if institutional structures constrain the identities of teachers, their imagination, and their practices. Although there are teachers developing social justice practices in isolation from the rest of the school, the barriers to doing so need to be recognized.

Engaging in practices of social justice can be high risk behavior, especially in some schools and school districts. Teachers can be retaliated against or fired from their jobs for encouraging critique of and change in the status quo. Art educators in higher education, who are preparing future teachers to undertake social justice pedagogies, need to understand and convey a sophisticated understanding of the contexts in which teachers work. They need to teach skills and strategies to accomplish change, such as building administrative and community support for school teachers' work, and spotlighting the successes of students in ways that appeal to their students, parents, other teachers, the administration, and the community.

Finally, education for social justice cannot take hold through a single class, and practice develops over time. This was an important underpinning of the failures Ellsworth (1989) experienced when she tried to teach critical pedagogy. Jennings & Potter Smith (2002) also affirms that teachers' understandings, beliefs, and practices are situated and context bound. In order to implement a transformative practice, teachers need to feel a tension between their beliefs in transformative practice and

what they do in the classroom. They need to learn to incorporate the needs, interests, and lives of their students while maintaining a focus on social justice. They must form coalitions with others teaching for social justice and work with them to change the institutions in which they work. They need to embrace their roles as teacher intellectuals and believe in the possibilities of what they are doing. All of this takes time and a lot of work and belief in the possibilities of education for social justice.

The Student Context. As teachers, we need to take care to see that students are producers of knowledge and culture themselves, not just recipients (Weis & Fine, 2000). In our zeal to convince our students about the need for social change, we may silence their voices. We must respect and understand the variety of identities a person has (Hicks, 1994), as well as the spaces they create for themselves. Weis and Fine's (2000) anthology *Construction Sites*, for example, includes several essays in which youth "engage in a kind of critical consciousness, challenging hegemonic beliefs about them(selves) . . . and restoring a sense of possibility for themselves and their peers, with and beyond narrow spaces of identity sustenance" (p. 3).

Related to this concern for respecting student voice, we need to recognize the risk involved in crossing borders for students—how education may inherently present other worlds to students, but in crossing borders they are at risk. No space is insulated from social contradictions: racism, sexism, homophobia, classism, power, or privilege. "All spaces carry the capacity and power to enable, restrict, applaud, stigmatize, erase, or complicate threads of youth identity and their ethical commitments" (Weis & Fine, 2000, p. xiii).

Applying the Theory: My Role

Over the years, I have concentrated on a few themes with my pre-service teachers in order to guide them to the possibilities of educating for social justice. I have been working with them to find ways:

1. To understand how culture influences our values, experiences, and understandings of the world, and to help them see how identities get caught up in consumer ideas;
2. To know, understand, and value cultures beyond our own, and beyond the dominant ones, and to look at a broad range of art making, especially local and regional art and collaboratively produced and socially-oriented art;
3. To begin the painful process of looking into how racism, sexism, and other forms of discrimination are embedded in U.S. culture and implicate all of us; and
4. To inspire future teachers to discover ways to take action against corporate and racist cultures.

I will briefly examine each goal individually. They have helped me to coalesce some of the characteristics of social justice education, as well as to work through some of the problems adumbrated above.

Identity. Strong identities seem to be a prerequisite to respecting individuals and cultures outside of oneself. Bourdieu (1984) urges that we look at our own positions, asking in what field of power and from what position in that field, one writes, speaks, or understands. In the second and third position statements of Wasson, Stuhr, & Petrovich-Mwaniki (1990), they acknowledge that teaching is a social and cultural intervention, and that students (as well as communities) must be one center of the educational process. This sensitivity to students is important to maintain in education.

Identity can be misunderstood as making monograms or collages of self-identification. Any such productions must be examined as they exist in a larger framework of consumer culture and cultural, class, ethnic, racial, and national studies. They must be pursued in the context of critical and reflective questioning and thinking. As Rabinow (1986) points out, identity study should not "reduce knowledge to social position or interest per se but, rather, to place all of these variables within the complex constraints—Bourdieu's *habitus*—within which they are produced and received" (p. 252).

Identity must be understood as shifting and ever-changing in two ways. First, identity is not fixed: it changes over the course of a lifetime. Second, identity is how others perceive us. Resemblance is relative to the culture and the purpose of classification. In *The Twilight of Common Dreams*, Todd Gitlin eloquently notes,

> To a passerby or a census-taker, I am White. To an anti-Semite, I am simply a Jew. To a German Jew, I may be one of the Ostjuden; to Sephardiim, an Ashkenazi Jew; to an Israeli Jew, American; to a religious Jew, secular; to a right wing Zionist, an apostate, or no Jew at all. (cited in Torres, 1998, p. 178)

Identity is how we understand ourselves in relation to others. It is an ongoing reflective and developmental process.

Understanding Beyond Ourselves. In my classes, we look at what art and artists can tell us. We look at art in relation to an artist's culture. We also begin to consider students' own cultural norms, and the norms that they perceive about the cultures they are studying, so that we talk about art in different ways. We begin the processes of taking care not to simplify an artwork in relation to the artist's culture or to simplify a culture (as I have written elsewhere, hamburgers are not a food of all U.S. Americans, just as Spanish is not spoken by all Chicanos, and mariachi music and milagros shouldn't represent the whole of Mexican art [Garber, 1995]). In students' interviews with artists who are different racially, ethnically, or sexually

from themselves, the real focus of their inquiry is not on the facts they learn from the artist, but on their internalization and reflections. The students' interviews with artists and research into the artists' cultures result in a mediation on cultural diversity, representation, and inquiry strategies.

Perhaps it seems obvious that in classrooms we should turn to celebrating the indigenous, the local, and the regional. I see variations of this celebration in classrooms across my home state, and in commercial curricula, and have incorporated the local into my own teaching. The local can help build stronger communities, engender a sense of involvement and possibility for change, and help us communicate with a variety of people. Although students are often ready to celebrate local and untrained ("folk") art and artists, I try to instill in them a willingness to look at the complexity of influences on any artist along with the web of the artists' and the students' own values and beliefs. I want them to understand that the substitution of "local" for "global" or "capitalist" is not a simple remedy, that the local can insulate us from understanding the variety and complexity of people and their ways, especially in communities that are homogeneous.

The position I openly navigate students toward in doing this, is that of the aforementioned "border crossers." In Henry Giroux's *Border Crossings* (1992), he used the concept of border crossing as a way to formulate the role cultural workers (teachers, postmodern theorists, feminists, and others) might play in the development of a critical pedagogical practice that works across disciplines and differences. In my 1995 article, I argued that border crossing should be a basic component of education.

Discrimination. Racism, and other forms of discrimination, are deeply embedded in U.S. culture, as in other cultures. With my students, we learn theoretically about race, ethnicity, nationality, sex, gender, sexual orientation, and ableness. We learn about three types of racism identified by Helms (1990), the forms that sexism and homophobia take, as well as preferential treatments based on nationality and ableness. We look at how being White, male, U.S. American, and able accrues human rights that are at times denied other people, and how these characteristics also offer unearned privileges (McIntosh, 1989). We look at our own positions in society, asking from what field of power and from what positions we act and understand. I ask students to confront "White" as a cultural space that is significant but is not the invisible norm of so-called "mainstream" culture (Roman, 1993; Helms, 1984, 1990, 1995; McLaren, 1997). We read Cornel West's account of taxicab drivers refusing to pick him up even though he is a well-dressed black man (and a leading intellectual in the U.S.). We discuss Jonathan Kozol's (1992) accounts of the disparity between schools. We broaden our look at disparities, based on human differences.

Whereas students readily learn the cultural narratives of others, if they do not learn about themselves, those about whom they learn remain other. Having worked

with these themes over the past few years, I have found discrimination the most dif-
ficult topic I have ever incorporated into my teaching. Whereas students readily learn
the cultural narratives of "others,"[5] they find this confrontation with themselves an
extremely emotional process. The process of learning sensitivity to forms of prejudice
and discrimination is lengthy. Helms' (1984, 1990, 1995) work on racism confirms
this.[6]

Torres (1998) writes, "an antiracist pedagogy that takes seriously the nuances
of the White experience should enable White students to move beyond positions of
guilt and resentment" (p. 177). An understanding of discrimination and prejudice
should help students grow into citizens who willingly take on an active role in insur-
ing democracy for all. In Paulo Freire's concept of border crossing, he suggested that
people should become culturally diverse individuals educated to cross borders for
their own empowerment and to challenge the oppression of others.

Becoming Political Subjects. Freire (1998) wrote that as educators we must assume
the political nature of our work.

> It is not enough to say that education is a political act . . . It is necessary to
> truly assume the political nature of education. I cannot consider myself pro-
> gressive if I understand school space to be something neutral, with limited
> or no relation to class struggle, in which students are seen only as learners of
> limited domains of knowledge which I will imbue with magic power. (p. 46)

Freire indicated that teachers must know the political nature of education and be
clear about their position.

> Clarifying the question of in whose favor I practice, puts me in a certain
> position, which is related to class, in which I devise against whom I practice,
> and necessarily, for what reasons I practice—that is, the dream, the type of
> society on whose behalf I would like to intervene, act, and participate. (p. 46)

To this end, we look closely at what is worth teaching, and whether the content and
means of teaching work towards these goals. We also consider whom we are teaching,
taking into account Freire's conception of teachers as "neither *tabula rasa* in cognitive
or ethical terms nor fully equipped for the exercise of their democratic rights and
obligations" (Torres, 1998, p. 46). Anthropologist Paul Rabinow (1986) uses the term
"political subjects," in which ethics combines with dialogics in an effort "to create a
relation with the Other" (p. 255). This is similar, I think, to Banks & Banks' (1993)
fourth stage of multiculturalism: the "policymaking approach," in which students
learn that inter-group relations are always an integral part of social and historical
conflicts; they learn to employ political action to achieve greater equality, freedom,
and social justice. It is also consistent with Sleeter and Grant's (1988) "social recon-
structionist" education, in which analytical and critical thinking are paired with

political actions focused on the redistribution of society's resources, especially power and wealth, among diverse groups.

These four themes of identity, understanding beyond ourselves, discrimination, and becoming political subjects, constitute an approach to taking on the complexities of becoming a citizen and a border crosser in a globalized world where democracy, the autonomy of the individual, and the importance of local seem to be losing force.

Concluding Thoughts

In this paper, I have attempted to bring several radical education initiatives and theories together as a reform initiative in educational theory appropriate for art education. Examples of practice, my own inclusive, are tentative; that is, they are not exemplary, but continue to develop over time.

The ideologies underpinning visual culture education (e.g., Duncum, 1987, 1997, 2001; Freedman, 2000, 2003; Tavin, 2002, 2003) are similar, with each emphasis slightly different. While visual culture education advocates emphasize tangible manifestations of culture that can be studied using the principles of social justice or critical pedagogy, the emphasis of social justice education is on the acts and outcomes, rather than the objects. For me, this is an important difference because although visual culture education is more approachable, many teachers are likely to get caught up in the change of objects as subjects for study but then ignore the point of doing so: to change the way and the why of how we educate our students. Education for social justice puts the goals of social engagement up front, where they cannot be mistaken. Education for social justice is education for a society where the rights and privileges of democracy are available to all. Art education for social justice places art as a means through which these goals are achieved.

Endnotes

1. In art education, examples of work in these areas are: *Feminist studies* (e.g., Ament, 1998; Collins, 1995; Collins & Sandell, 1996; Garber, 1990, 2003; Hagaman, 1990; Hicks, 1990; Keifer-Boyd, 2003; Sandell, 1991; Smith-Shank, 1998; Zimmerman, 1990). *Race and multicultural studies* (e.g., Carpenter, 1999; Chalmers, 1987, 1999, 2002; Daniel & Delacruz, 1993; Delacruz, 1995, 1996; Desai, 2000; Eldridge, 2003; Floyd, 2003; Garber, 1995, 2002; Haynes, 1993; Hicks, 1994; Stuhr, 1994; Stuhr, Petrovich-Mwaniki, & Wasson, 1992). *Queer studies* (e.g., Check, Deniston, & Desai, 1997; Honeychurch, 1995; Lampela, 1995, 1996; Lampela & Check, 2003). *Disability rights* (e.g., Blandy, 1991, 1993; Guay, 2003; Nyman, 2003; Nyman & Jenkins, 1999). *Identity studies* (e.g., Ballengee-Morris, Mirin, & Rizzi, 2000; Ecker, 1990; Hayes & Robinson, 2001; Smith-Shank, 1999–2000; Springgay & Peterat, 2002/2003). *Peace studies* (e.g., Anderson, 1997; Kauppinen, 1991). *Environmentalism* (e.g., Barbosa, 1991; Birt, Krug, & Sheridan, 1997; Blandy, Congdon, & Krug, 1998; Blandy & Cowan, 1997; Congdon, 2000; Garoian, 1998). *Community based education* (e.g., Bastes, 2001; Blandy & Congdon, 1988; Keyes & Ballengee-Morris, 2001). Critical pedagogy (e.g., Tavin, 2003;

Yokley, 1999). *Performance pedagogy* (e.g., Garoian, 1999). Social reconstruction (e.g., Delacruz, 1990; Hicks, 1994; Stuhr, 1994). *Visual culture* (Duncum, 1987, 1997, 2001; Freedman, 2000, 2003; Tavin, 2002, 2003).

2. C. B. Macpherson, *The political theory of Possessive Individualism: Hobbes to Locke* (Oxford: Oxford University, 1962) and *Democratic theory: Essays in retrieval* (Oxford University, 1973).

3. Kozol points out a difference in revenue equality and across-the-board equality, and argues that if the principle behind foundation levels worked, districts might achieve revenue equality but not necessarily general equality.

4. Although disparities in school spending have been challenged in the Supreme Court, the Court sided with the wealthy, stating that the Equal Protection Clause of the Constitution does not guarantee absolute equality and that the Constitution does not provide explicitly for education as a right.

5. The first time I taught gender issues in a tertiary art education setting, the students had an assignment to create a self-portrait based on their gender identity. A male student asked if he could do a portrait of one of the female students at the table because women really had gender identity issues but he just was. The anecdote is not unique, but serves as an example of the difficulty of confronting our own identities in comparison to learning about people different from ourselves.

6. Helms' (1984, 1995) model includes stages of movement away from racism: contact, in which racism is not really examined; disintegration, in which the person realizes that the world is constructed systematically along racial lines; reintegration, in which the person believes people of color should learn to adapt to whatever are the perceived norms; pseudo-independence, in which the person actively works to abandon racism, particularly from an intellectual and "assisting" position; immersion-emersion, in which racism is confronted on both emotional and intellectual terms and the person turns to their own race to solve racial problems; and autonomy, in which the person has fully internalized a flexible view of the world and people in it, values and seeks out cross-racial and cross-cultural experiences, and views himself in a noncomparative way.

Author Note

Earlier drafts of this paper were presented in 2003 to audiences at the University of British Columbia, the National Art Education Association Convention, and Harvard University; in 2004, it was presented to an art education graduate class at Arizona State University. Thanks to participants in each of these forums, as well as reviewers of this journal, for their thoughtful feedback, which has improved the paper.

References

Albers, P. M. (1999). Art education and the possibility of social change. *Art Education*, 52(4), 6–11.

Ament, E. (1998). Using feminist perspectives in art education. *Art Education*, 51(5), 56–61.

Anderson, T. (1997). Art, education, and the bomb: Reflections on an international children's peace mural project. *Journal of Social Theory in Art Education*, number 17, 71–97.

Apple, M. (1986). *Teachers and texts: A political economy of class and gender relations in education*. New York: Routledge & Kegan Paul.

Aronowitz, S., & Giroux, H. (1985). Radical education and transformative intellectuals. *Canadian Journal of Political and Social Theory/Revue Canadienne de theorie politique et social,* 9(3), 48–63.

Ayers, W., & Quinn, T. (2000). Series foreword. In L. Weis & M. Fine (Eds.), *Construction sites: Excavating race, class, and gender among urban youth,* pp. vii–viii. New York: Teachers College.

Banks, James A., & Banks, C. A. M. (1993). *Multicultural education: Issues and perspectives.* Boston: Allyn & Bacon.

Ballengee-Morris, C.; Mirin, K.; & Rizzi, C. (2000). Decolonialization, art education, and one Guarani nation of Brazil. *Studies in Art Education,* 41(2), 100–113.

Barbosa, A. M. (1991). Art education and environment. *Journal of Multicultural and Cross-cultural Research in Art Education,* 9, 59–64.

Barrett, T. (2003). Interpreting visual culture. *Art Education,* 56(2), 6–12.

Bastos, F. M. C. (2002). Making the familiar strange: A community-based art education framework. In Y. Gaudelius & P. Spiers (Eds.), *Contemporary issues in art education,* pp. 70–83. Upper Saddle River, NJ: Prentice Hall.

Becker, C. (1994). *The subversive imagination: Artists, society, and social responsibility.* New York: Routledge.

Birt, D.; Krug, D.; & Sheridan, M. (1997). Earthly matters: Learning occurs when you hear the grass singing. *Art Education,* 50(6), 6–13.

Blandy, D. (1991). Conceptions of disability: Toward a sociopolitical orientation to disability for art education. *Studies in Art Education,* 32(3), 131–144.

Blandy, D. (1993). Community-based lifelong learning in art for adults with mental retardation: A rationale, conceptual foundation, and supportive environments. *Studies in Art Education,* 34(3), 167–175.

Blandy, D., & Congdon, K. (1988). Community based aesthetics as exhibition catalyst and a foundation for community involvement in art education. *Studies in Art Education,* 29(4), 243–249.

Blandy, D.; Congdon, K.; & Krug, D. (1998). Art, ecological restoration, and art education. *Studies in Art Education,* 39(3), 230–243.

Blandy, D., & Cowan, D. (1997). Imagine! Yellowstone: Art education and the reinhabitation of place. *Art Education,* 50(6), 40–46.

Bolin, P., & Blandy, D. (2003). Beyond visual culture: Seven statements of support for material culture studies in art education. *Studies in Art Education,* 44(3), 246–263.

Bourdieu, P. (1984). *Distinction: A social critique of the judgment of taste.* Cambridge, MA: Harvard University Press.

Carpenter, B. S. II (1999). Thoughts on black art and stereotypes: Visualizing racism. *Journal of Multicultural and Cross-cultural Research in Art Education,* 17, 103–115.

Carpenter, B. S. II, & Sessions, B. (2002). (Re)shaping visual inquiry of three-dimensional art objects in the elementary school: A content-based approach. In Y. Gaudelius & P. Spiers (Eds.), *Contemporary issues in art education,* 370–383. Upper Saddle River, NJ: Prentice-Hall.

Carter, R. T. (1997). Is white a race? Expressions of white racial identity. In M. Fine, L. Weis, L. C. Powell, & L. Mun Wong (Eds.), *Off white: Readings on race, power, and society,* 198–209. New York: Routledge.

Chalmers, F. G. (1987). Culturally based versus universally based understanding of art. In D. Blandy & K. Congdon (Eds.), *Art in a Democracy*, pp. 4–12. New York: Teachers College.

Chalmers, F. G. (1999). Cultural colonialism and art education. Eurocentric and racist roots of art education. In D. Boughton & R. Mason (Eds.), *Beyond multicultural art education: International perspectives*, pp. 173–183. New York & Berlin: Waxmann.

Chalmers, F. G. (2002). Knowing art through multiple lenses: In defense of purple haze and grey areas. In P. Duncum & T. Bracey (Eds.), *On knowing: Art and visual culture*. Christchurch, NZ: Canterbury University.

Chapman, L. (1978). *Approaches to art in education*. New York: Harcourt, Brace, Jovanovich.

Check, E.; Deniston, G; & Desai, D. (1997). Living the discourses. *Journal of Social Theory in Art Education*, 17, 40–70.

Collins, G. (1995). Explanations owed my sister: A reconsideration of feminism in art education. *Studies in Art Education*, 36(2), 69–83.

Collins, G., & Sandell, R. (1996). *Gender issues in art education: Content, contexts, and strategies*. Reston, VA: NAEA.

Congdon, K. (2000). Beyond the egg carton alligator: To recycle is to recall and restore. *Art Education*, 53(6), 6–12.

Congdon, K.; Delgado-Trunk, C.; & Lopez, M. (1999). Teaching about the ofrenda and experiences on the border. *Studies in Art Education*, 40(4), 312–329.

Corrin, L. (1993). Mining the museum 1. *Proceedings of Seminar on Discipline-based Art Education and Cultural Diversity* [A National Invitational Seminar Sponsored by the Getty Center for Education in the Arts], pp. 72–75. Santa Barbara, CA: The J. Paul Getty Trust.

Daniel, V., & Delacruz, E. M. (1993). Editorial. Art education as multicultural education: The underpinnings of reform. *Visual Arts Research*, 19(2), v–ix.

Danto, A. (1986). *The philosophical disenfranchisement of art*. New York: Columbia University Press.

Delacruz, E. M. (1990). Revisiting curriculum conceptions: A thematic perspective. *Visual Arts Research*, 16(2), 10–25.

Delacruz, E. M. (1995). Multiculturalism and art education: Myths, misconceptions, misdirections. *Art Education*, 48(3), 57–61.

Delacruz, E. M. (1996). An examination of approaches to multiculturalism in multicultural art curriculum products: Business as usual. *Journal of Aesthetic Education*, 30(1), 29–41.

Desai, D. (2000). Imaging Difference: The Politics of Representation in Multicultural Art Education. *Studies in Art Education*, 41(2), 114–29.

Duncum, P. (1987). What, even Dallas? Popular culture within the art curriculum. *Studies in Art Education,* 29(1), 6–16.

Duncum, P. (1997). Art education for new times. *Studies in Art Education*, 38(2), 69–79.

Duncum, P. (2001). How Are We to Understand Art at the Beginning of a New Century? In P. Duncum & T. Bracey (Eds.), *On knowing: Art and visual culture*. Christchurch, NZ: University of Canterbury.

Duncum, P. (2002b). Theorising everyday aesthetic experience with contemporary visual culture. *Visual Arts Research*, 28(2), 4–15.

Ecker, D. (1990). Cultural identity, artistic empowerment, and the future of art in the schools. *Design for Arts in Education*, 91(3), 14–20.

Eldridge, L. (2003). Confronting stereotypes of Native Americans. In S. Klein (Ed.), *Teaching art in context: Case studies for preservice art education* (pp. 24–29). Reston, VA: National Art Education Association.

Ellsworth, E. (1989). Why doesn't this feel empowering? Working through the repressive myths of critical pedagogy. *Harvard Educational Review*, 59(3), 297–324.

Felshin, N. (Ed.) (1995). *But is it Art? The spirit of art as activism*. Seattle: Bay.

Floyd, M. (2003). Issues in teaching African-American students. In S. Klein (Ed.), *Teaching art in context: Case studies for preservice art education* (pp. 30–33). Reston, VA: National Art Education Association.

Foster, H. (1996). The artist as ethnographer. In *The return of the real: The avant-garde at the end of the century*, pp. 171–203. Cambridge, MA: MIT University Press.

Freedman, K. (2000). Social perspectives on art education in the U.S.: Teaching visual culture in a democracy. *Studies in Art Education*, 41(4), 314–329.

Freedman, K. (2003). *Teaching visual culture*. New York: Teachers College.

Freedman, K., & Schuler, K. (2002). Please stand by for an important message: Television in art education. *Visual Arts Research*, 28(2) [Issue 56], 16–26.

Freire, P. (1970/1993). *Pedagogy of the oppressed*. Transl. M. B. Ramos. New York: Continuum.

Freire, P. (1998). *Politics and education*, translated by P. L. Wong. Los Angeles: University of California, Los Angeles, Latin American Center.

Gablik, S. (1991). *The reenchantment of art*. New York: Thames & Hudson.

Garber, E. (1990). Implications of feminist art criticism for art education. *Studies in Art Education*, 31(1), 17–26.

Garber, E. (1995). Teaching art in the context of culture: A study in the borderlands. *Studies in Art Education*, 36(4), 218–232

Garber, E. (2002). Post 9/11: Politics, diversity, and multiculturalism in art education. *Journal of Cultural Theory in Art Education*, 19–20, 36–46.

Garber, E. (2003). Teaching about gender issues in the art education classroom: Myra Sadker day. *Studies in Art Education*, 45(1), 56–72.

Garber, E. (In press). MOO: Using a computer gaming environment to teach about community arts. *Art Education*.

Garber, E., & Pearson, R. (1995). Women, ads, and art. In T. Barrett (Ed.), *Lessons for teaching art criticism*, pp. 43–48. Bloomington, IN: ERIC: Art.

Garoian, C. (1998). Art education and the aesthetics of land use in the age of ecology. *Studies in Art Education*, 39(3), 244–261.

Garoian, C. (1999). Performing pedagogy *Toward an art of politics*. Albany, NY: State University of New York (SUNY) Press.

Giroux, H. A. (1991). Postmodernism as border pedagogy: Redefining the boundaries of race and ethnicity. In H. A. Giroux (Ed.), *Postmodernism, feminism, and cultural politics: Redrawing educational boundaries*, pp. 217–256. Albany, NY: SUNY Press.

Giroux, H. A. (1992). *Border crossings: Cultural workers and the politics of education*. New York: Routledge.

Giroux, H. A., & Simon, R. I. (1988). Critical pedagogy and the politics of popular culture. *Cultural Studies* 2(3), 294–320.

Giroux, H. A., & Simon, R. I. (1989a). Popular culture as pedagogy of pleasure and meaning. In H. A. Giroux & R. I. Simon (Eds.), *Popular culture, schooling, and everyday life*, pp. 1–29. New York: Bergin & Garvey.

Giroux, H. A., & Simon, R. I. (1989b). Schooling, popular culture, and a pedagogy of possibility. In H. A. Giroux & R. I. Simon (Eds.), *Popular culture, schooling, and everyday life*, pp. 219–235. New York: Bergin & Garvey.

Gomez-Peña, G. (1986). Border culture: A process of negotiation toward utopia. *La Linea Quebrada/The Broken Line*, 1, 1–6.

Gomez-Peña, G. (1989). A new artistic continent. In A. Raven (Ed.), *Art in the Public Interest*, pp. 105–117. Ann Arbor, MI: UMI Research Press.

Gomez-Peña, G. (1993). *Warrior for Gringostroika*. St. Paul, MN: Graywolf.

Gomez-Peña, G. (2000). *Dangerous border crossers: The artist talks back*. New York: Routledge.

Grauer, K. (2002). Teenagers and their bedrooms. *Visual Arts Research*, 28(2) [Issue 56], 86–93.

Greene, M. (2000). Lived spaces, shared spaces, public spaces. In L. Weis & M. Fine (Eds.), *Construction sites: Excavating race, class, and gender among urban youth*, pp. 293–303. New York: Teachers College.

Grossberg, L. (1989). Pedagogy in the present: Politics, postmodernity, and the popular. In H. A. Giroux & R. I. Simon (Eds.), *Popular culture, schooling, and everyday life*, pp. 91–115. New York: Bergin & Garvey.

Guay, D. (2003). Case study: Disabled or ignored? In S. Klein (Ed.), *Teaching art in context: Case studies for preservice art education*, pp. 51–55. Reston, VA: National Art Education Association.

Hagaman, S. (1990). Feminist inquiry in art history, art criticism, and aesthetics: An overview for art education. *Studies in Art Education*, 32(1), 27–35.

Hayes, A. M., & Robinson, M. (2001). Haitian art: Exploring cultural identity. *Art Education*, 54(1), 25–32.

Haynes, J. S. (1993). Historical perspectives and antecedent theory of multicultural art education: 1954–1980. *Visual Arts Research*, 19(2), 24–34.

Helms, J. (1984). Toward a theoretical explanation of the effects of race on counseling: A Black/White interactional model. *The Counseling Psychologist*, 12(4), 153–165.

Helms, J. (Ed.) (1990). *Black and white racial identity: Theory, research, and practice*. New York: Greenwood Press.

Helms, J. E. (1995). An update of Helms' white and people of color racial identity models. In J. Ponterotto, J. M. Casas, L. A. Suzuki, & C. M. Alexander (Eds.), *Handbook of multicultural counseling*, (pp. 181–198). Thousand Oaks, CA: Sage.

Hicks, L. (1990). A Feminist Analysis of Empowerment and Community in Art Education. *Studies in Art Education*, 32(1), 36–46.

Hicks, L. E. (1994). Social reconstruction and community. *Studies in Art Education*, 35(3), 149–156.

Honeychurch, K. (1995). Extending the dialogue of diversity: Sexual subjectivities and education in the visual arts. *Studies in Art Education*, 36(4), 210–217.

Jennings, L. B., & Potter Smith, C. (2002). Examining the role of critical inquiry for transformative practices. *Teachers College Record*, 104(3), 456–481.

Kantonen, L. & P. (2003). Conversation and listening as methods of art. Unpublished manuscript.

Kauppinen, H. (1991). Peace education in art: Focus on gender. Eric Documents Accession No: ED342710.

Keifer-Boyd, K. (1997). Re-presentations in virtual museums. *Art and academe: A journal for humanities and sciences in the education of artists*, 9(2), 38430.

Keifer-Boyd, K. (2003). A pedagogy to expose and critique gendered cultural stereotypes embedded in art interpretations. *Studies in Art Education*, 44(4), 315–334.

Kellner, D. (1991). Reading images critically: Toward a postmodern pedagogy. In H. A. Giroux (Ed.), *Postmodernism, feminism, and cultural politics: Redrawing educational boundaries*, pp. 60–82. Albany, NY: SUNY.

Kester, G. (Ed.) (1998). *Art, activism, and oppositionality: Essays from Afterimage*. Durham, NC: Duke University Press.

Kester, G. (1999). The art of listening (and being heard): Jay Koh's discursive networks. *Third Text: Third World Perspectives on Contemporary Art and Culture*, 47, 19–26.

Kester, G. (2002). Community and communication in dialogical art. In *Focas: Forum on Contemporary Art and Society*, 4, 90–101.

Keyes, K. & Ballengee-Morris, C. (2001). Car art and cruise in: A tour through community culture. In K. G. Congdon, D. Blandy, & P. E. Bolin (Eds.), *Histories of community-based art education*, pp. 42–53. Reston, VA: National Art Education Association.

Kincheloe, J. L. & Steinberg, S. R. (1998). Lesson plans from the outer limits: Unauthorized methods. In J. L. Kincheloe & S. R. Steinberg (Eds.), *Unauthorized methods: Strategies for critical teaching*, pp. 1–23. New York: Routledge.

Kozol, J. (1992). *Savage inequalities: Children in America's schools*. New York: Crown.

Lacy, S. (1995). *Mapping the terrain: New genre public art*. Seattle, WA: Bay.

Lampela, L. (1995). Challenge for art education: Including lesbians and gays. *Studies in Art Education*, 36(4), 242–248.

Lampela, L. (1996). Concerns of gay and lesbian caucuses within art, education, and art education. *Art Education*, 49(2), 20–24.

Lampela, L., & Check, E. (2003). *From our voices: Art educators and artists speak out about lesbian, gay, bisexual, and transgendered issues*. Dubuque, IA: Kendall/Hunt.

Lenz, E. (2002). Dressing up: Clothing as a visible expression of identity. *Art Education*, 55(5), 25–32.

Májozo, E. C. (1995). To search for the good and make it matter. In S. Lacy (Ed.), *Mapping the terrain: New genre public art*, pp. 88–93. Seattle, WA: Bay Press.

May, W. T. (1994). The tie that binds: Reconstructing ourselves in institutional contexts. *Studies in Art Education*, 35(3), 135–148.

McFee, J. K. & Degge, R. (1980). *Art, culture, and environment: A catalyst for teaching*. Dubuque, IA: Kendall Hunt.

McIntosh, P. (1989, July/August). White privilege: Unpacking the invisible knapsack. *Peace and freedom*.

McLaren, P. (1995). *Critical pedagogy and predatory culture: Oppositional politics in a postmodern era*. New York: Routledge.

McLaren, P. (1997). Unthinking whiteness, rethinking democracy: Critical citizenship in gringolandia. Chap. in P. McLaren, *Revolutionary multiculturalism: Pedagogies of dissent for the new millennium*. Boulder, CO: Oxford University Press.

Nyman, A. (2003). Teaching students with special needs. In S. Klein (Ed.), *Teaching art in context: Case studies for preservice art education* (pp. 60–62). Reston, VA: National Art Education Association.

Nyman, A., & Jenkins, A. M. (1999). *Issues and approaches to art for students with special needs.* Reston, VA: National Art Education Association.

Osbourne, K. (1988). *Educating citizens: A democratic socialist agenda for Canadian education.* Toronto: Our Schools/Our Selves Educational Foundation.

Rabinow, P. (1986). Representations are social facts: Modernity and post-modernity in anthropology. In J. Clifford & G. Marcus (Eds.), *Writing culture: The poetics and politics of ethnography*, pp. 234–261. Berkeley, CA: University of California Press.

Roman, L. (1993). White is a color! White defensiveness, postmodernism, and anti-racist pedagogy. In C. McCarthy & W. Crichlow (Eds.), *Race, identity, and representation in education*, pp. 71–88. New York: Routledge.

Sandell, R. (1991). The liberating relevance of feminist pedagogy. *Studies in Art Education*, 32(3), 178–187.

Sehr, D. (1993, April). Studying the democratic school: A theoretically framed, qualitative approach. Paper presented at the Annual Meeting of the American Educational Research Association (Atlanta, Georgia, April 12–16, 1993). ED357074.

Shumway, D. (1989). Reading rock 'n' roll in the classroom: A critical pedagogy. In H. A. Giroux & P. McLaren (Eds.), *Critical pedagogy, the state, and cultural struggle*, pp. 222–291. Albany, NY: SUNY.

Simon, R. I. (1992). *Teaching against the grain: Texts for a pedagogy of possibility.* Toronto: Ontario Institute for Studies in Education.

Sleeter, C., & Grant, C. (1988). *Making choices for multicultural education: Five approaches to race, class, and gender.* Columbus, OH: Merrill.

Smith-Shank, D. (1998). Sugar and spice and everything: Reflections on a feminist aesthetic. *Journal of Social Theory in Art Education*, 18, 21–28.

Smith-Shank, D. (1999–2000). Mirror, mirror on the wall: Searching for the semiotic self. *Arts and Learning Research*, 16(1), 93–96.

Springgay, S., & Peterat, L. (2002/2003). Touch, fantasy, and performance: Re-representing bodies in a high school fashion show. *The Journal of Gender Issues in Art and Education*, 3, 52–68.

Sproll, P. A. C. (1990). The utilitarian object as appropriate study for art education: An historical and philosophical inquiry grounded in American and British contexts. Unpublished dissertation. Ohio State University. DAI, 51, no. 10A, (1990): 3309.

Stokrocki, M. (2002). Shopping malls from preteen and teenage perspectives. *Visual Arts Research*, 28(2) [Issue 56], 77–85.

Stuhr, P. (1994). Multicultural art education and social reconstruction. *Studies in Art Education*, 35(3), 171–178.

Stuhr, P., Petrovich-Mwaniki, L., Wasson, R. (1992). Curriculum guidelines for the multicultural classroom. *Art Education*, 45(1), 16–24.

Tavin, K. (2002). Engaging advertisements: Looking for meaning in and through art education. *Visual Arts Research*, 28(2), 38–47.

Tavin, K. (2003). Wrestling with angels, searching for ghosts: Toward a critical pedagogy of visual culture. *Studies in Art Education*, 44(3), 197–213.

Tavin, K., &Anderson, D. (2003). Teaching (popular) visual culture: Deconstructing Disney in the elementary art classroom. *Art Education*, 56(3), 21–35.

Taylor, P. (2002a). Service-learning as postmodern art and pedagogy. *Studies in Art Education*, 43(2), 124–140.

Taylor, P. (2002b). Singing for someone else's supper: Service learning and empty bowls. *Art Education*, 55(5), 46–52.

Torres, C. A. (1998). *Democracy, education, and multiculturalism: Dilemmas of citizenship in a global world.* Lanham, MD: Rowman & Littlefield.

Wales, A. (2001, September). Encouraging young cartoonists. *School Arts*, pp. 29–31.

Wasson, R.; Stuhr, P.; & Petrovich-Mwaniki, L. (1990). Teaching art in the multicultural classroom: Six position statements. *Studies in Art Education*, 31(4), 234–246.

Weis, L., & Fine, M. (2000). Construction sites: An introduction. In L. Weis & M. Fine (Eds.), *Construction sites: Excavating race, class, and gender among urban youth*, pp. xi-xiv. New York: Teachers College.

Yokley, S. H. (1999). Embracing a critical pedagogy in art education. *Art Education*, 52(5), 18–24.

Zimmerman, E. (1990). Issues Related to Teaching Art from a Feminist Point of View. *Visual Arts Research*, 16(2), 1–9.

"Plotting" the Story of Race: Pedagogy Challenges in History and Literature

Amritjit Singh

In a frequently cited passage from his essay, "Twentieth Century Fiction and the Black Mask of Humanity" (1953), Ralph Ellison invokes the centrality of race in the narrative of the United States as a nation by proposing that "we view the whole of American life as a drama acted upon the body of a Negro giant, who, lying trussed up like Gulliver, forms the stage and the scene upon which and within which the action unfolds."[1] Most African Americanists know from their classroom experience how even short pieces such as W. E. B. Du Bois's "The Conservation of Races" (1897) or "Of Our Spiritual Strivings" (the opening chapter in *Souls of Black Folk* [1903]) or "Souls of White Folk" (1910), Randolph Bourne's "Trans-National America" (1916), Marita Bonner's "On Being Young—a Woman—and Colored" (1925), Langston Hughes's "The Negro Artist and the Racial Mountain" (1926), Wallace Thurman's "Nephews of Uncle Remus" (1927), Zora Neale Hurston's "How It Feels to Be Colored Me" (1928), Ellison's "What America Would Be Like without Blacks" (1970)—or, for that matter, Peggy McIntosh's "White Privilege: Unpacking the Invisible Knapsack" (1989)—can convey the layered complexity of "race" in the United States. Some of our students, like us, can come away from any one or two of these essays with humility and appreciation for the insights and provocations they comprise. Along with scores of films and countless discursive and fictional writings, these very teachable essays show the challenges involved in climbing the steep and treacherous terrains of the racial mountain.

Faced with the mountain, all of us—scholars of literature, history, anthropology, political science, and sociology alike—can benefit immensely from the new understandings of race that interdisciplinary, interethnic, feminist, transatlantic, transnational, postcolonial, and global approaches have brought us in recent decades.

37

From *Journal of American Ethnic History*, Vol. 32, No. 1 (2012), pp. 7–23.

In this regard, the intersection of history and literature is quite telling. History is not simply the "story," a chronological narrative of events, as it is often perceived to be. It is in fact much more like the "plot," Aristotle's "mythos." The distinction between story and plot is commonly honed in gateway courses for English majors. "Plot," according to M. H. Abrams's widely used text, *A Glossary of Literary Terms* (2011), refers to the events and actions of a narrative or dramatic work, "as these are rendered and ordered toward achieving particular artistic and emotional effects."[2] Our teaching, no less than our scholarly monographs in history or literature, involves a respect for chronology, but it calls even more for techniques and strategies that resemble the careful arrangement of a literary plot. In history, we would aim our arrangements or strategies toward a desired end or outcome, focusing our plot on critical issues and consequences.

At their best, the classes we teach are shaped by our goal of challenging our students' assumptions and unsettling the narratives of America or race that they might have already received from uncles and aunts, priests and politicians, friends and neighbors, teachers and mentors, myth and folklore. While most of us do not have a particular doctrine to preach or a specific content to sell, we are not entirely neutral or detached, either. We could be moral and purposeful, activist and political, in varying degrees, in our different styles of teaching. We are interested in making our students aware of the existence of multiple narratives of history and culture—some of them more historically grounded than others. We want to help our students to rearrange the furniture in their minds and to begin questioning any ideologies of white supremacy they might have internalized consciously or unconsciously. We expect them to become critical readers in their own right, capable of examining or imagining the past in fresh and sophisticated ways. The distinction between story and plot is thus an appropriate metaphor for much of what we do as teachers and scholars in the humanities. As in rendering an essay or monograph, so in the classroom, the more palpable our design, the less effective we become in achieving our goals, regardless of our teaching styles or theoretical preferences. In teaching or writing, we are more likely to lose our audiences if our personal biases or ideological predilections are openly on display. I, for one, feel very fortunate when, in the midst of a difficult dialogue, one or two students bring up a critical point of view before I feel compelled to express it. I know from experience that such a point when expressed by me, a figure of authority in the classroom and a foreign-born person of color, would meet with resistance from some or many of my students, making it harder to achieve my goals as a discussion leader.

In this issue of *JAEH*, such pedagogical concerns find expression in Laila Haidarali's extended exploration of Du Bois's novel *Dark Princess* (1928), and even more directly in the other six shorter pieces that encapsulate a wide range of uses historians make of fictional and life narratives in their teaching and scholarship.

These thoughtful reflections by historians would likely bear a cousinship to similar accounts that some teacher-scholars of literature might offer about their uses of history in their work. In either case, our goal is to help our students develop into alert and articulate readers of diverse books and become smart and skeptical consumers of everything they find on the Web or watch on the screen. In literary pedagogy and scholarship there has been "the race for theory" (Barbara Christian's phrase) since the 1970s. But there has also been a growing recognition of the dangers in surrendering completely to the abstraction and undecidability that deconstruction and other poststructuralist approaches have valorized at the cost of historical specificity and cultural context. Postmodernists and poststructuralists such as Jacques Derrida and Jean-Francois Lyotard declared the demise of objective truth, leaving us solely with difference (Derrida's *différance*), signaling the need for tolerance of each individual's construct of reality shaped by his or her dominant social group.[3] As Christian notes in her 1987 essay, the dominance of poststructuralist theory came about—ironically—at the same time as the emergence of African American and other ethnic literatures in the U.S. literary canon. She was concerned that literary criticism was becoming an end unto itself, abandoning literature as the focus of its endeavor. As she put it, "Critics are no longer concerned with literature, but with other critics' texts, for the critic yearning for attention has displaced the writer and has conceived of himself as the center."[4] She was also reluctant to give literary criticism the power to determine that which is valuable, giving rise to the possibility that creative artists would stifle their organic creative tendencies and instead pursue moves that adhere to critics' definitions of what is worthy and valuable in literature. Christian viewed women writers and writers of color as especially vulnerable, and she worried that literary criticism would reproduce social inequities by denying the dynamic nature of difference and the power of difference to empower both writers and readers.

Evidently, Christian's understanding of difference was quite distinct from Derrida's and much more centered in the particularities of history and culture. While some colleagues read Christian's cautionary essay to represent a rejection of theory, others would view it as a plea to recognize that theory, like culture, takes place in multiple modes, forms, and styles. The following words from the early pages of Christian's essay are especially relevant to the special focus for this issue of *JAEH*:

> People of color have always theorized—but in forms different from the Western form of abstract logic. . . . Our theorizing (and I intentionally use the verb rather than the noun) is often in narrative forms, in the stories we create, in riddles and proverbs, in the play with language, because dynamic rather than fixed ideas seem more to our liking. . . . My folk, in other words, have always been a race for theory—though more in the form of the hieroglyphic, a written figure that is both sensual and abstract, both beautiful and communicative.[5]

In his essay "Listening to Learn" (1990) and in his book *Time Passages* (2001), George Lipsitz has expressed similar concerns, arguing that "American studies would be served best by a theory that refuses hypostatization into a method, that grounds itself in the study of concrete cultural practices, that extends the definition of culture to the broadest possible contexts of cultural production and reception, that recognizes the role played by national histories and traditions in cultural contestation, and that understands that struggles over meaning are inevitably struggles over resources."[6] Both Christian and Lipsitz would be supportive of the uses historians are finding today for memoirs, autobiographies, short stories, and novels in their teaching and scholarship—turning to such texts to validate and complicate the interplay between the story (chronology) and the plot (arrangement, construction, design) of history.

Haidarali's *Dark Princess*

Haidarali's essay on Du Bois's intriguing novel *Dark Princess* gestures toward color and transnationalism, but it examines the narrative mostly through a feminist historian's lens. While primarily a work of new scholarship, the essay has pedagogical meanings both in relation to women's voices in our classrooms and the possible uses of woman-centered texts authored by male writers. Haidarali seeks to reposition both African American women and Asian Indian women as central to understanding Du Bois's heroine, Kautilya, as a raced, gendered, and classed representation of the brown woman's body. Haidarali views *Dark Princess* as an unusual text that offers perspectives on both Asian Indian and African American womanhood during a period of vibrant social change and static gendered values. She underscores in her own way the grand problematic of race as we experience it in the discursive, fictional, and autobiographical prose, as well as in writings in other genres, by diverse writers throughout the African American literary tradition. In many ways, African American novelists of the 1920s and 1930s—such as Jean Toomer, Nella Larsen, Jessie Fauset, Rudolph Fisher, Thurman, and Hurston—both struggled against, and rejoiced in, the racializing of their identities as New Negroes. As a consequence, Harlem Renaissance literature is rich in the multiple voices and meanings that were often articulated as modern, urban, and progressive. Both as scholars and teachers, historians can surely gain alternative understandings from this literature as well as nuanced ways of viewing popular historical narratives about race, gender, and sexuality during the 1920s. The focus on brownness as a literary metaphor highlights the broader social and cultural factors influencing the meanings of race.

Haidarali references incisive critiques by many black feminist historians and literary scholars that drew attention in the 1980s and 1990s to the peripheral treatment of African American women's writing during and after the Harlem Renaissance, paving the way for continuing engagements with black feminism by sociologists,

historians, and other scholars. It has been especially helpful that courses in Africana Studies, English, History, and Women/Gender Studies have paid particular attention to reading women-authored texts in order to listen more carefully to the social concerns, physical realities, and emotional subjectivity of African American women during the Harlem Renaissance years.

So why does Haidarali analyze a male-authored text to address the raced and gendered ideologies of the 1920s? What does it mean to draw on a text by a most powerful African American man of the era whose intellectualism, activism, and personal life have continued to elicit a diverse body of scholarship on his long career as truly a renaissance man? For African American artists and thinkers of the Harlem Renaissance, both men and women, Du Bois was as indispensable a figure as Ralph Waldo Emerson was to the American Renaissance of the 1850s. Inspired by *Souls of Black Folk* and in awe of his influence as the editor of *The Crisis*, most of them admired Du Bois's intellect and civil rights commitments even as they often challenged or rejected his aesthetic criteria.[7] But instead of assessing Du Bois's personality or biography to determine his gendered and sexed politics, Haidarali has chosen to read *Dark Princess* as a literary representation whereby the audience, rather than the author, assumes responsibility for the reading engagement. In doing so, she underscores the historical meanings of brownness in broader contexts. In considering gender as a relational category, Haidarali also demonstrates the value of this text not necessarily in firming up knowledge about African American women's social realities, but more directly in showing how representations from the period reveal sets of social and community ideals as informed by the raced politics of the era and in ways that a typical historical narrative might not. Additionally, this essay hints as to why certain male-authored texts on women's bodies may tell us something that women-authored ones may not. For example, in *Dark Princess*, Du Bois draws women's bodies with reverence, sensual delight, and a conservative masculine imperative. Contrasted with Du Bois's radical race politics, his transnational vision, and his celebratory view of modern interracial sexuality, the conservative gender values accorded in the novel to brown and black women highlight the ideology of the period as one that strategically embraced only some ideals of modern womanhood.

Haidarali's analysis is thus instructive in understanding multiple layers in the histories of African American women. She helps us to see how past and contemporary perceptions of African Americans demanded rethinking, especially in relation to the growing social values of a modern 1920s America and its expanding embrace of independent womanhood along with greater sexual freedoms. Her analysis also draws attention to how representations of African American middle-class women continued to reflect concerns that collectivized race without including women's gendered position from a female point of view. Women's voices rightly deserve our continued attention, and perhaps more in conversation with, rather than in opposition to, the voices of the male authors with whom they socialized and worked to create the body

of literature that historians and others find invaluable in considering the ideologies of the 1920s. Certainly Haidarali's analysis is a pointer toward how our syllabi might be constructed to model gender discourse: to allow both male and female voices to share space in one course as they validate, refine, or contradict one another.

Forum on Pedagogy: Race in History and Literature Courses

Some of Haidarali's concerns are reflected again in the six pieces that comprise the Forum section in this issue, focused as they are on the uses of fiction and life narratives in the teaching of history and general education courses on a variety of U.S. campuses. For the most part, these essays strike a personal note in documenting and reflecting upon the interdisciplinary approaches that help to break down students' resistance to imagining the role race has played in our past and how it continues to blur our understandings of social and political phenomena in the present. While only some of the essays describe in some detail students' interaction with the particular texts, these essays individually and collectively do convey a view of U.S. history not as a steady expansion of freedoms but as a constant struggle, with many setbacks and backlashes along the way. Cheryl Greenberg relates this resistance or denial quite aptly to the way the Civil Rights Movement has been often taught to show that "American history is a slow but inexorable trek from inequality to equality, from injustice to justice, from an imperfect to a more perfect union."

Greenberg is fortunate that most of her students at Trinity College in Hartford, Connecticut, have a "basic knowledge of the civil rights movement . . . and know the names of Martin Luther King, Jr., Rosa Parks, and Malcolm X," something uncommon on most U.S. campuses. In responding to the needs of student populations who often know little about the major events and figures in U.S. history, I begin my courses in nineteenth- and twentieth-century African American literature by showing a video such as Marlon Riggs's *Ethnic Notions* (1986), followed by an extended presentation on U.S. history from the Civil War to the Civil Rights Act of 1964 and the Voting Rights Act of 1965. In offering this history to groups comprised mostly of European Americans, ethnically inflected or not, I am aware, as my students sometimes are too, that they are learning the fundamentals of their own history from a turbaned Sikh immigrant from India. I build my sweeping narrative of U.S. history, that "drama acted upon the body of a Negro giant" in Ellison's phrase, from the Reconstruction years, 1865–1877, our first short-lived affirmative action program, through the 1890s, widely regarded as the nadir of African American citizenship rights, to the Harlem Renaissance, whose considerable successes in the arts did not translate well into basic civil rights for blacks. I underscore along the way the importance of dates such as 1876 (the election of President Rutherford Hayes and the subsequent withdrawal of federal troops from the South) and 1896 (the *Plessy v. Ferguson* Supreme Court decision). I

note wryly the significance of 1895 in the trajectory of black leadership: the year in which Du Bois, with a PhD from Harvard in hand, embarked on his academic and public career; Booker T. Washington made his controversial Atlanta Compromise speech; and Frederick Douglass died after making for three years some of the bitterest and most despairing speeches on race after having been persuaded back into public life by Ida Wells following years of silence and retreat. Despite his access to the White House, Washington's failure to stem the level of violence directed at young African American males around the turn of the century brought the resounding rejection of his accommodationist politics by the Niagara Movement in 1905, leading eventually to the formation in 1909 of the NAACP as the first major civil rights organization by a group of concerned citizens: black and white, Christian and Jewish. We briefly examine President Truman's decision to integrate the armed forces in 1948 and the landmark 1954 Supreme decision, *Brown v. Board of Education*, in the midst of a world where the Cold War was heating up and European colonialism had begun to unravel in Asia and Africa.

Taking the time to capture these key moments in African American history opens valuable spaces and contexts in my American and African American Literature courses to connect a scene; an idea; or a character in a poem, short story, novel, or play to the plot if not the story of U.S. history. I gesture too, in quick strokes, toward Asian American history during the same years—mentioning several landmarks from the Chinese Exclusion Act of 1882 to the passing in 1924 of the National Origins Act (Johnson-Reed Act), with the latter's definitively exclusionary goals preceded by restrictionist markers such as the Gentleman's Agreement with Japan (1907–1908) and the two Supreme Court decisions on Asian naturalization: *Takao Ozawa v. United States* (1922) and *United States v. Bhagat Singh Thind* (1923). It is no mere coincidence that President Lyndon Johnson signed the Immigration Act of 1965 (Hart-Celler Act) on October 3 that opened up immigration from around the world less than three months after he had signed into law the Voting Rights Act that resuscitated the long-ignored provisions of the Fifteenth Amendment of 1870.

To someone like me, a U.S. citizen by choice and not by birth, this history has special poignancy that I hope gets conveyed in some measure in the classroom with its probable shock of recognition for some of my students—that very few white Americans gave a tinker's damn about rectifying the wrongs that began to be institutionalized between 1877 and 1896. For me, such a lesson when effectively delivered is much more valuable than any investment of classroom time in the abstractions of postmodernist, poststructuralist theory toward our need to deconstruct the received narratives of race in North America. On the other hand, carefully culled concepts such as Orientalism, mimicry, and hybridity from postcolonial theory could be pertinent to teaching texts by writers as diverse as Langston Hughes (a poem such as "Theme for English B" [1951] or a short story like "The Blues I'm

Playing" [1934]), Thurman (*The Blacker the Berry* [1929]), Nella Larsen (*Quicksand* [1928]), Wright (*Black Boy* [1945] or *Uncle Tom's Children* [1938]), Morrison (*The Bluest Eye* [1970]), Alice Walker (*Meridian* [1976]), or Charles Johnson (*Middle Passage* [1990]). Even more relevant to our work in the classroom are insights from critical race theory, lucidly contextualized in a text such as Michael Omi and Howard Winant's *Racial Formation in the United States* (1986).[8] But with or without postcolonial or critical race theory, scores of African American literary texts in a variety of genres would demonstrate how black American artists have shaped their distinctive, and sometimes opposing, aesthetic responses to the lived experience of racial stereotyping and warped projections of difference from white America. These texts bear witness to the persistent search in African American life and cultural expression for individual personhood and agency. They also draw much-needed attention to their citizenship rights that were systematically eroded by a series of court decisions and legislation that followed the notorious political compromise of 1877 which ended Reconstruction, compelling blacks both in the South and the North to live segregated lives, barred from catching "the full spirit of Western Civilization, . . . [living] somehow in it but not of it," as Wright observes in *Black Boy*.[9] Since the 1960s the road to full citizenship rights for African Americans and other minority populations has been marked by continual progress but also by recurrent setbacks. Many literary texts document and explore that story of this ongoing search for freedom and equality in ways that enhance and reinforce the experience of historical accounts.

In light of my classroom experiences with the teaching potential of my students' own personal narratives of race and difference, I am not surprised that five of the six contributors to the Forum section talk about their use of life narratives—memoirs or autobiographies—in service of their goals as history teachers.[10] Perhaps life narratives, like documentary films, inject into the dry factual renditions of history the humanizing appeal of what happened to real people in real life, making historical events and figures more believable. In many ways, life narrative as a genre represents a fascinating interaction between story and plot, between chronology and constructed or strategic narrative. While life narratives strike us much more as versions of lived experience than works of fiction, our students need to recognize that their writers, like novelists, have complete control over what they choose to reveal—or hide—about events or motives or impulses they describe. Further, the occasional heroism or resilience of a life narrative's protagonist may inspire our students to imagine the past in ways that bolster their self-conscious participation in the present or the future as responsible citizens who no longer feel powerless as individuals. I would hesitate to describe such a possibility of epiphany or response as a poststructuralist moment.

The pedagogical practices that Julie Longo and Cheryl Greenberg explore have one thing in common: their use of less-than-ideal texts in order to provoke debate and

peer engagement in the classroom. In tandem with the gendered urbanism of Haida-rali's essay, Longo offers reflections about her freshman seminar, which is focused not on race but on the study of "the city, using Detroit as a case study." Paul Clemens's memoir, *Made in Detroit* (2005), captures the experience of Clemens growing up in a white, Catholic, working-class family after the 1973 election of Coleman Young, the city's first black mayor and a former Tuskegee airman. Longo tells us that while Clemens's book is accessible and frank in its narrative account, it has had mixed reviews and is not written in a particularly engaging style. And yet this flawed text, when used with mostly all-white student groups, allows Longo to meet her primary goal in the course—to show students "how historians must handle potential sources." For Longo, Clemens's "ambivalent, often controversial discussions of race" make his memoir an appropriate and challenging exercise. For example, some of her students find Clemens racist, but she expects them to find evidence in the text to support that claim. "Difficult texts" such as Clemens's allow Longo's students to gain a level of comfort with "the shades of grey: working with ambiguity and contradiction." As Longo puts it, "Indeed, *Made in Detroit* is not about race, just as Detroit's past is not only a story of racism." At the same time, some readers may feel a stronger presence of race in the book because Clemens's narrative seems so intent on denying or dismissing it.

Greenberg, likewise, chooses *Assata* (1987), a memoir by Assata Shakur, aka JoAnne Chesimard, a Black Panther who was accused of killing a police officer but escaped from prison before she could be tried. Greenberg hopes to destabilize her white and black students' blasé assumption that racial strife is "behind us as we march into the twenty-first century united and basically bias free." Even though Shakur's narrative is "partial or incorrect" and includes "dangerous distortions," students become "uneasy, then angry and militant themselves, as they read and discuss the book together." Through their engagement with Assata's autobiographical account, many of them realize that "regardless of her innocence or guilt, Assata's rights seem to be violated consistently, from inappropriate behavior of judges and prosecutors in the courtroom to the unconscionably harsh and medically dangerous conditions she [and other women] endured in prison." Greenberg's goal in using *Assata* is not to debunk the official narrative of the Civil Rights Movement, but more to compli-cate its understanding in her students' minds, helping them toward "greater critical thinking, and greater appreciation for the struggle of masses of black people who were (and are) necessary for any political success." Assata allows Greenberg to raise many issues (including gender and racial disparities in law enforcement) that "are central to the study of race, social movements and African American history." Assata's plot in her account might dispel the students' preconceptions about black militancy in the 1960s and early 1970s. Similarly, whenever my students have read *The Autobiography of Malcolm X* (1965) they begin to view him with clarity and admiration as a civil rights

leader in his own right, not just as Martin Luther King's nemesis. Life narratives by Assata and Malcolm X might allow young readers to discover the interlocking nature of violence and nonviolence in black Americans' search for freedom and justice in the U.S. and to make connections to similar struggles around the world.

Greg Carter and Walter Greason expose two different kinds of deceptive corridors that comprise the illusions and realities in the castle of race in North America. Carter uses a contemporary life narrative, Anatole Broyard's *Kafka Was the Rage* (1993), in conjunction with Larsen's Harlem Renaissance novel *Passing* (1929), to introduce his students to the perplexities of race and color—including hybrid identity and racial passing—in both positive and negative terms. In teaching his course Mixed Race Identity in American Culture on three different campuses, Carter has sometimes persuaded his students to read the long meditative essay on Broyard by Henry Louis Gates Jr., who views Broyard's passing as a bold act of reinvention and as "a sin against authenticity, one of the founding lies of the modern age." Gates views Broyard as "a connoisseur of the liminal—of crossing over and, in the familiar phrase, getting over. But the ideologies of modernity have a kicker, which is that they permit no exit. Racial recusal is a forlorn hope. In a system where whiteness is the default, racelessness is never a possibility. You cannot opt out; you can only opt in."[11] Carter hopes to show his students that while racial oppression may not often involve violence for light-skinned African Americans, racial passing can still be viewed as "a reasonable response," considering how racism can affect any individual citizen's "life outcomes" in all kinds of circumstances. While Carter explores with his students the layers of an "ex-colored man's" psyche, Greason uses Tim Wise's autobiography, *White Like Me* (2007), in all-white classrooms to register the discomfort surrounding students' gradual confrontation with their own white supremacy. In a style much less personal than those of the other contributors, Greason talks specifically about the experience of three of his students as they studied "the function of whiteness on one college campus." Greason's students begin with hostility toward white privilege discourses until they discover the presence of racial judgment in post–Jim Crow institutional structures. These students' unsettling experiences mirror the process by which white antiracism activists like Peggy McIntosh and Tim Wise have struggled to confront their own deep-seated white privilege. For Greason, Wise's book "opens the door to a new epistemology for the future" of our higher education by alerting us to the myopia of white privilege that prevents a meaningful connection with "a multifaceted, universal human experience."

In a strikingly personal tone, Suzanne Sinke offers a straightforward account of how the dark-skinned Cuban American Evilio Grillo's focus on the phenotype-driven exploration of his black identity and experiences allows her and her colleagues at Florida State University to complicate issues surrounding multiple identities in a multisection course, Race, Ethnicity and Citizenship. Despite the book's title, in

Black Cuban, Black American: A Memoir (2000), Grillo largely ignores his Cuban heritage and identity, focusing instead on his experiences at historically black colleges and on opportunities that came his way as a black person. Because Grillo offers a rather positive view of Cuba in comparison with the 1930s United States, his narrative opens up some unconventional possibilities of engaging the mostly Republican and conservative Cuban American students on the Florida campus in discussions on race, ethnicity, and ideology. Finally, Daniel Widener is the only contributor to the Forum whose teaching involves fictional works by African American novelist Chester Himes, even though the work he deals most with is the semi-autobiographical novel, *If He Hollers Let Him Go* (1945). In his piece, Widener uses Himes's short story, "Lunching at Ritzmore" (1942), a gentle satire on racism in downtown Los Angeles and the naïveté of white denial, to segue into Himes's own experiences of racism and exclusion in the Los Angeles of pre–World War II years that shape the story of the "carefully constructed everyman," Bob Jones, and his complicated life in *If He Hollers*. Widener's essay does not describe his students' responses to Himes's novel. However, he expects that by pairing *If He Hollers* with secondary sources on wartime workers of different backgrounds, he can make his students aware of a multiethnic America that Himes evokes in his fiction and nonfiction. Toward the end of his essay, Widener notes the aptness of comparing Himes with Wright because "both men spent important parts of their creative lives negotiating their intellectual relationships to a common set of ideas: the political left, existentialism, pan-Africanism, whiteness." One may add to such a list the shared interest Wright and Himes had in exploring these issues through social realism that became one of the dominant modes of artistic expression among African American artists in the 1930s, 1940s, and 1950s.

Historians: Social Realism and Beyond

I would like to end this editorial essay by returning briefly to the Ellison essay with which it began. "Twentieth Century Fiction" was written in 1946 and first published in 1953 in *Confluence* at the invitation of its editor, Henry Kissinger, then a graduate student at Harvard University. In many fascinating ways, the essay represents the matrix of race and representation that is bounded at one end by, say, Du Bois's *Dark Princess* and at the other by Ellison's own highly regarded novel *Invisible Man* (1952). It looks back to Bourne's "Trans-National America" and to the ways in which Harlem Renaissance writers explored black humanity and art in a variety of styles and modes. On the other hand, in its capacious framework, "Twentieth Century Fiction" prefigures the "symbolic action" of Ellison's own novel, even as it embraces the speculative and meditative power of fictions by, among others, John Edgar Wideman, Charles Johnson, and Octavia Butler. Although unacknowledged in Toni Morrison's *Playing in the*

Dark (1993) (based on Morrison's William E. Massey Lectures at Harvard University, Cambridge, MA, 1990), "Twentieth Century Fiction," along with a few other essays in Ellison's *Shadow and Act* (1964), clearly anticipates the discourses on race and the white literary imagination in Morrison's text.[12]

In "Twentieth Century Fiction," Ellison outlines the conflict at the heart of America, "between older, dominant groups of white Americans . . . and the newer white and nonwhite groups . . . over the major group's attempt to impose its ideals upon the rest, insisting that its exclusive image be accepted as the image of the American." But as Ellison notes, "fortunately for the United States, its minorities, and perhaps for the world," the idea of what this "American" is has not been "finally defined." Thus, "far from being socially undesirable this struggle between Americans as to what the American is to be is part of that democratic process through which the nation works to achieve itself."[13] In acknowledging the nature of Wright's recognition that black and white Americans were engaged in a war over the nature of reality (a recognition that young Salman Rushdie found inspirational in creating his own "imaginary islands" in books such as *Midnight's Children* [1981]), Ellison's essay validates the social realism of Wright's *Native Son* (1940) and *Black Boy* (1945), William Attaway's *Blood in the Forge* (1941), and Ann Petry's *The Street* (1946). Although *Dark Princess* may be viewed as a novel of romantic love or as a utopian fantasy of transnational racial politics, it is by no means a literary antecedent to the social realism that became a dominant trend during the two decades following its publication in 1928. Nonetheless, the social realist trend is not entirely absent from the Harlem Renaissance, as evidenced in Du Bois's "The Coming of John" (in *Souls of Black Folk*); Toomer's "Blood-Burning Moon" and "Kabnis" (in *Cane* [1923]); Fisher's *The Walls of Jericho* (1928) as well as his short fiction; Thurman's *The Blacker the Berry* (1929); Hughes's *Not without Laughter* (1930); Countee Cullen's *One Way to Heaven* (1932); as well as in the novels by Fauset, Larsen, and Walter White.[14]

Historians who utilize fictional and life narratives to meet specific goals in their teaching and scholarship often feel a special attraction to social realism because of its felt or perceived closeness to the plot of history. Yet the range of uses represented in the seven essays and reflections in this issue of *JAEH* would suggest that history students can and do connect with and profit from all kinds of literary works—from the ones that seem most appropriate to the less than ideal, from the realistic or the harshly naturalistic to the symbolic, from the speculative and the phantasmagoric to the comic and the satirical, from the aesthetic and the apolitical to the polemical, from the metafictional to the magic realist. Often these narrative modes and genres are shaped by and/or reflect each writer's particular interpretation of the African American experience, and for some writers their choice of form serves as a valuable heuristic tool. Also, there is a productive struggle among African American writers and critics over what literary modes would best make sense of their historical

experience and best imagine its future, paralleling the productive struggle that Ellison highlights over the meaning of "American." In "Twentieth Century Fiction," Ellison underscores the freedom of artists to create and of the audiences to receive. In linking these freedoms to the necessarily social character of art, Ellison recognizes that "while the artist can determine within a certain narrow scope the type of social effect he wishes his art to create, here his will is definitely limited. Once introduced into society, the work of art begins to pulsate with those meanings, emotions, ideas brought to it by its audience and over which the artist has but limited control."[15]

The story, or narrative, in history does not by any means equal the truth, a comprehensive, commonly chronological account of facts in relation to a topic or a period. If fiction, broadly defined, expands our sense of the human through the motives and actions of its distinct if sometimes unfamiliar characters, the historical narrative, too, reminds us that there is a difference between us and those who inhabited the past, even though we might share something with them. For both historians and literary scholars, there is much to celebrate in and learn from both the interconnectedness and the openness of these plots. As a means to achieving deeper historical understanding, literary works can provide an effective lens to a more human and pulsating version of events to grasp, a pedagogical approach that becomes even more critical when issues of race and ethnicity, class and gender, are woven into the story.

Notes

I would like gratefully to acknowledge several friends for reading and commenting on this essay in draft: Heath Bowen, C. Lok Chua, Robin Field, Ayesha Hardison, Gary E. Holcomb, Janis Holm, Charles Johnson, Nicholas Kiersey, and Peter Schmidt. While their dedication to collaborative scholarship is admired, I would not hold any of them responsible for my views or my shortcomings.

1. Ralph Ellison, *The Collected Essays of Ralph Ellison*, ed. John F. Callahan (New York, 1995), 85. In 1973 Ellison told an audience at Harvard, "all of us are part white, and all of y'all are part colored." Cited in Maryemma Graham and Amritjit Singh, eds., *Conversations with Ralph Ellison* (Jackson, MS, 1995), xiii.

2. M. H. Abrams, *A Glossary of Literary Terms*, 10th ed. (Boston, 2011), 283. As Charles Johnson reminded me, E. M. Forster's similar distinction in *Aspects of the Novel* (1927) between "story" and "plot" focuses more cogently on causation and interpretation—so while the story gives us what happened, the plot is a pointer to why it happened.

3. Discussions of questions regarding historical objectivity and narrative may be found in the following works: Hayden White, *Metahistory: The Historical Imagination in Nineteenth-Century Europe* (Baltimore, 1975); Peter Novick, *That Noble Dream: The "Objectivity Question" and the American Historical Profession* (New York, 1988); and Joyce Appleby, Lynn Hunt, and Margaret Jacob, *Telling the Truth about History* (New York, 1994).

4. Barbara Christian, "The Race for Theory," in *African American Literary Theory, A Reader*, ed. Winston Napier (New York, 2000), 280. Christian's essay first appeared

in *Cultural Critique* (Spring 1987) and was reprinted with changes in *Feminist Studies* (Spring 1988) and also in *The Nature and Context of Minority Discourse*, ed. Abdul JanMohamed and David Lloyd (New York, 1991). In the Napier volume, Christian's essay can be read in the context of Michael Awkward's reading of Christian's essay as a rejection of theory (331–38) and Deborah McDowell's response to that reading of Awkward's (563–64). Also in Napier, interested readers would find details of a heated exchange in the pages of *New Literary History* (Winter 1987) between Joyce Ann Joyce on one hand and Henry Louis Gates Jr. and Houston A. Baker Jr. on the other, as well as extensive discussions surrounding the theoretical paradigms developed respectively by Baker in *Ideology, Blues, and Afro-American Literature* (Chicago, 1984) and Gates in *The Signifying Monkey* (New York, 1988). Joyce's most recent statement on Gates is "A Tinker's Damn: Henry Louis Gates, Jr., and *The Signifying Monkey* Twenty Years Later," *Callaloo* 31, no. 2 (2008): 370–80.

5. Christian, "Race for Theory," 283.

6. Cited from "Conversations with Scholars of American Popular Culture: George Lipsitz," at http://www.americanpopularculture.com/journal/articles/spring_2002/lipsitz .htm (accessed February 16, 2012). See also George Lipsitz, "Listening to Learn and Learning to Listen: Popular Culture, Cultural Theory, and American Studies," *American Quarterly* 42, no. 4 (December 1990): 615–36; George Lipsitz, *Time Passages: Collective Memory and American Popular Culture* (Minneapolis, MN, 2001).

7. Claude McKay wrote a stinging letter to Du Bois questioning his literary judgment and Thurman attacked Du Bois's didacticism quite bluntly in a review essay "High, Low, Past, Present." See *Collected Writings of Wallace Thurman*, ed. Amritjit Singh and Daniel M. Scott (New Brunswick, NJ, 2003), 19, 26n30, 218–21.

8. Many of us also have found it helpful to refer students to the cultural Marxist approaches associated with the work of literary scholars such as Barbara Foley, William Maxwell, Bill Mullen, and James Smethurst. In an e-mail of January 24, 2012, my colleague Gary Holcomb (author of *Claude McKay, Code Name Sasha: Queer Black Marxism and the Harlem Renaissance* [2007]) writes that "the problem with poststructuralism from the cultural Marxist perspective was that on its own it elided historical and political contexts. Language, Lacan's 'Symbolic Order,' was paramount, but language as a discourse had to be understood as a Bakhtinian web of multiple impulses and sign systems that reflected ideology and, in the Marxist sense, historically constructed realities. The Marxist analysis may borrow the poststructuralist reading technique—that useful inquiry into stable binaries—but it rejects the idea that language functions in an ideological vacuum."

9. Richard Wright, *Black Boy* (1945; New York, 1993), 37.

10. Over the years I have found a powerful pedagogical resource in the stories my white students have shared in the classroom about their own first encounters as individuals with racism within their own families and neighborhoods, schools and churches. As a teacher, I have found individual empowerment similarly illustrated in Hiram Haydn's retelling of how his father, Howell Haydn, a disabled World War I veteran, handled the plea from the delegation of a dozen white neighbors in suburban Cleveland for him to persuade the light-skinned African American novelist Charles W. Chesnutt to sell his house on their block and move elsewhere. Hiding in the dining room, Hiram "watched my father struggle to his feet and literally brandish his cane in the faces of his guests. 'Get out of my house, you whited sepulchres, he said, . . . and if one of you dares to approach that fine man with the purpose you have just described to me, I shall personally thrash you.' . . . So far as I know [Chesnutt] lived in his house on our street for the rest of his life." "Charles W. Chesnutt," *The American Scholar* 42, no. 1 (Winter 1972–73). Reprinted in SallyAnn H. Ferguson, ed., *Charles W. Chesnutt, Selected Writings*, (Boston, 2001), 369–70.

11. Henry Louis Gates Jr., "The Passing of Anatole Broyard," in his *Thirteen Ways of Looking at a Black Man* (New York, 1997), 207.

12. For one engaging reading of this unacknowledged indebtedness of *Playing in the Dark* to *Shadow and Act*, see Sabine Broeck, "The Ancestor as Subtext," at http://transatlantica.revues.org/4257 (accessed February 15, 2012). Noting the very absent presence, or present absence, of Ellison in Morrison's Massey Lectures, Broeck observes: "Reading *Playing in the Dark* however, one may be struck not only by deep resonances of Ellison's work on the 'lower frequencies' as it were, but as well by a strategy of what I would like to call *enphrasement*: a re-membering of his articulations in and by Morrison's own utterance."

13. Ellison, *Collected Essays*, 82–83.

14. The following works include helpful discussions of social realism: Martha Nussbaum, *Poetic Justice: The Literary Imagination and Public Life* (Boston, 1995); Stacy Morgan, *Rethinking Social Realism: African American Art and Literature, 1930–1953* (Athens, GA, 2004); Steven Reich, "The Great Migration and Literary Imagination," *Journal of the Historical Society* 9, no. 1 (March 2009): 87–128. Of related interest, but offering very different perspectives, are books such as Monica Miller's *Slaves to Fashion: Black Dandyism and the Styling of Black Diasporic Identity* (Durham, NC, 2009) and Richard Iton's *In Search of the Black Fantastic: Politics and Popular Culture in the Post–Civil Rights Era* (New York, 2008). African American artists have had a long history of struggling against aesthetic dictates from both whites and blacks, the Left and the Right. African American literary works that underscore the diversity of U.S. history also open the way to understanding the diversity of ethnic or racial identity.

15. Ellison, *Collected Essays*, 94.

Utopian Performatives and the Social Imaginary: Toward a New Philosophy of Drama/Theater Education

Monica Prendergast

Prologue

Raymond Williams—A Found Poem

shadows of shadows

fiction;
acting;
idle dreaming
 and
 vicarious spectacle;

the simultaneous satisfaction
of
 sloth and appetite;

distraction
 from
distraction
 by
distraction

a heavy (even gross) catalogue
of our errors

till the eyes tire
millions of us
watch

From *Journal of Aesthetic Education*, Vol. 45, No. 1 (2011), pp. 58–73.

shadows of shadows
(and find them substance);

scenes
 situations
 actions
 exchanges
 crises

slice of life drama
now
 a voluntary
 habitual
 internal rhythm;

flow of action
 and acting
of representation and performance

raised to a new convention . . .
 a basic need.[1]

Introduction

Philosophy is not a theory but an activity.
—Ludwig Wittgenstein

My interest in aesthetic philosophy and performance theory has offered me the opportunity to engage with the recent work of political philosopher Charles Taylor and performance theorist Jill Dolan.[2] As I read these studies, I see interesting and potentially useful contributions to be drawn from their philosophical investigations toward the beginning moments of a new philosophy of drama education that is rooted in *the collective creation of socially imagined performative utopias*. It is through this process that I arrive at the understanding that the very nature of the dramatic education process embodies and defines *socially committed moral values of active and engaged democracy and the protection and implementation of universal human rights*.

Thus, this paper is organized into three sections. First, I will introduce Dolan's philosophical insight that, under certain conditions, we can experience "glimpse[s] of utopia" in performance contexts.[3] Second, I will broaden my viewpoint beyond the realm of performance and culture out into society itself with Taylor's philosophical argument that we (that is, modern humanity) have socially imagined our way into the present and can shift those collective acts of imagination that underscore how we live with new imaginary acts that envision other ways to live in the world. Third, I will suggest how these philosophical works can be adapted and seen as a fresh and

welcome way to see, reflect upon, and assess what we are doing as drama educators and applied theater practitioners who practice "socially committed pedagogy."[4] I conclude by inviting drama education scholars to consider more deeply the aesthetics and poetics of what we do in an act of conscious resistance to the cult of scientism that still dominates how we teach, research, think, and live in the world.

This process is supported by the inclusion of selected found poems created from the writings of drama/theater theorists and educational philosophers; it is hoped that these poems function effectively as indicators that it is possible to know the world and to demonstrate research and learning successfully in more aesthetic forms than are seen in standardized qualitative research writing.[5] As an educational researcher rooted in the arts, I am interested in representative forms that are consonant and resonant with my research topics. Arts-based educational research offers such possibilities of rendering research into visual art, music, drama, or creative writing.[6] My own interest has been in drawing on poetry in an attempt to more fully express the affective, embodied, transitory, and ephemeral nature of performance.[7] I include some examples of my poetic inquiry practice within this essay as found poems created from theorists whose work engages dialogically and relationally with Dolan and Taylor and their notions of utopian performatives and the social imaginary.

Defining Terms: Performative Utopias

Baz Kershaw—A Found Poem

spectacles of deconstruction in the performative society

mediatization
disperses performance
through culture: the eye of the camera
 the ear of the microphone
 the body of the keyboard
 the extra finger of the mouse

everything as performance
(for someone else and
crucially
 for ourselves)

mediatization coupled to liberal democracy
 to late-capitalism

the market at the heart of the social
 ubiquitous and spectacular:

politicians perform
 shares perform
 life-styles perform

(the ghost in the global machine is a performer and we are that ghost)

every vision of disaster
every fantasy of civilization
the spectacle of knowledge itself
contained in the magic of the micro-chip

 shrinking the human to nothing
dispersing the human everywhere
 destabilizing the human

(where are we in this?)

a culture founded on narcissism:
we are always looking for ourselves
through spectacles of deconstruction
(in which we always see ourselves looking)

mighty cultural processes
 the ways power circulates
create performative societies

(with
spectatorial
participation
and agency
as key
to activism)[8]

British performance theorist Baz Kershaw first coined the term *performative society* in 1994, and it has become a touchstone concept in his various writings.[9] The word *performative* has had an interesting history in its theorization over the past four decades, since the landmark Harvard lectures of philosopher and linguist J. L. Austin entitled *How to Do Things with Words.*[10] Austin distinguishes performative language as that which *does* something, rather than simply describes or represents. For example, saying "I do" at a wedding is both word and action combined into a *performative utterance.* Austin's germinal work was to have a deep resonance with emerging performance studies scholars and has been theorized in multiple ways.[11] Essentially, *performative* is an adjective that describes someone or something as being constituted in, through, and by performance—that is, actively, presentationally, in embodied and often fictive ways. These constitutive qualities may be either viewed

as positive or negative, depending on context. Often, in discourse on performativity, this notion is conflated with acts of resistance (as in Butler's work on performativity and gender constitution).[12] However, Kershaw reminds us that performativity can also be allied to conformity and the status quo. Kershaw's position is that society itself has become performative, a world where we are all pushed into constant states of performance and spectatorship that are alienating, exhausting, and numbing, leading to a culture with a hugely rich and diversely interconnected surface but little substance or authenticity. His conclusion that "spectatorial participation and agency are key to activism"[13] conforms to my own, which is explored throughout these pages.

"Utopias are generally oppositional in nature, reflecting, at the minimum, frustration with things as they are and the desire for a better life."[14] The history of Utopia and utopian thinking and writing is a long one; while Thomas More gave us the name from the Greek homonyms meaning "Good Place/No Place," visions of better worlds that don't exist have come down to us from writers over many hundreds, even thousands, of years.[15] What is Paradise if not a utopia? Yet the problem with utopias and utopian thinking over time is that a utopia for one person may be a dystopia for another. More's description of his island farming community Utopia (which may have been largely satirical in intent) is of a communistic world of tolerance and cooperation but also of conformity and control. As Carey points out in his excellent anthology of utopian writings, various utopias have included ideas of genocide of nonwhite people (H. G. Wells), extreme punishment of criminals as deterrence (many examples), eugenics (as in Nazism and Aryanism), conditioning behavior in children (B. F. Skinner), the abolition of the family (Plato and others), a drugged existence and free love (Aldous Huxley and many others)![16] However, Carey helps us return to more positive visions with his definition: "To count as a utopia, an imaginary place must be an expression of desire. To count as a dystopia, it must be an expression of fear":

> Because they grow from desire and fear, utopias cry out for our sympathy and attention, however impractical or unlikely they may appear. Anyone who is capable of love must at some time have wanted the world to be a better place, for we all want our loved ones to live free of suffering, injustice and heartbreak. Those who construct utopias build on that universal human longing.[17]

It is in this definition that I begin to see reflections of our work in the field of drama/theater education, at least in the practices of those of us who have been and remain committed to using the tools of drama/theater with our students to explore the dystopias and utopias that exist in both dramatic and real-world settings. These dystopic and utopic dramatic envisionings are not intended to be dichotomous; rather, they are situated at either end of a continuum that shifts and swings, pendulum-like,

from one end to the other. After all, there is important learning to be found in the discovery that one person's desire is another person's fear, and our work in drama/theater education holds the power to make these dystopic/utopic visions and their inherent tensions explicit. Overall, I suggest that dramatic explorations of utopias and their opposites are centrally interested in the idea and practice of *hope* as enactive processes that arise from the articulation of desires for a better world.[18]

To conclude this section, we have seen that conscious performativity offers a way of being actively engaged through performance that may counter prevailing sociopolitical problems of passive spectatorship and its attendant apathy. We have also seen that utopia/dystopia offers a powerful framework within which to potentially place our work as drama educators. These imaginary worlds are both created and driven by the potent emotions of fear and desire, which are essential elements of both art in general and drama in particular, and are focused on acts of resistance to *what is* in the name of *what might be*.

Opposition and Desire: Utopias in Process

Jill Dolan's recent book *Utopia in Performance: Finding Hope at the Theater* (2005) offers her theory of "utopian performatives" that

> describe small but profound moments in which performance calls the attention of the audience in a way that lifts everyone slightly above the present, into a hopeful feeling of what the world might be like if every moment of our lives were as emotionally voluminous, generous, aesthetically striking, and intersubjectively intense.[19]

I want to examine Dolan's theory within the domain of process drama, or applied drama/theater, by simply replacing the word "audience" with the word "students" and the word "performance" with the words "process drama."[20] It is the participatory and process-based understandings of spectatorship—evident in Gavin Bolton's *self-spectatorship in process drama* and in the theories and practices of Augusto Boal's *spect-actor* in the theater of the oppressed—that I wish to apply here to Dolan's philosophical theory of utopian performatives.[21] To more fully define her term, Dolan says

> [U]topian performatives let audiences [students] experience a processual, momentary feeling of affinity, in which spectators [students] experience themselves as part of a congenial public constituted by the performance's [process drama's] address. Hailed by these performatives . . . spectators can be rallied to hope for the possibility of realizing improved social relations. *They can imagine, together, the affective potential of a future in which this rich feeling of warmth, even of love, could be experienced regularly and effectively outside the theater* [process drama].[22]

Dolan's book goes on to document performance analyses of productions that contain and create utopian performatives, mostly plays that can comfortably be labelled as sociopolitically progressive in both form and content. These performances include autobiographical/ethnographical performances dealing with issues such as feminism, homophobia, gay rights, racism, and ethnic tension. She draws on her spectator experience of both lesser-known and well-known plays, the latter including Moises Kaufman and Tectonic Theatre's collectively created *The Laramie Project,* Anna Deavere-Smith's *Fires in the Mirror,* Jane Wagner's *Search for Signs of Intelligent Life in the Universe,* and Mary Zimmerman's adaptation and production of Ovid's *Metamorphoses.* In each case she documents her perceptions of moments in the performance where she felt, along with the rest of the audience, "the lucid power of intersubjective understanding"[23] that is echoed in anthropologist Victor Turner's *communitas.*[24]

Communitas is described by Dolan as

> the moments in a theater event or ritual in which audiences or participants feel themselves become part of the whole in an organic, nearly spiritual way; spectators' individuality becomes finely attuned to those around them, and a cohesive if fleeting feeling of belonging to the group bathes the audience.[25]

One must tread carefully here, of course. Spectators of the Nuremberg rallies in Nazi Germany arguably engaged in communitas, so we must not attach progressive, socialist, or even democratic ideals to this term. Turner himself comments more positively on communitas this way:

> Is there any of us who has not known this moment when compatible people—friends, congeners—obtain a flash of lucid mutual understanding on the existential level, when they feel that all problems, not just their problems, could be resolved, whether emotional or cognitive, if only the group which is felt (in the first person) as "essentially us" sustain its intersubjective illumination?[26]

These notions have been taken up previously in drama education, primarily by Cecily O'Neill in her book *Drama Worlds: A Framework for Process Drama* (1995) and her treatment of the drama teacher as "liminal servant" who opens the doorway for students to travel across thresholds into possible (utopian?) worlds.[27] Also, within these moments when spectator/participants feel "that all problems . . . could be resolved"[28] lie resonances with Neelands's position that a "socially committed pedagogy of drama struggles to re-negotiate and re-translate inherited cultural perceptions and (un) realities of self and other can also be addressed as necessary and transformational struggles in our social lives beyond the studio or workshop."[29] In this same essay, Neelands proposes a "para-aesthetics of drama . . . which acknowledge the social/ artistic dialectic and which are intended to develop a broader range of social and cultural learning."[30] Again, Neelands's work stands alongside Dolan's and Turner's in

seeing *the social as an extension of the aesthetic*, such that socially committed drama/theater connects us to each other, performers and spectators/teachers and learners, in more meaningful ways.

In process drama and performance, our goal as teachers and artists is to explore the desire for a better world through our imaginations, creativity, and dramatic/theatrical work. However, as drama/theater is built on tension and conflict, often it is dystopian thinking and imagining that leads us into seeing its opposite as more desirable and worth pursuing in the "real world." After all, as the Talking Heads put it so well, "Heaven is a place / A place where nothing / Nothing ever happens" (*Fear of Music*, 1979). We inject dystopic elements into our improvised structures as provocations for student spect-actors to struggle collaboratively against in order to see more clearly the various strategies needed to move us toward real-world utopias. It is this work of resistance that defines us and our practices as socially committed, not utilitarian or antiaesthetic.[31] In fact, it is in specifically working through the aesthetic forms we know so well that we begin to act in communal creative resistance to a dominant ideology that is centered in individualistic, economistic, and technocratic ways of thinking and being in the world.[32]

Utopian performatives at work in process drama involve moments of deep empathy and intimate dialogue.[33] These qualities of empathy and intimacy, I suggest, are key to creating utopic moments of "intersubjective understanding"[34] and are, by extension, worthy characteristics of any project or program that intends to promote good citizenship and the values of human rights. Utopian thinking and the worlds it creates also involve the "empathic intelligence" wherein empathy is "a sophisticated ability involving attunement, de-centering, conjecture and introspection: an act of thoughtful, heartfelt imagination."[35] "Empathic intelligence is a way of using various intelligences and sensitivities to engage effectively with others. Typically there will be an awareness of purpose and effect in these engagements and a capacity to shift dynamics if necessary."[36] Clearly, empathic intelligence and the inherent intimacy of engaging dialogically with others are two qualities we will see in utopian performatives at work (and play).

The Social Imaginary

Yet another term I want to pull out of a different field and apply to our own, as I have done with the utopian performative from performance studies, is the theory of the *social imaginary* as articulated by philosopher Charles Taylor. Taylor describes the social imaginary as

> the way ordinary people "imagine" their social surroundings, and this is often not expressed in theoretical terms; it is carried in images, stories, and legends. But it is also the case that theory is usually the possession of

a small minority, whereas what is interesting in the social imaginary is that it is shared by large groups of people, if not the whole society. . . . *the social imaginary is that common understanding that makes possible common practices and a widely shared sense of legitimacy.*[37]

It is not difficult to see clear reflections of process drama here. Taylor is talking about *the social work of imagination*, which can be linked with Neelands's socially committed pedagogy and Dolan's utopian performative with seeming ease. For me, philosophically and politically, the social imaginary gives us a useful philosophical term and activity to draw on in describing what we do, what we are trying to do, and what we often struggle so hard to keep doing: to bring people together in aesthetic ways, to value the collective as much as the individual, to see the world (both natural and human) as made up of multiple and complex processes, to recognize commonalities and respect difference, to work toward common understandings that involve the development of empathic intelligence. Taylor continues:

> Our social imaginary at any given time is complex. It incorporates a sense of the normal expectations that we have of one another, the kind of common understanding which enables us to carry out the collective practices that make up our social life. This incorporates some sense of how we all fit together in carrying out the common practice. This understanding is both factual and "normative"; that is, we have a sense of how things usually go, but this is interwoven with an idea of how they ought to go, of what missteps would invalidate the practice.[38]

Again, process drama works very much in this way, through the social imaginary, to engage in "common understanding" and "collective practices" that are rooted not only in "how things usually go" but also, and more importantly, in "how they ought to go."[39] Taylor finally reminds us that the social imaginary is a realm of resistance as well as compliance:

> This confidence that we and other human beings can sustain a democratic order together, that it is within our range of possibilities, is based on images of moral order through which we understand human life and history. It ought to be clear . . . that our images of moral order, although they make sense of some of our actions, are by no means necessarily tilted toward the status quo. They may also infuse revolutionary practice . . . just as they may underwrite the established order.[40]

Taylor's examples of how revolutionary practice has emerged out of the social imaginary include the historical moves in Western culture from religious to secular societies, and from monarchical/aristocratic to republican/democratic governance, including examples like the French and American revolutions. Large groups of people have to be able to first *collectively imagine society as changeable in these dramatic ways* in order

for the reality of these huge social changes to take place. As Taylor says, "There has to be a break with these old forms, in which equality replaces hierarchy, and in which at the same time the personalized, particular relations of the old dependencies are dissolved and replaced by a general and impersonal recognition of equal status."[41] In my long-lived experiences in both theater and drama education, it is those moments when the established hierarchy and moral order is most closely questioned, even threatened, that catharsis happens, that utopian performatives happen, and that learning (even enlightenment!) happens. All of these interrelated qualities of utopian performatives, empathic intelligence, and the social imaginary potentially create in our field what Philip Taylor calls "goose-bump drama," "where [one] is arrested, emotionally and intellectually, by the participants' responses."[42]

Toward a New Philosophy of Drama/Theater Education

We have all experienced these goose-bump moments, as teachers or participants, in structures when there is a real sense of one mind at work, where the focus is intense and the emotional investment in the drama is high. Personally, I feel these moments when engaged in such activities as Corridor of Voices (also called Conscience Alley), Image Theatre or tableaux, vocal collages or soundscapes, and those rare moments in improvised role-play encounters where students have genuine moments of understanding what it means to suffer injustice and the price to be paid in the necessity of talking back to power. The most powerful drama structures I know are what I would characterize as *open texts*, wherein students have to genuinely wrestle with moral dilemmas in which there is no foregone conclusion in "doing the right thing" (a *closed text*).[43] These are processes within which whole group decisions mirror a kind of utopian existence wherein all voices are honored and heard as equal in import and all outcomes are provisional, open to broad interpretation and critical reflection and analysis, to conspectus, not consensus.[44] Drama education has perhaps engaged with utopian performatives and social imaginaries since its inception, yet only recently is it seeking the terms to name itself as *other than* social science, *other than* instrumental, *other than* anti- or anaesthetic.

In the sister field of applied theater, we see utopian performatives and the social imaginary working inside the processes of community-based theater practices that offer nontheater specialists the means of production to begin to locate and describe their own collective visions of a better world.[45] In Boal's Theatre of the Oppressed, these qualities are also in clear evidence, as participants take over the stage to alter *as-is* into *what-if*[46] or *not-yet*.[47] This kind of socially imagined drama/theater work, happening as it does in often greatly challenging locations such as theaters of war, prisons, and impoverished, developing, or otherwise disadvantaged communities, I would strongly suggest potentially create more moments of lucid intersubjective

understanding between and amongst performers/spectators than a whole raft of mainstream theater experiences.[48]

Notions of utopia and the social imaginary are emerging in theater/performance and cultural studies in ways that assure me that this philosophical positioning is a fruitful one. Daniel Meyer-Dinkgrafe connects Dolan's theory to consciousness studies and theater in his recent book *Theatre and Consciousness: Explanatory Scope and Future Potential:* "If we take higher states of consciousness as characteristics of individual utopia, and as such as the basis of social utopia, then theatre has the potential of developing utopia for the individual, and through the individual for society."[49] Virginie Magnat's essay "Devising Utopia: Asking for the Moon" draws on Dolan to argue for devising practices in postsecondary theater education:

> When trying to make a case for devised theatre, it is . . . critical to foreground the utopian dimension of collectively created work, inasmuch as devising reflects the desire to engage in a mutual endeavor whose goal is the active involvement of each participant in the overall process. From this perspective, the teaching of devising exposes students to the broader existential question of how human beings can learn to live and work together—a question that has perhaps never before been endowed with so much urgency. [This] provocatively utopian view [suggests] that theatre education can achieve much more than preparing students to join an increasingly precarious professional world.[50]

Magnat's essay is part of a special issue of the journal *Theatre Topics* on devising, which in itself constitutes a socially imagined move away from text-centric traditional postsecondary theater studies.

Michael Warner responds to Taylor's theorization of the social imaginary with his own articulation of "publics and counterpublics."[51] His definitions offer interesting applications to drama/theater education, indicating a proliferation of connections with these new philosophical concepts:

1. A public is self-organized. (50)
2. A public is a relation among strangers. (55)
3. The address of public speech is both personal and impersonal. (57)
4. A public is constituted through mere attention. (60)
5. A public is the social space created by the reflexive circulation of discourse. (62)
6. Publics act historically according to the temporality of their circulation. (68)
7. A public is poetic world making. (82)

Warner contrasts these criteria with those of a counterpublic, such as the feminist or the gay/queer communities, as having "at some level, conscious or not, an awareness of its subordinate status. The cultural horizon against which it marks itself off is not

just a general or wider public, but a dominant one."[52] Our socially committed work in process drama/applied theater operates as publics *or* counterpublics, performances *or* counterperformances in reassertion with *or* opposition to dominant cultural publics and performances.[53] As in any performance process, these choices are contingent, dependent on our collective intentionality and multiple socio-political and cultural contexts that come into play. Warner's notion of "poetic world making" is a resonant and powerful one for drama/theater education, effectively erasing the instrumental/aesthetic divide in recognition that we both *make* and *discover* in dramatic activity; we are both artists and scientists.[54]

Finally, Augusto Boal's last book *The Aesthetics of the Oppressed* provides important reconsiderations of the utopian (that is, visions of desire) within the aesthetics of theater created for sociopolitical ends: "The theatre is a privileged means by which we may find out who we are, in the creation of images of our desire—we are our desire, or we are nothing."[55]

A *utopographer* is one who maps out utopias.[56] I propose that socially committed drama/theater educators and their students can become the utopographers of better worlds; visions desperately needed in these ever-more globally divisive days. In this regard, a recent collection of essays in critical pedagogy, *Utopian Pedagogy: Radical Experiments against Neoliberal Globalization,* convinces me that our utopias need not be "from the tradition of excessively rationalistic dream-states" but rather are created within "a critical attitude towards the present and a political commitment to experiment in transfiguring the coordinates of our historical moment."[57]

To conclude, I wish to highlight the philosphical terms presented here and to suggest how these might move our field forward in ways that are both socially and aesthetically committed. First, the notion of and historical emergence of Utopia and its opposite Dystopia offers us a new way of viewing our work in drama/theater education. Some reflective questions to consider are: What are the utopian and/or dystopian elements of our curriculum and pedagogy? How are we cocreating performative visions of better worlds with our students/participants? What are the moments of intersubjective understanding that occur in our practices that we can capture through our research and hold up to the light as utopian performatives? How are we able to sustain and move these moments from the imaginary to the real world as actions that mirror and exemplify "active, critical citizenry"[58] and support of human rights? Second, the social imaginary also offers us a new way to reflect on "the ensemble of imaginings that enable our practices by making sense of them."[59] In this regard, the drama classroom holds the potential to become the place and space in schooling where students and their teachers can socially imagine *how we got where we are* and *how we might get where we're going* as performative forms of philosophical investigations. Large themes such as citizenship, justice, human rights, education, economics, and politics can be explored through research, interviews, storytelling,

collective creation, and process drama that focus on how these broader issues play out in our day-to-day lives. By using the philosophical positions and terminology discussed in this essay, drama/theater educators can draw their own and their students' attention to the complex ways that we cocreate and perform socially imagined utopias. Our dramatized utopias may, in turn, move us into finding new pathways toward making these *no-places* (yet) realizable in the richly complex worlds we inhabit together.

Epilogue

Alan Read—A Found Poem

ethics and performance

i. the spectator's eye
 watches for an entrance

 when that entrance
 is denied
 (by the performance)

 waits for a movement

 when that movement
 is denied
 (by stillness)

 the spectator's eye
 suspects the dance
 within that stillness
 & can sense
 the discreetest breath
 (in passage)

ii. where there is no breath
 the funeral rites begin

 the audience witnesses
 the entry of the priest
 (to the body)

 and so
 everyday life
 and theatre
 continue
 (albeit with understudies)

... heightened theatrical
 expectations

... sudden substitutions
 of the unknown
 for the known[60]

Notes

1. R. Williams, *Drama in a Dramatised Society: An Inaugural Lecture* (Cambridge: Cambridge University Press, 1975), 7; also in M. Prendergast "Audience in Performance: A Poetics and Pedagogy of Spectatorship" (PhD diss., University of Victoria, British Columbia, 2006), 14-15; and M. Prendergast, *Teaching Spectatorship: Essays and Poems on Audience in Performance* (Amherst, NY: Cambria Press, 2008), 7–8.

2. See M. Prendergast, "Audience in Performance"; Prendergast, "Found Poetry as Literature Review: Research Found Poems on Audience and Performance," *Qualitative Inquiry* 12, no. 2 (2006): 369-88; Prendergast, "'Playing Attention': Contemporary Aesthetic Philosophy and Performing Arts Audience Education," *Journal of Aesthetic Education* 38, no. 3 (2004): 36–51; Prendergast, "'Shaped Like a Question Mark': Found Poems from Herbert Blau's *The Audience*," *Research in Drama Education* 9, no. 1 (2004): 73-92; and *Teaching Spectatorship*; C. Taylor, *Modern Social Imaginaries* (Durham, NC: Duke University Press, 2004); and J. Dolan, *Utopia in Performance: Finding Hope at the Theater* (Ann Arbor: University of Michigan Press, 2005).

3. J. Dolan, "Performance, Utopia and the 'Utopian Performative,'" *Theatre Journal* 53, no. 3 (2001): 458.

4. J. Neelands, "Miracles Are Happening: Beyond the Rhetoric of Transformation in the Western Traditions of Drama Education," *Research in Drama Education* 9, no. 1 (2004): 47.

5. L. Neilsen, A. L. Cole, and J. G. Knowles, eds., *The Art of Writing Inquiry* (Halifax, NS: Backalong Books, 2001); R. L. Irwin and A. De Cosson, eds., *A/R/Tography: Rendering Self Through Arts-Based Living Inquiry* (Vancouver, BC: Pacific Educational Press, 2004); C. Leggo, "Astonishing Silence: Knowing in Poetry," in *Handbook of the Arts in Qualitative Research*, ed. J. G. Knowles and A. Cole (Thousand Oaks, CA: Sage, 2008), 165-74; M. Prendergast and C. Leggo, "Astonishing Wonder: Spirituality and Poetry in Educational Research," in *The International Handbook of Research in Arts Education*, ed. L. Bresler (New York: Springer, 2007), 1459-80; M. Prendergast, C. Leggo, and P. Sameshima, eds., *Poetic Inquiry: Vibrant Voices in the Social Sciences* (Rotterdam: Sense Publishers, 2009).

6. D. J. Clandinin and M. Connelly, *Narrative Inquiry: Experience and Story in Qualitative Research* (San Francisco: Jossey-Bass, 2000); S. Finley, "Arts-Based Inquiry in *QI*: Seven Years from Crisis to Guerrilla Warfare," *Qualitative Inquiry* 9, no. 2 (2003): 281-96; J. Saldaña, ed., *Ethnodrama: An Anthology of Reality Theatre* (Walnut Creek, CA: Altamira Press, 2005); M. Cahnmann-Taylor and R. Siegesmund, eds., *Arts-Based Research in Education: Foundations for Practice* (New York: Routledge, 2008); J. G. Knowles and A. Coles, eds., *Handbook of the Arts in Qualitative Research* (Thousand Oaks, CA: Sage, 2008); P. Leavy, *Method Meets Art: Arts-Based Research Practice* (New York: Guilford Press, 2008).

7. See M. Prendergast, "Found Poetry as Literature Review"; Prendergast, "'Shaped Like a Question Mark'"; Prendergast, *Teaching Spectatorship*; and Prendergast, "Inquiry and Poetry: Haiku on Audience and Performance in Education," *Language*

and Literacy 6, no. 1 (2004). Available online at http://educ.queensu.ca/~landl/current.html.

8. B. Kershaw, "Curiosity or Contempt: On Spectacle, the Human, and Activism," *Theatre Journal* 55, no. 4 (2003): 605–6; also in Prendergast, "Audience in Performance," 15-16 and "*Teaching Spectatorship*," 8-9.

9. B. Kershaw, "Framing the Audience for Theatre," in *The Authority of the Consumer,* ed. N. Abercrombie, R. Keat, and N. Whiteley (New York: Routledge, 1994), 166–86; Kershaw, *The Radical in Performance: Between Brecht and Baudrillard* (London: Routledge, 1999); Kershaw, "Dramas of the Performative Society: Theatre at the End of Its Tether," *NTQ: New Theatre Quarterly* 17, no. 3 (2001): 203–11; Kershaw, "Curiosity or Contempt."

10. J. L. Austin, *How to Do Things with Words* (Cambridge, MA: Harvard University Press, 1962).

11. R. Schechner, *Performance Studies: An Introduction* (New York: Routledge, 2002), 110–42.

12. J. Butler, "Performative Acts and Gender Constitution: An Essay in Phenomenology and Feminist Theory," *Theatre Journal* 40, no. 4 (1998): 519–31.

13. Kershaw, "Curiosity or Contempt," 606.

14. R. Schaer, G. Claeys, and L. T. Sargent, *Utopia: The Search for a New Society in the Western World* (Oxford: Oxford University Press, 2000), 8; cited in J. Dolan, *Utopia in Performance: Finding Hope at the Theater* (Ann Arbor, MI: University of Michigan Press, 2005).

15. T. More, *Utopia* (1516; repr., New Haven, CT: Yale University Press, 1965).

16. J. Carey, ed., *The Faber Book of Utopias* (London: Faber and Faber, 1999), xiii–xix.

17. Ibid., xiii.

18. B. Anderson, "'Transcending without Transcendence': Utopianism and an Ethos of Hope," *Antipode* 38, no. 4 (2006): 691-710; E. Bloch, *The Principle of Hope, Volumes 1–3*, trans. N. Plaice, S. Plaice, and P. Knight (Cambridge, MA: MIT Press, 1986).

19. Dolan, *Utopia in Performance,* 5.

20. C. O'Neill, *Drama Worlds: A Framework for Process Drama* (Portsmouth, NH: Heinemann, 1995); P. Bowell and B. Heap, *Planning Process Drama* (London: David Fulton, 2001).

21. G. Bolton, *Acting in Classroom Drama: A Critical Analysis* (Stoke on Trent, UK: Trentham, 1998); A. Boal, *The Rainbow of Desire: The Boal Method of Theatre and Therapy,* trans. A. Jackson (New York: Routledge, 1995); Boal, *Theater of the Oppressed,* trans. C. A. and M. O. Leal McBride (New York: Urizen, 1979).

22. Dolan, *Utopia in Performance,* 14; emphasis added.

23. Dolan, "Performance, Utopia and the 'Utopian Performative,'" 479.

24. V. W. Turner, *Drama, Fields and Metaphors: Symbolic Action in Human Society* (Ithaca, NY: Cornell University Press, 1974); Turner, *From Ritual to Theatre: The Human Seriousness of Play* (New York: Performing Arts Journal Publications, 1982).

25. Dolan, *Utopia in Performance,* 11.

26. Turner, *From Ritual to Theatre,* 47-48; also cited in R. Schechner, *Performance Studies.*

27. O'Neill, *Drama Worlds,* 66.

28. Turner, *From Ritual to Theatre,* 47.

29. Neelands, "Miracles Are Happening," 54.

30. Ibid., 50.

31. S. Schonmann, "'Master' Versus 'Servant': Contradictions in Drama and Theatre Education," *Journal of Aesthetic Education* 39, no. 4 (2005): 31–39.

32. M. Greene, *Releasing the Imagination* (San Francisco: Jossey-Bass, 1995).

33. P. Bundy, "Dramatic Tension: Towards an Understanding of Tension of Intimacy" (PhD diss., Griffith University, Australia, 2003); R. F. Scuka, *Relationship Enhancement Therapy: Healing Through Deep Empathy and Intimate Dialogue* (New York: Routledge, 2005).

34. Dolan, "Performance, Utopia and the 'Utopian Performative,'" 479.

35. R. Arnold, *Empathic Intelligence: Teaching, Learning, Relating* (Sydney: University of New South Wales Press, 2005), 86.

36. Ibid., 19.

37. Taylor, *Modern Social Imaginaries*, 106; emphasis added.

38. Ibid.

39. Ibid.

40. Ibid., 110.

41. Ibid., 148.

42. P. Taylor, *The Drama Classroom: Action, Reflection, Transformation* (New York: Routledge, 2000), 53, 55.

43. M. DeMarinis, "Dramaturgy of the Spectator," *TDR: The Journal of Performance Studies* 31, no. 2 (1987): 103.

44. J. Neelands, *Making Sense of Drama: A Guide to Classroom Practice* (Portsmouth, NH: Heinemann, 1984), 40.

45. J. Cohen-Cruz, *Local Acts: Community-Based Performance in the United States* (New Brunswick, NJ: Rutgers University Press, 2005); H. Nicholson, *Applied Drama: The Gift of Theatre* (New York: Palgrave Macmillan, 2005); P. Taylor, *Applied Theatre: Creating Transformative Encounters in the Community* (Portsmouth, NH: Heinemann, 2003); J. Thompson, *Applied Theatre: Bewilderment and Beyond* (New York: Peter Lang, 2003); M. Prendergast and J. Saxton, eds., *Applied Theatre: International Case Studies and Challenges for Practice* (Bristol: Intellect, 2009); T. Prentki and S. Preston, eds., *The Applied Theatre Reader* (London: Routledge, 2008); J. Thompson, *Digging Up Stories: Applied Theatre, Performance and War* (Manchester: Manchester University Press, 2005).

46. A. Boal, *Theater of the Oppressed; The Rainbow of Desire; Legislative Theatre: Using Performance to Make Politics*, trans. A. Jackson (New York: Routledge, 1998).

47. Bloch, cited in Anderson, "'Transcending without Transcendence,'" 693.

48. That said, my own work in audience education uses theater performances as catalysts for dramatic process, thereby moving mainstream theater experiences toward the utopian performative and the social imaginary through the collective exploration of the world of a given play by its spectators. M. Prendergast, "'Imaginative Complicity': Audience Education in Professional Theatre" (master's thesis, University of Victoria, 2001); Prendergast, "Audience in Performance"; and Prendergast, "Teaching Spectatorship."

49. D. Meyer-Dingkrafe, *Theatre and Consciousness: Explanatory Scope and Future Potential* (Portland, OR: Intellect, 2005), 174.

50. V. Magnat, "Devising Utopia, or Asking for the Moon," *Theatre Topics* 15, no. 1 (2005): 82.

51. M. Warner, "Publics and Counterpublics," *Public Culture* 14, no. 1 (2002): 49–90.

52. Ibid., 86.

53. N. Blackadder, *Performing Opposition: Modern Theater and the Scandalized Audience* (Westport, CT: Praeger, 2003); N. Postman, *Teaching as a Conserving Activity* (New York: Dell, 1979).

54. M. Midgley, *Science and Poetry* (2001; reprint, New York: Routledge, 2006).

55. A. Boal, *The Aesthetics of the Oppressed,* trans. A. Jackson (New York: Routledge, 2006), 61.

56. A. Philippopolous-Mihalopolous, "Mapping Utopias: A Voyage to Placelessness," *Law and Critique* 12, no. 2 (2001): 137.

57. M. Coté, R. J. F. Day, and G. De Peuter, eds., *Utopian Pedagogy: Radical Experiments Against Neoliberal Globalization* (Toronto, ON: University of Toronto Press, 2007), 13.

58. C. West, "From *Prophetic Thought in Postmodern Times* [1993]," in *Philosophical Documents in Education,* ed. R. F. Reed and T. W. Johnson, 2nd ed. (New York: Addison-Wesley Longman, 2000), 183.

59. Taylor, *Modern Social Imaginaries,* 165.

60. A. Read, *Theatre and Everyday Life: An Ethics of Performance* (London: Routledge, 1993), 95; also quoted in Prendergast, "Audience in Performance," 276; and Prendergast, "Teaching Spectatorship," 180–81.

Disability, Hybridity, and Flamenco *Cante*

Seema Bahl
Bellevue College

Using my personal experience as a performer, I demonstrate how my vocals are exemplary of the hybridity that often defines flamenco history and performance. Disability and diasporic identity have allowed me to connect to the deeper emotions of duende *in flamenco as I contemplate themes of loss, anger, and displacement in flamenco lyrics. My body, deserted by health, has deeply embraced the agony erupting in the lyrics of* palos *(flamenco styles) such as "Solea" and "Martinete." In this essay, I explore the following questions: When expressing authentic emotions around disability through* cante, *do I transcend the oppression of the audience gaze? When performing an art form marked by cultural fluidity and a diverse plethora of global influences, how is my expression of flamenco* cante *representative of its true, vibrant spirit, as I personify the* cantaora *operating, even flourishing, at the intense intersection of race, disability, and performance?*

Introduction

For many years as a young adult, I passionately engaged in flamenco dance. Engagement with this physically demanding art form ceased at a certain momentous point due to sudden-onset disability caused by an attack of Multiple Sclerosis. Not able to abandon my commitment to flamenco, I gradually shifted my energies to flamenco singing. Of Asian Indian background, I had earlier studied South Indian classical vocals and was, therefore, able to meet the demands of traditional flamenco *cante* (singing) technique. I embraced the complicated rhythms, tonalities, and *melismas*[1] while concomitantly invoking my own experience of racial and ethnic displacement

69

through my expression of *duende* (the deep "essence" of flamenco). Indeed, my vocals were exemplary of the hybridity that often defines flamenco history and performance.

Ultimately, disability and diasporic identity allowed me to connect to the deeper emotions of flamenco as I contemplated themes of loss, anger, and displacement in the lyrics. My body, deserted by health, deeply embraced the agony erupting in the lyrics of *palos* (flamenco styles) such as "Solea" and "Martinete." My "ontologically contingent"[2] corporeality unveiled itself as I expressed these sentiments in songs of the distant past.

This essay examines my flamenco singing and performance from an intersectional perspective—in particular, the way that I express my racialized and disabled subjectivity onstage through *cante*. My argument is twofold: 1) that I regard my claim to *duende* as authentic vis-à-vis my onstage intersectional subjectivity; and 2) that I complicate the current discourse on "passing" and "coming out" in a performance context by introducing a powerful alternative modality for communicating the lived experience of disability. This modality utilizes the intense circulation of energy among the performers and with the audience and is coupled with my explosive vocal expression of *duende*. During our performances, I convey the true emotions of the more angst-ridden *palos* as I am also telling my own story of *displacement* as a racialized second-generation South Asian immigrant, *loss* of physical function, and *redemption* through the act of singing. Still, I grapple with the question of cultural appropriation and onstage legitimacy as a South Asian American. My identity as a non-Hispanic or Iberian, nonnative Spanish speaking, and non-Gypsy[3] flamenco singer is charged. With courage and trepidation, I introduce my unique vocal inflections with my racialized and "potentially disabled" embodiment to the stage.

Roots, Identity, and Shape-Shifting

I am a second-generation South-Asian American woman from the Seattle area in the United States. During my youth, I had experiences of social, cultural, and racial alienation and felt a deep sense of the "displacement" that is often evoked when discussing experiences of diaspora. As a "devalued"[4] girl child, I navigated the harsh landscape of American life as a racialized other.

Santayani and Shamita Das Dasgupta (1998) articulate this dynamic well:

> While growing up, daughters of Asian-Indian immigrants are surrounded by television and advertising images of blonde, blue-eyed beauty, a standard against which they can only come up short. Indian-American women, like most women of color, often admit to seeing themselves as "ugly" in their youth, emphasizing a preoccupation with their darker skin color. (121)

I took many trips to India to visit relatives as a child and was able to reap the benefits of traveling such a considerable geographic distance via layover stays in Europe and Asia from time to time. Not surprisingly, I felt more at "home" on these trips than I ever did in the Seattle suburbs, and I developed an early passion for languages, transnational cultural experiences, and peripatetic wandering in general.

My interest in the art of flamenco evolved in New York City, and I pursued research and dance studies in Andalusia. At the time, my passion and devotion to flamenco *baile* (dance) was second to none, and I quickly advanced in technique while nurturing a love for the Gypsy music of the Andalusian region. In Spain, it was notable that, although I was not immune to the overt racism pervading Europe since the influx of new immigrants from the Global South, the Gypsy population residing in the caves of Sacromonte in Granada and the *tablaos* of Jerez de la Frontera connected with me on many occasions, either interpersonally or nonverbally. They demonstrated an unequivocal recognition of *una prima de ellos* (a cousin of theirs), though I was, in fact, an outsider to their community. Notably, many Gypsies had skin tones and facial features so similar to those of my own family that I could immediately see the faint traces of genetic persistence journeying from the South Asian plains millennia ago. Could the suffering that I experienced as an alienated child of the South Asian diaspora have been echoed in the mournful laments of the disenfranchised Gypsies of Andalusia?

Here is an illustration of this lament from the song "Naci en Alamo," featured in the 2000 film *Vengo*:

> No tengo lugar, no tengo paisaje, yao meno tengo patria.
> Con mis dedos hago el fuego, con mi Corazon te canto, las cuerdas de mi Corazon lloran.
>
> [I have no place, I have no path, I don't even have a country.
> I strike a fire with my finger, I sing with my heart, the chords of my heart weep.]

Suzanne Bost (2010), who examines disability, race, and the "shape-shifting" identity of disabled flamenco dancer Carmen "la Coja" (Carmen "the Cripple") in Ana Castillo's *Peel My Love like an Onion*, draws upon works of flamenco scholars Antonio Parra and Silvia Lorente-Murphy to illustrate the redemptive potential of flamenco. She highlights their claims that flamenco reflects the pain, suffering, and uncertainty of nomadic life, which is rootless and rejected by those who would persecute them. The interpretive and fluid nature of flamenco dance, Bost claims, must express both the "suffering" and the "triumph" of simply being alive (169). What happens on stage may be improvised, unrehearsed, born of the moment, and responsive to the calls of the dancers, singers, musicians, and audience. I claim the same redemptive

quality of flamenco through my *cante*. Though I am seated, though my disability may not always be apparent during the performance, I am conveying the eternal message of Gypsy suffering.

Bost articulates an analysis of Gypsy identity in Chicago in Castillo's work as nomadic and true to the Spanish Gypsy culture that produced many of the flamenco melodies, lyrics, and dance forms that we perform today. Castillo's disabled flamenco dance performer, Carmen, identifies with these "racially diverse international travelers" (2010, 180); and, interestingly, Bost remarks that "just as flamenco moves the body, Gypsy identity is by definition uprooted and oriented toward possible travel. Since Carmen is a shape-shifter at the corporeal level, her identifications at the communal level are world-traveling" (ibid.). As mentioned, I also identify with this "nomadic travel" as a child of the South Asian diaspora. "Carmen's dancing and fluctuating identity enables her to move outside the system. . . . She is constantly self-reconstructing, reorienting her body to new contexts" (ibid.). As I infuse a traditional musical form with my own intonations and South Asian-influenced vocal inflections and proclivities to the flamenco song, I too escape preconceived expectations as I receive the gaze of the audience; I do not represent a fixed (either disabled or nondisabled) embodiment, nor do I fit neatly into a cultural or ethnic category that might be expected onstage, such as marginalized, Rom, Spanish or Hispanic native, persecuted, and so forth. I represent the fluctuation, the hybridity, the fluidity, and the transnational nature of flamenco spirit and Gypsy sentimentality.

Indeed, Bost poses a powerful question to consider vis-à-vis the malleable nature of both identity and embodiment:

> Does moving around jettison the idea of identity? "Gypsy" and "disabled" are identities without borders. Both refer to a heterogeneous range of embodiments that are ex-centric to normative ways of being and belonging. Their movements are, by definition, in friction with fixed identities. (2010, 187)

Disability and Multiple Othering

My commitment to mastery in flamenco dance training was abruptly halted by an unwelcome introduction to the world of chronic illness and disability. This sudden, seemingly catastrophic catapult into bodily disarray left me gasping for air as I was in the midst of reconciling my racialized past and claiming power as a woman of color. The rapid bodily shift to an altered set of capacities introduced me to a grieving process common to those with chronic illness and disability. All of a sudden, the physical and psychic empowerment that I was feeling with regard to my racial identity was acutely complicated by my rapidly morphing bodily reality so as to halt liberation in its tracks.

How was I to feel that my body was valuable, "productive," and meaningful as the disease was wreaking havoc on its functionality? How was I to make peace with my past exclusion and move forward with confidence and dignity in the world as another mark of stigma, to use Erving Goffman's term,[5] was thrust upon me? All of a sudden, I embodied Vernon's (1999) characterization of the "multiple Other" (389) who would undergo "simultaneous oppressions" (394). I was now situated at the intersection of race, gender, and disability.

Though my ability to dance was compromised, my addiction to the art of flamenco remained strong. Through a fortuitous set of personal connections, I was given the opportunity to provide vocal accompaniment to an accomplished Cuban flamenco dancer upon my return to Seattle from New York City.

Duende and Ontological Contingency

Flamenco is said to be an art form primarily transmitted by blood within the Spanish Gypsy community, and the pure spirit or essence of flamenco is called *duende*.[6] Federico Garcia Lorca (1933) commented specifically on duende:

> Todo lo que tiene sonidos negros tiene duende . . . Estos sonidos negros son el misterio, las raíces que se clavan en el limo que todos conocemos, que todos ignoramos, pero de donde nos llega lo que es sustancial en el arte. (N.p.)

> [Everything with black sounds has *duende*. These black sounds are the mystery, the roots that probe through the mire that we all know of, and do not understand, but which gives us that which sustains us in art.]

In addition, he claimed,

> Yo he oído decir a un viejo maestro guitarrista: "El duende no está en la garganta; el duende sube por dentro desde la planta de los pies." Es decir, no es cuestión de facultad, sino de verdadero estilo vivo; es decir, de sangre; es decir, de viejísima cultura, de creación en acto.

> [I heard an old guitar master say: "The *duende* is not in the throat, the *duende* comes up from inside, up from the soles of the feet." That is to say, it is not a question of capability, but of a true living style—of blood, in other words; of what is oldest in culture; of creation in the act itself.]

If *duende*, the soul of flamenco, has "black" sounds, sounds of the Gypsy bloodline and of true, authentic art, then how does my expression of *duende* through flamenco *cante* convey this "blackness" that is both racialized and imbued with suffering and loss? How does the Gypsy experience of oppression, displacement, anger, despair, and redemption, coupled with its ancient South Asian roots, provide an alluring context for the manifestation of my own true, deep, and passionate expression of *duende*?

How can I work through, and possibly transcend, the rage that I harbor toward my disability through my dynamic interaction with the lyrics and melody?

To illustrate the circulation of *duende* during our performances, I offer a "thick description" of the evening of one of our shows, beginning with an excerpt from a local newspaper review:

> Take a Cuban dancer [of Spanish descent] with fierce black eyes. Add a ballet-trained blonde and brunette. Give them some music by a guitarist from Maple Valley, a deep-throated Indian classical singer and a jazz vocalist. What you get is Tacoma Flamenco, a flamenco group whose dancers have been teaching and performing with local studios for years, but who are now getting out into the café scene.
>
> . . . Tacoma Flamenco goes way beyond Spain in musical influences. While Brandenburg (a former WCB ballet mistress) and Rector have both danced with Fleites for eight years and teach flamenco themselves, the two singers come from very different backgrounds. Seema Bahl was trained in Indian classical singing and her sultry, powerful alto floats over the ornaments with both emotion and agility. She's also studied flamenco dance and the traditions of the Spanish gypsies. (Ponnekanti 2011)

In preparation for a large café performance in Tacoma, Washington, we were interviewed by Rosemary Ponnekanti of the *Tacoma News Tribune*. As a group, our eclectic styles and diverse backgrounds formed a rich environment for the creation of multitextured musical and rhythmic synergy. On the afternoon of one particular performance, we all congregated at the house of our performance company founder and lead dancer, Marisela Fleites-Lear. It was a hot summer afternoon, and due to my heat intolerance, I was provided a large fan and ample ventilation as we rehearsed for the upcoming show. The rehearsal went smoothly, with all performance pieces well choreographed and adequately practiced. Confidently, we made our way to the performance venue.

The air was thick with anticipation in this large, lively café that was to hold more than 150 guests through the course of the evening. I walked in and headed toward the performers' dressing room area behind our guitarist, our three dancers, and my fellow singer. Backstage, we made final costume preparations and allowed ourselves a quiet moment before the start of our performance. I wore my flat, black dress shoes that provided me with orthopedic support for my short walk to the stage. Carefully calculating the mobility requirements of proper balance, coordination, strength required to climb stairs, and travel from backstage to front stage, I successfully managed to find my seat alongside the other performers and waited for our guitarist to begin his folk tune in a major key.

> Fleites joins fellow dancers . . . in a trio pulsing in and out of a circle. It's a fairground dance, set steps in a folk tradition, rather than the complex

footwork of the solos. Fleites, with short black hair and black toreador-style pants and shirt, contrasts with the blonde Brandenburg and brunette Rector in their flouncy skirts and shawls. (Ponnekanti 2011)

As they pulse, I command the upbeat melody that calls out to the world to behold the beautiful face of the *Gitana* (Gypsy woman) that is dancing the steps of this folk dance from Seville, Spain. I claim the power and intensity of the *Gitano* (male Gypsy) voice, the voice that is seeking celebration and respite from the grueling challenges of ethnic persecution and nomadic life. My body is rootless, rogue, undependable, as is the life of the Gypsy claiming the space of folk celebration, of revelry in the *barrios*[7] of Seville. I am "at home in my discomfort" (Sandoval quoted in Samuels 2013, 328) as I represent this simultaneous revelry, rebellion, displacement, and suffering through my voice. The audience claps and cheers in response to the energy produced by the explosive comingling of song, dance, and guitar. "Ole!!" "Guapa!" "Que Fuerza!" "Vamos chicos!" are the expressions conveyed by the audience of celebratory cheer and of solidarity with the revolutionary spirit of the Gypsy community.

Later in the program, one of the dancers rises to dance one of the oldest flamenco *palos*, or styles, that is still performed today. This is the Martinete, which I sing a cappella, true to its traditional form:

> Yo ya no soy quien era, ni quien debia yo de ser, soy un mueble de tristeza, arrumbao por la pared, Si no es verdad, esto que yo digo, que Dios me mande un castigo, si es que me lo quiere mandar . . .

> [I am now not who I was, nor who I was supposed to be, I am a statue of sadness, shattered on the ground. It is not true, that which I say, that God sent me a curse, that is what he wanted to send. . . .] (Ruiz 2000)

This complex, five-beat syncopated rhythm carries us through the song and is marked by the haunting "clang" of a glass bottle, which is meant to signify the original "crashing" of the Gypsy blacksmith's hammer onto his anvil as he works in the forge. I am wailing at odd moments in between the clinking of the bottle, intentionally voicing my extreme despair and physical pain as I articulate the sentiments of the lyrics. The dancer is cued by my scream and moves in strong, angry sweeps of the arm along with furious, powerful, and rapid stomps on the stage floor to heighten the frenzied sense of anguish onstage, as both she and I manifest the dire reality of the "cursed" Gypsy that must endure this harsh reality. The audience is rapt; many are Spanish speakers and understand the gravity of the lyrics, but they can also see and feel the "ontological contingency" circulating between the dancer, myself, and their own realities. "Que pena!" (What pain!) they cry. This is our collective manifestation of *duende*, of black sounds, of pure energy of the tormented, despondent soul permeating the public domain at that moment.[8] This story traverses time and space, and it is

truly my story to share. As I perform Martinete, I am communicating with myself, with the audience, with my fellow performers, and with the universe. I lay claim to this powerful lament, for, in those explosive onstage moments of connection to the Martinete lyrics, I am fervently channeling *duende puro* (authentic *duende*) as a performer representing the interstices of race, gender, and disability.

As the evening progresses, I sing the Solea. According to James Woodall (1992), the Solea can be etymologically traced to the Gypsy expression for the word *soledad*, or solitude, and "the connection with the centuries-old Gypsy experience of social and cultural isolation" (99). This cultural isolation, coupled with the often perilous occupations that were historically thrust upon the oppressed Gypsy populations, resulted in an obsession with death in the lyrics of many flamenco *palos*, including the Solea. Importantly, sudden-onset disability and/or gradually progressing chronic illness would have been a common reality accompanying this extreme socioeconomic marginality.[9]

The dancer draws the dance to a new level of intensity with her rapidly mounting, agitated, highly percussive footwork, set in complex counter-rhythm with the guitar. I prepare for, and then execute, an anxiety-ridden, cataclysmic, mournful Solea screech:

> Cada vez que considero, que me tengo que morir, tiro una manta en el suelo ayee, y mi harto de dormir.
>
> [Each time that I think about the fact that I have to die, I throw a blanket on the floor, ayeee, and I fall into an exhausted sleep.][10]

Through these lyrics, I convey the "ontological contingency" present in my disabled body's isolated existence. As functional loss upon loss accumulates, I see the imminence of my death, and loneliness inevitably accompanies this recognition of my own fragile mortality. This, of course, is an ambivalent psychic process of accepting my own despair, even as I continue to function and thrive in the world as a disability justice activist, artist, academic, mother, and all of my other roles.

Indeed, notwithstanding this desolation, my own academic and social justice work depends upon the "humane" truth that disabled people are as deserving of the fundamental human rights of dignity, empowerment, and happiness as the nondisabled. Therein lies the contradiction, one that is well known in the disability community. Ultimately, however, in the exalted moments of flamenco *cante* performance, I leave behind these analyses, for I am elevated to a different plane of subjectivity wherein the deepest, visceral expression of the *duende* described by Lorca claims proud legitimacy and authenticity as I transmit the suffering wails of all of those eternally displaced in time and space. I cry "Ayayyayayayeeeeee" as the traditional opening, or *salida*, of the Solea, conveying deep Gitano lament.

Unpacking Flamenco at the Intersections:
Authenticity, Appropriation, and Expressions of Resistance

Many "flamencologists" insist that one cannot describe flamenco solely as a static Gitano (Gypsy) art form expressing only suffering and loss (Mitchell 1997). Flamenco has always been incredibly fluid and porous to external cultural and musical influences, incorporating melodic traditions from the Arab,[11] Jewish, and Latin[12] worlds, as well as more classical Spanish musical styles. To be sure, flamenco has been appropriated, hybridized, and blended into a variety of "fusion forms" while still performed as one of the highest European theatrical forms in operatic venues and in film.[13] My claim to *duende* does not ignore this vast and richly layered tradition; rather, it welcomes and embraces it as universally accepting and representative of global culture. Everyone can "be" flamenco. Everyone can express the *duende* gloriously described by Garcia Lorca. To be sure, Mitchell (1997) echoes the universality of the flamenco tradition:

> Today's international flamenco, and perhaps other varieties of what is now called "world music," effect the transposition of ethnicity (i.e., historical trauma/cathartic release) to a new key: creative mood modulation. For most of us, flamenco will evoke a structured affective state involving a set of linked conscious and unconscious fantasies about Spain, gypsies, magic, passion, pain, and so on, mixed with personal, unconscious early events that color our perceptions of exotic music.

Though I configure myself as the ethnic and disabled "other" onstage, I am still the essence of this multitextured tradition. The deep roots of *duende*, the "black sounds" of struggle and spirit seeking, are inscribed upon my own flesh as I wail the "Ayeeees" of the Martinete, Solea, and other *palos*. So too do I represent the hybridity of flamenco art and its plethora of influences; my South Indian (Karnatak) vocal technique contributes a unique and valuable element in the production of our performance as a whole.

How can I further interrogate the possibility of my own participation in the business of cultural appropriation? In reference to hegemony, popular culture, and resistance, Stuart Hall (2002) claims that the tension between popular culture and dominant culture is predicated upon a constantly morphing antagonism, influence, and dialog. It is within this dialectic that I am both a vital participant in the visual and auditory economy of the cultural production of flamenco and a producer of audience desire as subaltern *cantaora* (singer). In addition, as a disabled woman, I echo Rosemarie Garland Thomson's declaration of the vital need for people with both recognizable and hidden disabilities to insist upon remaining in the public eye, as too often they are forced out of sight (2009). Given these truths, performance for

me is an act of resistance. The risk-taking onstage as I manage my disability is great, and it is compounded by my perceived ethnic and racial "difference" as a performer of "Spanish" flamenco.

Yet through flamenco *cante*, my agency is palpable. I am simultaneously embodying the cultural fluidity and flexibility that has defined it for hundreds of years and using the art form as my own vehicle for cultural and social resistance through my expression of *duende*. In communication with the audience, I am redefining the parameters of my oppressed "othering" as a racialized, gendered, and disabled performer. I control the stage through my powerful *cante, cante* that tells the universal story of loss, struggle, redemption, empowerment, and dignity.

We can return to Bost, who addresses the legitimacy of disability representation on the flamenco stage and the implications of shape-shifting as a means of resistance, authenticity, and identity formation in her analysis of Carmen la Coja. Bost argues that Carmen's response to pain "suggests expansive ways of being that exceed the boundaries of her disability and of her working-class Latino neighborhood" (2010, 155). Bost remarks that Carmen la Coja "mobilizes" her body and life to supersede this pain and impairment, whereas I may "mobilize" my voice to interact with flamenco lyrics and melody to do the same. I may also consciously and subconsciously draw upon the energy circulating in the interactive spaces that we foster as performers to "reinvigorate" my body, to enliven it, to transform it psychically and physically through the act of singing. Importantly, singing also increases blood flow and circulation of oxygen, known to be potentially helpful for those with my particular disabling illness. In such instances, I am also engaging in an "expansive," nontraditional, and very personally profound act of healing through performance. In other words, I mobilize my body to "escape pain" and suffering through the act of seated singing, which oxygenates my brain, just as Carmen utilizes her "crip genius" tools onstage to escape pain, such as "camouflaging" her limb impairments with flowing flamenco dresses and moving "beyond the expected postures for a woman with a leg brace" (Bost 2010, 167).

Reflections on Passing, Performance, and Challenging the Dominant Onstage Narrative

Carrie Sandahl (2002) remarks that one must consider the "inherently ideological" configuration of theatrical space in a disability context:

> In most theatres, audience spaces have been made minimally accessible, but the stage, backstage, rehearsal halls, lighting booth, box office, costume shop, and scene shop are usually not. (24)

The message cannot be clearer to the disabled performer: you are not wanted onstage unless you can "pass" or somehow accommodate yourself to the normative standard of the nondisabled performer.

As a performer walking gingerly to the stage, I perceive my flamenco presence to be at once racialized, gendered, and potentially disabled as I typically receive from the audience both the stare and the gaze. The audience can represent Baudelaire's *flaneur*,[14] looking for the commodified visual or performance spectacle; thus, I begin the show as the object of the potentially uneasy gaze described by Rosemarie Garland Thomson.[15] My audiences, some of whom are Spanish speakers and many of whom are white, often stare curiously at me: the South Asian American woman singing flamenco. Do they wonder what claim I may have to the art of flamenco? Do they know that I am also negotiating the performance space in efforts to "pass" (using Erving Goffman's conception) as nondisabled, that I am trying to hide the visual manifestations of my disability in a precarious, temporary fashion? The limelight is bittersweet, as I am tensely trying to mask a true part of myself in front of my audience as I perform onstage, situated at the precipice of my own potentially calamitous, or possibly cathartic, "outing."

With a sometimes nonrecognizable disability, I am often able to choose to perform when I am able to "pass" as nondisabled. When I think about the notion of passing as a performer, I am aware of the severely damaging psychic and physical repercussions of this act. Tobin Siebers (2008) and others have theorized this, noting that passing, however harmful, has historically been an act of self-preservation for many communities in the face of the systemic violence of white, able-bodied, heteronormative supremacy and empire.

Bost also examines the political significance of passing in Ana Castillo's shape-shifting main character, Carmen. Though Siebers and others have been critical of the act of "passing" as harmful to identity politics and movement building within the disability community, Bost argues that Carmen la Coja's shifting embodiment makes a strong political statement about identity:

> Carmen's physical fluctuation and mobility offer commentary on managing difference, and her story demands recognition for bodies that are not just different from others—as monolithic identities—but for bodies that, in themselves, are not recognizable as stable or categorizable entities. (2010, 174)

As a person with a disability that has periods of relapse and periods of remittance, I am also navigating this space of unstable corporeality on the stage. Like Carmen, I may be "la Coja" on stage, or I may be "la cantaora" that does not reveal a visible disability. This is my authentic political and cultural identity: valid, I argue, in the same way as is Carmen's "shape-shifting" identity that cannot be neatly categorized.

Samuels (2013) also comments on the tension in disability politics between visible disability, ranked high in the "hierarchy of oppressions," and invisible disability, where one can pass as nondisabled:

> [V]isibility [is] a key component of analogical language. Indeed, when we consider that theories and practices of identity and subject formation in Western culture are largely structured around the logic of visibility, whether

in the service of science (Victorian physignomy), psychoanalysis (Lacan's mirror stage), or philosophy (Foucault's reading of the Panopticon), it becomes apparent that the speculative or "invisible" has generally functioned as the subordinate term in analogical equations to this date. (2013, 318)

So if visibly disabled people are awarded political primacy due to the ocular legitimacy of their "oppressed" identity or experience, how do we consider the act of "coming out" for nonvisibly disabled people? Samuels, speaking of queer as well as disabled identity, underscores the need to be aware of the complexity of this act and warns against reverting to a simplified passing/coming out binary:

> Coming out can entail a variety of meanings, acts, and commitments. The dual meanings most crucial to my argument can be signified grammatically: to "come out to" a person or group usually refers to a specific revelatory event, while to "come out" (without an object) usually refers to the time that one first realized and came to terms with one's own identity. . . . Nor is coming out a static and singular event. . . . [T]he majority of us find that, even after our own internal shift, and even after a dozen gay pride marches, we must still make decisions about coming out on a daily basis, in personal, professional and political contexts. (2013, 319)

I argue that my own negotiation of passing and coming out onstage involves the crucial dimension of communication through the act of performing; that is, I am engaged in the act of "coming out" through my expression and vocal interpretation of the often angst-ridden lyrics, my subtly perceptible physical impairments, and my powerful centrality in the circulation of *duende* in the performance space. These factors complicate and enrich the framework presented by Samuels, who focuses on the verbal or internal communication of one's "experience" of nonvisible disability juxtaposed against the physical representation of disability that is clear "proof" of one's disability status. Samuels challenges the notion that there is only "assimilationist" privilege awarded to those who can pass and points to the vulnerability that nonvisibly disabled people face when attempting to "come out." For example, they may be subject to public mockery, nonacceptance of the extent of their disability, a reluctance to accommodate them, shaming, and surveillance due to mistrust of their disability status. Moreover, the act of passing weighs on the disabled individual's psyche and may lead to severe "internal dissonance" (to use Samuels's term) as one moves through the world hiding a part of one's identity. I argue that my flamenco singing onstage gives me a means of transcending these tensions and rifts between the visibly disabled and the nonvisibly disabled.

So if it can be accepted that the variable physical representation of my disability can be made manifest in a number of ways onstage—such as *physically*, in the case of a visible symptom emerging, *cognitively*, in the case of an inability to recall lyrics,

and *vocally*, through my communication of the lyrics and expression of *duende*—how exactly do I manage the political and social implications of "performing" my disability? As this combination of performance energies circulate, how does my corporeality unveil itself onstage? From the beginning of the show, I am engaging in those careful calculations of my environment in order to minimize my physical impairments. I am making the decisions articulated by Samuels necessary to show or not show my true self to the world. All of these decisions, and my reality as a disabled performer, are legitimate, meaningful, political, and powerful.

Poetic Interventions and Performing Nondisability

Petra Kuppers (2013), noted scholar in disability studies and community performance, conveys the profundity of meaning that may circulate among performers, sharing onstage their experience of pain and disability using nonverbal (tactile) techniques:

> In the Burning workshops and sharings, people do not "own" medical diagnosis. They do not step onto a stage and proclaim their medically given label. Instead, we twist and turn around and under words. Most of us identify as disabled or living with disease . . . others are . . . interested in the history and effects of racialization—all areas of culture-ing where labels and desirous bodies twist and turn into each other, where lived experience and language shift into each other with aching gears. (131)

Kuppers endorses a shift from telling textual "stories" of illness and disability to embodied "poetic interventions" within communal performance spaces about universal narratives of pain, loss (disability), and ontological contingency (mortality, expressed also in *palos*). There is a "rhizomatic"[16] exploration of the disease process onstage,

> in which the extrinsic and intrinsic mix and merge, as they do in my own physical and psychical being when I am in pain, and cannot walk up the stairs and wish for a painkiller, and take pride in my difference, and feel unable to speak of the nature of my discomfort, cannot find the words, but find comfort in the company of others whose pain might be different, but who somehow feel simpatico. (2013, 95)

So how can an art form marked by dynamic cultural fluidity and a diverse plethora of global influences facilitate the onstage manifestation of my own genuine, vibrant, "intersectional" identity in the context of Kuppers's rhizomatic model of disability? When expressing emotions of disabled, gendered, and racialized subjectivity through flamenco *cante*, akin to the "poetic interventions" referred to by Kuppers, I again propose that I am able to challenge, enrich, and complicate the weighty sociopolitical and phenomenological debates surrounding the act of passing versus the act of coming out. Indeed, as Kuppers suggests, moving from the "telling" of our disability

stories to the rhizomatic, embodied onstage expression of disability experience can be a liberating, powerful, and effective method of "coming out" to the world.

When the performance involves both disabled and nondisabled performers, Lennard Davis (2012) has remarked that an onstage "visible" disability would necessitate a transfer of the audience gaze to the disability represented, resulting in an uneasy abandonment of the central performance (3). He refers to this narrative shift as an "interference" of the main act (ibid.). As stated earlier, my performances always involve the very tentative act of "hiding" my disability onstage as I carefully navigate my way to the back of the set with the musicians and remain seated during the performance. There is the omnipresent risk of my disability's onstage "outing," either through an unstable fall, an evident limp, an inability to climb stairs to reach my seated destination, a visible tremor onstage, or a cognitive lapse as I sing. Despite this potential distraction, I argue that the binary proposed by Davis regarding the audience gaze must be interrogated further as the interaction between the audience and myself unfolds. Even as the "racialized other" uneasily managing her hidden disability onstage, again, I am "rhizomatically" conveying the "black sounds" elucidated by Garcia Lorca. I am singing my story of loss, displacement, abandonment, solitude, redemption, and sublime transmutation. The audience's gaze, on occasion transferred to me from the main dance performance, may be transfixed, curious, probing; but this may not necessarily be uneasy or oppressive. My visibility can invite the audience to challenge its own potentially Eurocentric and "ableist" expectations that a nondisabled, ethnoculturally "authentic" body will represent Spanish flamenco for them on the stage. In each local performance, there is the opportunity to "undo" audience expectations that are rooted in hegemonic cultural discourse, and this may be empowering, liberating, and transformative. This moment where I *tell my story* may be a moment of resistance, if not even a moment of liberation. Indeed, when expressing authentic stories of disability and diaspora through flamenco *cante*, I can contribute to the creation of complex, dynamic, interactive spaces in which audience and performer can communicate on multiple levels, thereby "shaking up" the perceived dominant narrative of the flamenco stage.

Returning to Sandahl (2002), who comments on symmetry and the aesthetic values of performance, we can accept that

> [d]isabled bodies also challenge certain aesthetic values of space, namely symmetry. Our often asymmetrical bodies and movement patterns can provide stark contrast and a visual commentary on the cultural valuation of symmetry as a component of the beautiful. (228)

Given this wisdom, what would it mean for me as a disabled singer whose disability status oscillates (like Castillo's character Carmen), but whose bodily movements are not so evident onstage, to allow for a greater acceptance of the vicissitudes of

my onstage embodied presence? What could an onstage self-embrace of my visibly disabled physicality mean to me, the other performers, and the audience? Recalling Bost's argument about the political validity of Carmen's shape-shifting, nonstatic physicality, or her body in constant "motion," I ponder this question as I continue to perform with awareness of the chronic-progressive, physically disabling nature of my disease. Currently, I am sometimes able to comply, after completing a momentary cost-benefit analysis, when asked to "move" or "perform nondisability" on stage. For example, singers are typically invited to dance collectively with the rest of the performers in an informal fashion at the end of the show before the final bow. They also routinely stand for part of the show and dance in between acts; thus, they must rely on the steadiness and dependability of their bodies. I have been faced with the management of these onstage exigencies and have called upon my own "crip genius" to maintain grace and dignity, as Carmen "la Coja" does on many occasions under her flowing flamenco skirts. One day, no longer able to pass, I may be confronted with the challenge of performing my physical disability visibly, unequivocally, and "centrally" to a flamenco audience. The vocal circulation of *duende* and my expression of flamenco lyrics will cease to be the only way my intersectional subjectivity will be manifest onstage. Will the audience gaze shift, thereby abandoning the focus on the central performance? To be sure, the performance will still be true to the roots of the Gypsy experience: an eternal, authentic story of pain, loss, anger, suffering, and brilliant resistance.

Notes

1. Melismas are movements up and down the scales, usually in Phrygian mode.
2. Rosemarie Garland Thomson (2009) notes that "the functional and formal conditions of our bodies that are termed disabilities are one of the most unpredictable aspects of life. Like death itself, disabilities come to us unbidden as we move through a world that wears us down even while it sustains us. Seeing disability reminds us of what Bryan S. Turner calls 'ontological contingency,' the truth of our body's vulnerability to the randomness of fate" (19).
3. "Gypsy" is a colloquial term identifying the ethnic Rom population in Europe; although contested in some circles as a racist classification, the term has been widely used in the flamenco canon as an auto-signifier with a potentially "reclaimed" cultural status. Jodie Matthews's (2012) research affirms that "Gypsies are proud to say that they are 'Gypsy' (and, for some, 'Travellers')" (4).
4. See hooks 1981.
5. According to Erving Goffman (1963), stigma refers to "bodily signs designed to expose something unusual and bad about the moral status of the signifier" (1), such as individuals with "physical deformities," "blemishes of . . . character," and "tribal stigma of race, nation or religion" (4).
6. It is important to note that there is considerable debate about the true ethnic origin of flamenco. Mitchell (1997) claims that "[f]lamenco has its origins not in ethnic purity but in what Julio Caro Baroja called 'ethnic chaos'" (56).

7. A Spanish term for "ethnic enclave."

8. Timothy Mitchell (1994) has argued that both singers and dancers of flamenco have often performed as facilitators of alcohol-fueled "psychodramas" in their mimetic representations. In this sense, I cannot assume that my fellow dancer is also expressing the true, authentic despair that I claim in my performance.

9. The study of disability and chronic illness in Gypsy populations from this historical perspective is beyond the scope of this essay, but it is a crucial area of scholarly inquiry that I hope to pursue in the future.

10. See Horizonte Flamenco.

11. Examples of flamenco styles influenced by Arab traditions are Zambra and Fandangos.

12. Flamenco traditions of the *ir y vuelta* or "departing to and returning from" (Latin America) style include Guajiras and Colombianas.

13. Antonio Gades was the director of the Ballet Nacional de España (the National Ballet of Spain), and Carlos Saura was the director of movies pivotal to the internationalization of flamenco such as *Tarantos* (1963), *Blood Wedding* (1981), *Carmen* (1983), and *El Amor Brujo* (1983).

14. According to Garland Thomson (2009), "In late capitalism, the predominant form of looking, the mass exercise of ocularcentricity, is what we might call consumer vision. . . . In a mobile urbanized environment where face-to-face encounters are usually anonymous, the modern individual circulates in space, status, and interpersonal relations. . . . The cultural call to be consumers primarily requires looking at commodities, not people. . . . The flaneur, the bourgeois spectator Baudelaire celebrated as the representative modern man, visually wanders through the urban landscape exercising his privilege of disengaged, amused looking. The flaneur is entertained, but never captivated; delighted but never enthralled" (29).

15. Garland Thomson (2009) refers to the gaze as an "oppressive act" (9).

16. Deleuzoguttarian notion that the circulation of meaning spawns a multiplicity of non-hierarchical meanings that are constantly giving birth to other meanings, undergoing rupture and rebirth, and constantly in "process" (Kuppers 2013, 95).

References

Bost, Suzanne. *Encarnacion: Illness and Body Politics in Chicana Feminist Literature.* New York: Fordham University Press, 2010.

Dasgupta, Santayani, and Shamita Das Dasgupta. "Sex, Lies, and Women's Lives: An Intergenerational Dialogue." In *A Patchwork Shawl: Chronicles of South Asian Women in America*, edited by Shamita Das Dasgupta, 111–28. New Brunswick, NJ: Rutgers University Press, 1998.

Davis, Lennard. "The Disability Paradox: Ghettoisation of the Visual." *Parallel Lines*, http://www.parallellinesjournal.com/article-the-disability-paradox.html (accessed October 3, 2012).

"Esa Letra." *Horizonte Flamenco*, September 17, 2002, last modified in 2013, http://www.horizonteflamenco.com/?page=esa-letra (accessed August 9, 2014).

Garcia Lorca, Federico. "Teoría y Juego del Duende." In *Cronología y Bibliografía de Domingo Rodríguez.* 2010 ed. Barcelona: Nortesur.

Garland Thomson, Rosemarie. *Staring: How We Look*. Oxford: Oxford University Press, 2009.

Goffman, Erving. *Stigma: Notes on the Management of Spoiled Identity*. New York: Simon & Schuster, 1963.

Hall, Stuart. "Notes on Deconstructing 'the Popular.'" In *Cultural Resistance Reader*, edited by Stephen Duncombem, 185–92. London: Verso, 2002.

hooks, bell. *Ain't I a Woman: Black Women and Feminism*. Boston: South End Press, 1981.

Kuppers, Petra. *Disability Culture and Community Performance*. New York: Palgrave Macmillan, 2013.

Matthews, Jodie. "Gypsies, Roma, and Irish Travellers: Histories, Perceptions, and Representations, A Review. Project Workshop Summary," 2012. University of Huddersfield Repository, http://eprints.hud.ac.uk/16393/ (accessed October 3, 2014).

Mitchell, Timothy. *Flamenco Deep Song*. New Haven, CT: Yale University Press, 1994.

———. "Gypsies and Flamenco: The Emergence of the Art of Flamenco in Andalusia." *Notes*, second series, 54, no. 1 (1997): 56–59.

Ponnekanti, Rosemary. "Homegrown Flamenco Group Brings Performers into a Spicy Musical Salsa." *The Tacoma News Tribune*. Last modified August 26, 2011, http://thenewstribune.com/2011/08/26/1795174/feeling-driven-flamenco.html (accessed March 2, 2014).

Ruiz, Rocio. *Cante Solo por Martinete*. OFS Records. Recorded January 1, 2000, compact disk.

Silva Pisa, Remedios. "Naci en Alamo" from *Vengo*, directed by Tony Gatlif, HVE Entertainment, 2000. Digital video disk.

Samuels, Ellen. "My Body, My Closet: Invisible Disability and the Limits of Coming Out." In *The Disability Studies Reader*, edited by Lennard J. Davis, 316–32. New York: Routledge, 2013.

Sandahl, Carrie. "Considering Disability: Disability Phenomenology's Role in Revolutionizing Theatrical Space." *Journal of Dramatic Theory and Criticism* 16, no. 2 (2002): 17–32. https://journals.ku.edu/index.php/jdtc/article/view/3394/3323 (accessed October 3, 2014).

Siebers, Tobin. *Disability Theory*. Ann Arbor: University of Michigan Press, 2008.

Vernon, Ayesha. "The Dialectics of Multiple Identities and the Disabled People's Movement." *Disability & Society* 14, no. 3 (1999): 385–98.

Woodall, James. *In Search of the Firedance: Spain through Flamenco*. London: Sinclair-Stevenson Limited, 1992.

Beyond Participation: A Reflexive Narrative of the Inclusive Potentials of Activist Scholarship in Music Education

Tuulikki Laes
Sibelius Academy of the University of the Arts Helsinki
Taideyliopisto, Finland

In this self-reflexive study, I examine the possibilities and limitations of inclusive methodologies within activist scholarship in music education. Stemming from my own experiences and struggles as an activist researcher, I reconsider the potentials of inclusivity within participatory research approaches, especially concerning, or done together with, persons labeled as having learning disabilities. Acknowledging that the vocabulary and ethical guidelines for inclusive knowledge production in (music) educational research methodologies is in its infancy, this study addresses the demand for new spaces of academic activism through negotiations with the research community, including research participants and funders, and reconsiderations of the research roles and processes as contingent and relational.

I always have to clean up
I always have to do the dishes
I always have to go to work
I always have to see the doctor
I can't use the computer
I can't watch TV
I can't even see my friends
I always have to be at home
I always have to take care of stuff
I always have to eat properly
I always have to drink properly
I can't eat sweets or drink soda
I can't even drink alcohol
I always have to rest

From *Bulletin of the Council for Research in Music Education*, No. 210–211 (2016), pp. 137–151.

I always have to sleep
I always have to get up
I always have to take a shower

—Kari Aalto, *"Aina mun pitää"* ["I Always Have To"][1]

We live in a scripted reality. In such a climate where the narratives of the powerful, the privileged, and the able define the center of society, certain individuals, groups, or traits are normalized, and others are cast as inferior. These intransigent lines of oppression are perpetuated by attempts to assist those who struggle by attending to them as a specific "area of need" (Patel, 2016, p. 23). In educational research and practices, even the label *special needs*, so often applied to students who differ from the centered norm, locates the problem within the different individual. In doing this, we reinforce the ableist scripts that narrate the majority as *normal* and the special as *other*. The lyrics that open this article are written by the lead singer of a Finnish punk rock band, Pertti Kurikan Nimipäivät, and are inspired by the artists' frustration of having to live in an assisted group home. This short verse illustrates how daily life for those defined within this specific area of need is often predetermined; indeed, life has been scripted for them. Often, when people with disabilities are seen as in need of care, professionals such as care workers, therapists, teachers, and researchers are often considered to know best, to know what is needed, and to know what might empower the marginalized. However, as the above lyrics lament, the members of the band are challenging the pervasive power hierarchies inherent in such approaches to empowerment through their own music, raising questions about how to resist and change the oppressive, scripted everyday realities (see Juntunen, Karlsen, Kuoppamäki, Laes, & Muhonen, 2014, for a more detailed account of the band).

Limited conceptions and discourses of disability may also be seen in music education. For example, students categorized as having learning difficulties are typically relegated to the fields of music therapy or special education, overlooking the fact that disability is by no means the only identity available for them (Garland-Thomson & Bailey, 2010). While individualized pedagogical solutions are undoubtedly useful in engaging students in musical activity, through assigning special categories for human variation as exceptions to the norm, scholarly work in music education maintains the dominance of a medicalized discourse on disability and difference (Dobbs, 2012). In correcting this power imbalance and dismantling and reconstructing the power of the prevailing disability metaphor, it becomes crucial to "[insist] on the personal story" (Shuman, 2015, p. 47) of the very people who have experienced disabilities themselves. It is generally agreed upon in qualitative research that the exploration of personal, lived experience is essential for ethical human research practices (Clandinin, 2006; Schwandt, 1994). Also, music education researchers have increasingly attended to narrative as a method and a research stance, seeking ways to uncover and amplify

multiple voices and meaning-makings that would otherwise remain silent or silenced (Stauffer & Barrett, 2009).

However, while the personal story such as the one presented through the punk band's lyrics is crucial for understanding perspectives other than your own, we also need to attend to our own roles as researchers in order to identify and deconstruct the power hierarchies within research. In this article, I present a self-reflexive narrative of an ongoing process of constructing activist scholarship, through problematizing the discursive and methodological constraints that construct the binary between academia and activism (Maxey, 1999). Stemming from shared, intersubjective experiences in my research with musicians with disabilities, this article focuses particularly on my own considerations of reflexivity as a catalyst for research. As suggested by Finlay (2002), reflexivity is a necessary and generative tool for negotiating and making use of a researcher's self-analysis and self-disclosure to reshape research practices and discourses. In narrative inquiry, Clandinin and Connelly (2000) also remind us that lived experience is to be understood as continuous, demanding researchers to move back and forth "between the personal and the social, simultaneously thinking about the past, present, and future" (pp. 2–3). Thus, through drawing on my own experience, my methodological approach here is a dialogical reflexivity between "inner speech" and written narrative form (Motta, Rafalski, Rangel, & de Souza, 2013), which helps me to "reflexively turn back" (Nichols, 2016) to the past events in order to understand and anticipate what is required in activist music education scholarship in the future.

Setting the Stage

My activist music education research that is the focus of this article takes place in the context of the music school Resonaari. This extracurricular school is an exceptional case in Finland, offering goal-oriented music education for children and adults with learning characteristics that traditional music schools and conventional pedagogies fail to respond to. Resonaari enacts inclusive, activist music education through unique policy and pedagogy solutions: promoting their students' musical agency *beyond* therapeutic care and creating for them possibilities to engage in public performances and make connections *beyond* institutional contexts, thus paving their way for professional musicianship (Laes & Schmidt, 2016). Activism in the music education work done at Resonaari may be seen through the production of culture, policy, and pedagogical practices through active engagements with social groups that have generally been relegated to remedial and therapeutic spheres of music education.

My research in this context has focused on wider impacts of agency construction among the students and musicians at Resonaari. Considering these individuals as active political agents, musical experts, and credible and important knowledge

producers in various music education contexts, Resonaari's contribution extends beyond music learning practices, to policy advocacy and political activism, collaboration with stakeholders, and development work in higher educational contexts (Laes & Schmidt, 2016; Laes & Westerlund, in press). Addressing these wider inclusive research aims led me to conclude that the key persons of Resonaari could no longer be called mere *participants* in my research. Their roles were not simply student, apprentice, or informant but rather teacher, expert, or colleague—and in the future, even coresearcher. This notion brought with it a need to clearly articulate and reflect upon *how* to make the research process more accountable and responsible, or as Patel (2016) suggests, *answerable*, to the inclusive aims of activist music education.

Emerging Methodological Questions

Navigating the emerging methodological considerations for this research, narrative inquiry offered an approach to *inclusive research* as a practice and a methodological stance for democratic dialogue (Nind, 2014b) between the researcher and persons who are often presumed to be incompetent by social services and wider society (Jenkins, 1998), including academia. Inclusive research has been defined by efforts to articulate participatory/collaborative/partnership/emancipatory approaches relating to, or involving, people with an intellectual disability that emphasize their involvement in studying matters concerning themselves and their communities (Knox, Mock, & Parmenter, 2000; see also Nind, 2014b; Ollerton, 2012; Walmsley & Johnson, 2003). The methods within the inclusive idiom have aimed both at social change and personal liberation in matters relevant to research participants' own lives. However, while inclusive research has mostly referred to specific methodological practices of doing research together with the people who have experienced disabilities, Nind (2014a, 2014b) proposes a broader definition of the term, encompassing a range of participatory, emancipatory, partnership, user-led, activist, and decolonizing research approaches, all of which strive for the democratization of the research processes.

In searching for a more democratic research process, inclusive research contributes to the role and definition of activist scholarship by emphasizing the need for renegotiating research roles. Nind (2014a) argues that "there is relatively little emphasis on transformation through bringing everyone together in *new* [emphasis added] research roles and the language of the traditional researcher remains somewhat dominant" (pp. 6–7) in much participatory research. In other words, while important scholarly work on narrating the personal and cultural experiences of disability has already been done (e.g., Clandinin & Raymond, 2006; Smith & Sparkes, 2008), less attention has been paid to projects where persons with disabilities are involved as coresearchers, rather than participants. Indeed, different approaches on inclusive research may create new alternatives to *knowing better* in academic contexts. In

reflexively and critically analyzing my own research process, I here address the following questions:

- How can I ensure that the participants are substantially involved in a research process that aims to enact inclusion?
- How can I succeed as an activist scholar in remaining ethically and politically sensitive, yet avoiding the reproduction of oppressive, scripted realities?
- How can I include persons that are the most important actors and self-advocates of activist music education in narrative-empirical work, data analysis, interpretation, and research communication in ways that are meaningful to them and to the research agenda?

In addressing these questions, I present a reflexive narrative of my personal experiences that led me to identify the potentials and challenges between the traditional contexts and tools of knowledge production and the formation of new research relationships within inclusive and activist research goals. In learning from my mistakes, illustrated in the narrative, I first engage with identifying the gaps between inclusive aims and spatial practices of academic research. Second, I attend to the narratives of care that often maintain the hierarchies within research relationships. I then turn back to self-analysis of my experience as a researcher as a tool for constructing activist scholarship. Leading from this, I consider the potentials of narrative techniques in mutual meaning-making and coconstruction of knowledge. Finally, I suggest how considerations of activist music education contexts as contingent and relational may demand reaching beyond the ostensible narratives of voice.

Learning From My Mistakes . . .

In fall 2015, I was preparing a conference paper presenting a study that examined the collaboration with Resonaari's musicians in a music teacher education context (Laes & Westerlund, in press). This study focused on expanding the notion of professional musicianship through a particular program at Resonaari, where former students engage in further study aiming toward a vocational degree in music. One of the musicians studying in this program was Jaakko, a 34-year-old singer and keyboard player. During my 7 years working as a music teacher in Resonaari, prior to my life in academia, I had played and performed music together with Jaakko many times. Through these experiences, I had learned that music, and especially singing, had always held an important place in his life—indeed, he is a *born* musician and performer. Later, when I was working in a music teacher education program as a lecturer, I had established a collegial relationship with Jaakko, inviting him and another musician from Resonaari to teach music teacher candidates for 3 consecutive years.

Taking into account our longstanding friendship and working relationship, I felt that it was important to invite Jaakko to present the paper with me, heeding the

call of inclusive research approaches to do research *with*, rather than *about*. Although I acknowledged that this venture would bring with it different kinds of questions and challenges relating to power relations (Seale, Nind, Tilley, & Chapman, 2015), particularly since Jaakko had not been involved in writing the paper itself, I considered my long acquaintance with Jaakko simply as an advantage. Indeed, I anticipated that presenting the paper together would not greatly alter our collaboration in other nonacademic contexts.

Before the conference, we discussed the premises and aims of an academic paper presentation. I described the theoretical framework and main conclusions of the study, and Jaakko and I sketched an outline of the presentation together. We planned to start with my talk followed by a video clip from one of the workshops Jaakko and his colleague had conducted at the university. After this, we planned that Jaakko would describe, in his own words, how the workshop was conducted, along with any other thoughts he would like to share with the audience. Our presentation relied on spontaneity rather than following a script, aiming toward a smooth, informal duet, as Jaakko is an experienced performer. However, the *problem* that arose was not one related to performance or spontaneity.

As Jaakko and I entered the presentation room, it was instantly apparent that there were expectations that defined who was the researcher and who was the researched. I became worried that the audience would make wrong assumptions of the underlying hierarchy relations between us, thus making the whole situation prone to different kinds of misinterpretations. Although the audience was certainly sympathetic, we received some important questions regarding the research process and the analysis of the data—my university students' reflections on Jaakko's workshops: "Did you analyze the data together?" (We had not.) "Should you have analyzed the data together?"

The boundaries between facilitating Jaakko's capacity to communicate his own ideas and speaking *for* him suddenly seemed blurry and dangerous. When an audience member asked about Jaakko's teacher role in the workshops, I saw that he looked puzzled. I recalled a conversation that had taken place only hours earlier when traveling to the conference. Jaakko had said: "I am a good musician. But I can never be the leader." It had been an important moment for me, realizing that while I wanted to support Jaakko to gain agency in new contexts, *he* might feel reluctant to take responsibility and independence as a teacher and a musician. I was compelled to jump into an academic discussion regarding these complexities but did not know how to address this comment on my research and our presentation without sounding like I was steering his thoughts. This was a daunting experience for me. Although I found it relatively easy to resist the reproduction of marginalizing discourses on paper, how to enact resistance in real life was clearly more complex. I was suddenly painfully aware that mere participation did not, and does not, equate with inclusion.

So, *should* we have analyzed the data together for this to be inclusive research? I agree that while striving toward activist scholarship does not necessarily mean that all researchers need to engage with participatory practices (Nind, 2014b, p. 52; see also Patel, 2016, pp. 64–65), or that all participants need to have authorship over all research publications (see Nind, 2014b, pp. 28–29), in this case, I should have at least shared the data with Jaakko and his colleague, allowing for dialogical and interreflexive (Barrett & Mills, 2009) possibilities. For me, this raises new questions regarding the relations between academia and activism and suggests that these two stances may be compounded within the researcher's own critical reflexivity (Maxey, 1999), rather than distinct and separate realms. In this way, my *mistake* of not stepping out from the traditional research process, which would have simultaneously meant stepping out of my comfort zone, raises new opportunities to confront this uncomfortable self-disclosure in a *generative* way. Indeed, reflecting on our actions can lead to *new learning* through willingness to improve future situations (McNiff, 2006).

. . . by Bridging the Gaps Between the Spatial Practices of Inclusive Research

An important consideration in learning from the mistakes I made in my own research process was that of methodological approach. In envisioning *democracy through difference* (Barton, 2001), the research methods employed hold significant implications for extending the boundaries within the *spatial practices* of academic research (Seale et al., 2015). In this way, innovatively employing different and new research strategies that create generative forms of dialogue become relevant. However, as new perspectives emerge, a "methods gap" may take place (Hesse-Biber & Leavy, 2008). This means that researchers may need to negotiate their roles both as an insider and outsider: as "researchers, they are insiders, given their familiarity with the research process, yet questions they now raise about what seemed familiar are now novel, and the methods tools they employ are not familiar" (Hesse-Biber & Leavy, 2008, p. 4). In other words, bridging the gaps may not only require unsettling the normative boundaries of official knowledge but also critically attending to questions of *what* is actually deemed appropriate within academic contexts and "architectures" (Patel, 2016, p. 20) and *why*, in order to put the concepts and theories of *inclusion* into practice. It is noteworthy, however, that inclusivity in research does not mean bringing the *other* into the mainstream practice, but rather opening new, contingent and dynamic spaces for cocreation (Gould, 2013; see also Biesta, 2009).

This complexity of democratic dialogue and considerations between "choice and voice" within, and beyond, academic-led research (Nind, 2014b, p. 52) call for constructing *third spaces* that focus on, and allow for, processes of interaction. Such

third spaces embrace uncertainty and irregularity through the use of methodological innovations as well as different research communication—seen as key to collaboration (Seale et al., 2015). The coconstruction of knowledge thus concerns the wider research community, including not only researchers and research participants, but practitioners, funders, committees, and others. In their attempt to cross boundaries for doing participatory research together with people with learning disabilities, Seale et al. (2015) suggest that a *messy space* in research practice might generate opportunities for creative approaches and reconsiderations of research processes and roles. My own reflexive considerations of the opportunities and obstacles of inclusive research after the conference presentation by Jaakko and myself attend to the very messiness and contingency of the spaces made available for inclusive research collaboration. Indeed, establishing new research roles and sharing the control over the research process (Nind, 2014a) demands letting go of certain practices and thinking models that we as scholars are trained for. Through learning from these potentials of allowing for the uncertain, I looked at my writings in the research study that I reported on at this conference presentation. I had referred to an expanded notion of professional expertise (Hulme, Cracknell & Owens, 2009) with regard to Resonaari's musicians working as teachers in university music teacher education contexts. But was this expanded notion evident in my own research practice? Working collaboratively with Jaakko should have prompted a pause and critical reflection of how his expertise may craft, contribute, and even question knowledges (Patel, 2016, pp. 57–58). In the efforts of making these spaces of collaborative knowledge production more inclusive, it is not enough that the research participants are considered as experts of their own personal experiences (Knox et al., 2000). Inviting Jaakko to represent his expertise on disability while maintaining the academic context and its discursive realities rather stagnant and unchallenged did not make the space more inclusive; in fact, this kind of action might have even fortified the dominant structures and inequalities. As Patel (2016) states, "We cannot alter the practices or close gaps without reconsidering the whole system and the societal design that creates inequalities rather than temporarily improving a small set of experiences" (p. 19). A more significant intervention of the spatial practices is then needed in order to reach third spaces within the scripted realities of academia.

. . . by Reaching Beyond Narratives of Care

In not speaking *for* Jaakko, or others, in the future, it is necessary to reach beyond dominant *narratives of care* that predefine our roles as researcher, researched, teacher, student, expert, learner. One means to do this is through activist scholarship. While activism is generally associated with social movements and grassroots organizations, Sudbury and Okazawa-Rey (2009), among others, strongly argue for activist

scholarship to be seen as a model for combining academia and movements for social justice. However, activist scholarship should not be built upon fixed and idealistic visions of emancipatory research, assuming that any kind of participatory action is empowering and antioppressive per se. In the same vein, activism has been argued as a *discursively produced concept* that can both resist and strengthen exclusive processes (Maxey, 1999). This may refer to, for example, the ambiguous relationship between power and powerlessness in social situations (Gaventa, 1980); indeed, who *defines* the power roles in these situations? What, then, is my role as an activist scholar in situations such as our conference presentation? Should I have protected Jaakko from such challenging and uncertain situations? Should I have prepared him better, minimizing the potential risks? Or should I embrace the uncertainty of what it means to stand up against the scripted realities and predetermined roles of academia and wider society?

A critical examination of the ethical considerations regarding activist research processes including people with intellectual disabilities, and those who have been seen as in need of care, has emphasized more complex issues than only those relating to obtaining informed consent (Goldsmith & Skirton, 2015; Knox et al., 2000). Processes that aim to avoid exclusive and discriminatory decisions imply a danger that the requirements for the type of research concerning these groups become overly restrictive in their political correctness, thus demanding a sensitivity between *protectionism* and *discrimination* (Iacono, 2006). Indeed, while this paradox between the importance to include persons in research concerning their personal lives and the willingness to protect them as a vulnerable group has been acknowledged (Goldsmith & Skirton, 2015), it needs to be even further problematized. As stated by Nichols (2016), sharing the power itself *is* an act of power, as it includes defining with *whom* the power should be *shared*, thus making a distinction between vulnerable and powerful individuals within the shared research context.

. . . by Celebrating the Value of My Flawed Efforts

Reaching beyond political protectionism indeed remains an ongoing challenge for every activist scholar, but it may be combated through the democratization of the research process on all counts by also considering those outside of academia as active and credible producers of knowledge. I consider the presentation with Jaakko as the first and the most important step, including learning from my mistakes—reflecting upon *what went wrong* and how I, or we, might manage the situation better next time.

Within inclusive research aims, activist scholarship may manifest itself through radical approaches on participatory democracy where fortifying the voices and actions of marginalized people is the starting point for identifying and dismantling hierarchical power relations (Oakes & Rogers, 2006). To *make* those voices heard, however, requires not only reconsiderations of democratic and transformational knowledge

production (Nind, 2014a), but reaching beyond the structural considerations of inclusion, attending to manifestations of the personal and the ethical within activist scholarship (see also Sudbury & Okazawa-Rey, 2009). Personal considerations naturally connect with reflexivity. However, rather than attempting to sidestep power issues through "transparent reflexivity," Maxey (1999) suggests a more radical, critical, and contingent reflexivity approach as the key for activist scholars to engage with these power relations. This means that as power simply cannot be identified and then avoided, rather, the researcher needs to learn from the flawed efforts (Maxey, 1999), simultaneously acknowledging that research as a whole is *relational*—a project and a product of cultural, political, and material conditions (Patel, 2016, p. 49). Furthermore, in her turn to *relational ethics*, Nichols (2016) suggests that the trustworthiness of a study ought to expand beyond the researcher's own self-reflection, to explicate the research relationships and practices involved as part of ongoing discussions of the relational aspects of research.

Expanding our collaboration beyond the safe and the familiar both in pedagogical and academic contexts is a leap into the unexplored (Juntunen et al., 2014), leading to processes of activist music education that may create alternative perspectives for the canons of musical knowledge and attest to the normative discourses of musicianship and expertise. Anticipating that in the future I need to construct my research stance differently, considering how I approached the conference presentation with Jaakko and myself, I turn to narrative methodologies to examine how to articulate these efforts in research communication in order to engage with inclusive activism.

. . . by Reconsidering the Narrative Voice in Inclusive Research

Although narrative methodologies have been said to hold potentials for the ethical and respectful establishment of research partnership, this is not without contest, nor complexity. As Stauffer and Barrett (2009) ask, within that shared power, "how does one raise questions that trouble certainty while maintaining epistemological humility?" and moreover, how can one construct research that "represents the lived experiences and meaning of participants while also being theoretically informed?" (p. 25). Constructing research partnerships within narrative inquiry has been carefully considered in *critical, emancipatory storytelling* that is "a discursive, emergent methodological process" consistent with ethical considerations of participatory research where a *restructuring* of the research relationship is necessary by honoring the storyteller's voice and expertise in his or her own life narrative (Nichols, 2013). Narrative researchers working with people with disabilities have reconsidered the roles and positionings of *storyteller* and *story analyst* in ways that challenge traditional research hierarchies and positionings (Smith & Sparkes, 2008). In this way, researchers are also required

to consider their own "positioning in the narrative" (Depperman, 2015). Already two decades ago, Booth and Booth (1996) argued that "researchers should put more emphasis on overcoming the barriers that impede the involvement of *inarticulate subjects* [emphasis added] in narrative research instead of dwelling on their limitations as informants" (p. 55). However, their advice overlooks the problem of *facilitation* in the research process: How can a researcher avoid steering the thoughts of research participants when thinking aloud *for* them? Moreover, false categorizations of people in terms of their personal dis/abilities may also be reinforced by stories constructed by researchers aspiring toward empowerment for their participants. Such facilitated stories may eventuate as "symbolic markers of knowledge power" (McNiff, 2006, p. 315), where the voice of the researcher, rather than of the participant, is amplified. Considering narrative as interactive, shared territory, questions of claiming and sharing the ownership of stories, opinions, and ideas particularly demand attending to the methodological, philosophical, and ethical stages of the participatory research process (Shuman, 2015).

Perhaps a more commonly identified dilemma in narrative inquiry has been the problem of *what* to select and analyze, as when people are invited to tell their stories, the conversation often develops richly. These concerns, however, extend beyond this particular context, this particular research project, and these particular participants. The question is rather *how* to operate, listen, and interpret the personal accounts of individuals with cognitive characteristics that may restrain their capacity to verbally communicate reflections on past events and future anticipations. Such concerns may have been one of the reasons why I hesitated to include Jaakko in the research process prior to the conference presentation—not because I would not have considered it important, or possible, but because of my own uncertainty regarding *how* to do it.

. . . by Attending to What Goes Unsaid

Instead of focusing on the articulate limitations of the research participants, researchers indeed need to turn focus on *what goes unsaid* (Booth & Booth, 1996). Narrative inquiry offers tools for this, through strategies that construct dialogical interrelationships in and through stories. Furthermore, it has been argued that finding a *metareflexive voice* is a mutual collaborative action, demanding both introspective and intersubjective reflections (Finlay, 2002). For example, one dialogical strategy employed in feminist narrative analysis proceeds on three levels: (a) the literal meaning of the participants' speech as they describe important events, (b) the symbolic meaning of why they believe certain events happened or why they are particularly significant, and (c) the researcher's understanding of the sociocultural environment that connects to the accounts (Sosulski, Buchanan, & Donnell, 2010). In line with this approach, instead of valuing the research process and communication only on the basis of the rational, narrative techniques may offer new possibilities to consider

how the unsaid in stories may be collaboratively evaluated. However, this implies the willingness to accept that the outcome of the dialogues may be different from researcher expectations. In the conference presentation, I may have been unaware of my wishes to hear certain things in Jaakko's accounts, even if—or exactly because— I consider the research as emancipatory. I long envisioned Jaakko as a leader, even though he did not want to be one. This self-reflexive analysis has manifested how not only managing but *allowing for* contingency and uncertainty within narrative work is important, even though it differs from our own preferences and expectations.

Toward Activist Scholarship

The song lyrics that serve as prelude to this article are by a band that has made a considerable impact on the punk music scene in Finland and beyond, raising awareness of whose music, and whose story, counts. The band has also shown how the scripted realities may be disrupted in previously unimaginable ways, by allowing the distorted voice on the stage. The presentation with Jaakko highlighted that participation per se is not necessarily inclusive, at least not without attending to questions regarding the coconstruction and reconstruction of knowledge production: Who are we having these methodological conversations and negotiations with? *Who* is narrating *whose* story? Through reflexively accounting for the mistakes made in my presentation with Jaakko, I have come to the conclusion that the engagement within activist music education requires attending beyond "the reflexive inclusion of the self" (O'Hanlon, 2003, p. 98). In other words, mere reflexivity of my *own* thinking and interpretations does not cater for the *generative dialogue* (Nind, 2014a) that is necessary in order to tune into new ways of constructing third spaces for inclusive knowledge production; instead, it requires negotiating a different type and quality of participation for both myself *and* the research participants. Moreover, such a space cannot be created on the spot but needs to be constructed collaboratively and continually from the onset of the research process.

Instead of selecting particular narrative techniques in order for the participants to *fit into* the researcher's plan, in this article, I draw attention to how disability—or any other society-defined difference—might reshape some of our basic assumptions and methodological approaches in qualitative inquiry. Indeed, sharing the power of academic knowledge production includes broader adjustments between the research goals and research process. These adjustments may demand further, productive unsettling of the tensions between dedicated activism and academic traditions through restoring disagreement and talk-back as an academic value. In practice, this might include, for example, tackling funding gaps through writing courageous funding applications and forming transprofessional research communities with members with nonacademic backgrounds and creative planning of research design, such as applying

arts-based methods, reporting results in different arenas, and producing reports written in plain language. Moreover, to be a credible activist scholar does not require making the decisions independently or holding the sole authorship over research processes. Rather, activist scholarship entails decentralizing power through constructing new spaces for academic knowledge production and research communication.

In sharing my reflections and learning from my mistakes, I hope to challenge scholars in our field to discuss how to include marginalized identities and persons with disabilities, in particular, within music education research practices. It may be argued that the purpose of activist scholarship, after all, is not to make methodological choices in order to *avoid* problems but rather to increase an awareness of methodological opportunities and obstacles and how we may change and shape the ways of how research can be done. The actual process of doing research inclusively in all its levels and messiness demands going beyond what appears to be a safe choice.

Author's Note

I thank Jaakko for giving permission to use his story (and our story) in this article.

This article is a part of a doctoral dissertation project undertaken as part of the ArtsEqual project funded by the Academy of Finland's Strategic Research Council from its Equality in Society program (project no. 293199).

This article is based on a paper presented at Narrative Soundings: The Fifth International Conference on Narrative Inquiry in Music Education (NIME5) at the University of Illinois at Urbana Champaign, May 21–23, 2016.

Contact the author at Sibelius Academy of the University of the Arts Helsinki, PO Box 30, 00097, Taideyliopisto, Finland. (+358) 407104373. tuulikki.laes@uniarts.fi.

Note

1. Performed by Pertti Kurikan Nimipäivät, http://www.pkn.rocks. English translator unknown.

References

Barrett, M., & Mills, J. (2009). The inter-reflexive possibilities of dual observations: An account from and through experience. *International Journal of Qualitative Studies in Education, 22,* 417–429.

Barton, L. (2001). Disability, struggle, and the politics of hope. In L. Barton (Ed.), *Disability, politics, and the struggle for change* (pp. 1–10). London, England: David Fulton.

Biesta, G. (2009). Sporadic democracy: Education, democracy, and the question of inclusion. In M. Katz, S. Verducci, & G. Biesta (Eds.), *Education, democracy, and the moral life* (pp. 101–112). Houten, Netherlands: Springer Media.

Booth, T., & Booth, W. (1996). Sounds of silence: Narrative research with inarticulate subjects. *Disability & Society, 11*(1), 55–70.

Clandinin, D. (2006). Narrative inquiry: A methodology for studying lived experience. *Research Studies in Music Education, 27*(1), 44–54.

Clandinin, D., & Connelly, F. (2000). *Narrative inquiry: Experience and story in qualitative research.* San Francisco, CA: Jossey-Bass.

Clandinin, D., & Raymond, H. (2006). Note on narrating disability. *Equity & Excellence in Education, 39*(2), 101–104.

Depperman, A. (2015). Positioning. In A. De Fina & A. Georgakopoulou (Eds.), *The handbook of narrative analysis* (pp. 369–387). Chichester, England: John Wiley & Sons.

Dobbs, T. (2012). A critical analysis of disabilities discourse in the *Journal of Research in Music Education*, 1990–2011. *Bulletin of the Council for Research in Music Education, 194*, 7–30.

Finlay, L. (2002). Negotiating the swamp: The opportunity and challenge of reflexivity in research practice. *Qualitative Research, 2*(2), 209–230.

Garland-Thomson, R., & Bailey, M. (2010). Never fixed: Modernity and disability identities. In M. Wetherell & C. Talpade Mohanty (Eds.), *The Sage handbook of identities* (pp. 403–417). Los Angeles, CA: Sage.

Gaventa, J. (1980). *Power and powerlessness: Quiescence and rebellion in an Appalachian valley.* Urbana: University of Illinois Press.

Goldsmith, L., & Skirton, H. (2015). Research involving people with a learning disability— methodological challenges and ethical considerations. *Journal of Research in Nursing, 20*(6), 435–446.

Gould, E. (2013). Companion-able species: A queer pedagogy for music education. *Bulletin of the Council for Research in Music Education, 197*, 63–76.

Hesse-Biber, S., & Leavy, P. (2008). Pushing on the methodological boundaries: The growing need for emergent methods within and across the disciplines. In S. Hesse-Biber & P. Leavy (Eds.), *Handbook of emergent methods* (pp. 1–15). New York, NY: Guilford Press.

Hulme, R., Cracknell, D., & Owens, A. (2009). Learning in third spaces: Developing trans-professional understanding through practitioner enquiry. *Educational Action Research, 17*(4), 537–550.

Iacono, T. (2006). Ethical challenges and complexities of including people with intellectual disability as participants in research. *Journal of Intellectual and Developmental Disability, 31*(3), 173–179.

Jenkins, R. (1998). Culture, classification and (in)competence. In R. Jenkins (Ed.), *Questions of competence: Classification and intellectual disability* (pp. 1–24). Cambridge, England: Cambridge University Press.

Juntunen, M-L., Karlsen, S., Kuoppamäki, A., Laes, T., & Muhonen, S. (2014). Envisioning imaginary spaces for musicking: Equipping students for leaping into the unexplored. *Music Education Research, 16*(3), 251–266.

Knox, M., Mok, M., & Parmenter, T. (2000). Working with the experts: Collaborative research with people with an intellectual disability. *Disability & Society, 15*(1), 49–61.

Laes, T., & Schmidt, P. (2016). Teacher activism within music education. Moving towards inclusion and policy change in the Finnish music school context. *British Journal of Music Education, 33*(1), 5–23.

Laes, T., & Westerlund, H. (2017). Performing disability in music teacher education. Moving beyond inclusion through expanded professionalism. *International Journal of Music Education,* Online First: May 14, 2017. doi:10.1177/0255761417703782

Maxey, I. (1999). Beyond boundaries? Activism, academia, reflexivity and research. *Area, 31*(3), 199–208.

McNiff, J. (2006). My story is my living educational theory. In D. J. Clandinin (Ed.), *Handbook of narrative inquiry: Mapping a methodology* (pp. 308–329). London, England: Sage.

Motta, F., Rafalski, J., Rangel, I., & de Souza, M. (2013). Narrative and dialogical reflexivity: An approach between writing and inner speech. *Psicologia: Reflexao e Critica, Porto Alegre, 26*(3), 609–616.

Nichols, J. (2013). Rie's story, Ryan's journey: Music in the life of a transgender student. *Journal of Research in Music Education, 61*(3), 262–279.

Nichols, J. (2016). Sharing the stage: Ethical dimensions of narrative inquiry in music education. *Journal of Research in Music Education, 63*(4), 439–454.

Nind, M. (2014a). Inclusive research and inclusive education: Why connecting them makes sense for teachers' and learners' democratic development of education. *Cambridge Journal of Education, 44*(4), 525–540.

Nind, M. (2014b). *What is inclusive research?* London, England: Bloomsbury.

Oakes, J., & Rogers, J. (2006). *Learning power: Organizing for education and justice.* New York, NY: Teachers College Press.

O'Hanlon, C. (2003). *Educational inclusion as action research: An interpretive discourse.* Berkshire, England: Open University Press.

Ollerton, J. (2012). IPAR, an inclusive disability research methodology with accessible analytical tools. *International Practice Development Journal, 2*(2), 3. Retrieved from http://www.fons.org/library/journal.aspx

Patel, L. (2016). *Decolonizing educational research: From ownership to answerability.* New York, NY: Routledge.

Schwandt, T. (1994). Constructivist, interpretivist approaches to human enquiry. In N. Denzin & Y. Lincoln (Eds.), *Handbook of qualitative research* (pp. 118–137). Newbury Park, CA: Sage.

Seale, J., Nind, M., Tilley, L., & Chapman, R. (2015). Negotiating a third space for participatory research with people with learning disabilities: An examination of boundaries and spatial practices. *European Journal of Social Science Research, 1*(4), 483–497.

Shuman, A. (2015). Story ownership and entitlement. In A. De Fina & A. Georgakopoulou (Eds.), *The handbook of narrative analysis* (pp. 38–56). Chichester, England: John Wiley & Sons.

Smith, B., & Sparkes, A. (2008). Narrative and its potential contribution to disability studies. *Disability & Society, 23*(1), 17–28.

Stauffer, S. L., & Barrett, M. S. (2009). Narrative inquiry in music education: Toward resonant work. In M. Barrett & S. Stauffer (Eds.), *Narrative inquiry in music education: Troubling certainty* (pp. 19–29). Dordrecht, Netherlands: Springer.

Sosulski, M., Buchanan, N., & Donnell, C. (2010). Life history and narrative analysis: Feminist methodologies contextualizing Black women's experiences with severe mental illness. *Journal of Sociology & Social Welfare, 37*(3), 29–57.

Sudbury, J., & Okazawa-Rey, M. (2009). Introduction: Activist scholarship and the neoliberal university after 9/11. In J. Sudbury & M. Okazawa-Rey (Eds.), *Activist scholarship: Antiracism, feminism, and social change* (pp. 1–14). New York, NY: Routledge.

Walmsley, J., & Johnson, K. (2003). *Inclusive research with people with learning disabilities: Past, present, and futures.* London, England: Jessica Kingsley.

Companion-able Species: A Queer Pedagogy for Music Education

Elizabeth Gould
University of Toronto
Toronto, Ontario, Canada

What might the "coming out" of LGBTQ studies in music education mean for the profession? How might we interact with each other, enacting a pedagogy based not on a discourse of inclusion situated in terms of identities that necessitate exclusion, but one holding each other in regard, meeting face to face, as companion-able species? What makes lives mundane in affect yet consequential in effect is integral to a queer pedagogy that would seek to create (music-al) lives worth living. As a "category-in-question," Donna Haraway's (2008) concept of "companion species" acknowledges difference in the context of conjoined processes of bodily worldly entanglements. I add the suffix -able to underscore underlying affection and active participation requisite for the relationality in which we all take part. We are messmates at table, the terms of which do not exist a priori, but which we co-create—a table at which all are guests and no one is host. Rather than "including" queer perspectives in straight music education, a queer pedagogy of companion-able species opens spaces for co-creating a contingent, dynamic table where music education messmates might commit to practices of regard and response in ways that compel us to learn from and with each other in the context of humility, doubt, and respect, using felt, as opposed to sufficient, reason.

Nearly twenty years ago, Gregory Bredbeck (1995) embarked on what he characterized as "a relatively bleak project: describing the impossibilities of a queer pedagogy" (p. 169). Remarking on Teresa de Lauretis's (1990) remark on Luce Irigaray's (1985) distinction between homosexuality and hommo-sexuality, a pun on the French word

From *Bulletin of the Council for Research in Music Education*, No. 197 (2013), pp. 63–75.

for man: *homme*, the Latin word for man, *homo*, and the Greek word for same, *homo*, Bredbeck trenchantly observed,

> In each "classroom," homosexuality is erased by hommo-sexuality; the presence of one self-reproductive gender (male) subsumes both gender difference and sexual difference; . . . spreading the word of *one* gender: man without end, (a)men. In this classroom, the hommo-social woman can be nothing but a reproductive less-than-man, the gay man can be nothing but a differently reproductive man, and the lesbian, I am afraid, can be nothing at all. The frame of the classroom has a function . . . in which any difference only perpetuates sameness. . . . The hommo-sexuality of the heterosexual that marks this supposedly different practice subsumes anything that is not the same and reproduces any difference as indifference. (1995, p. 172, emphasis in original)

In other words, regardless of what or how we teach, we introduce and accept difference in the classroom only to the extent that it is the same, which is to say that it is *in*different. Outcomes of queer pedagogy, then, are nothing more than "the reproduction of reproduction, the reproduction of sameness" (p. 178).

Consistent with critical theory, Bredbeck offers a solution to demystify the hegemony of hommo-sexuality by foregrounding that the classroom is always already hommo-sexual. He admits that his solution is a "Pollyannish project" dependent on the fallacy of Marxist analysis that equates quality with quantity by which the former changes by increasing the latter. Through an unknown and ultimately unknowable alchemy, the sheer weight of continuously using queer pedagogy nevertheless reproducing sameness would eventually render sameness itself queer. Monique Wittig, also in the frame of Marxist analysis, attempted with her novel *Les Guérillères* (1971) a very similar project to make the specific (homosexuality) general (heterosexuality), not so that heterosexuals might experience the world as homosexuals, but so that homosexuality was the only, hence universal, perspective by which to experience the world (Zerilli, 2005). Both, of course, were utopian projects, like my lesbian imagination (Gould, 2007), flawed but necessary to the extent of articulating potentialities. Other theorists (e.g., Britzman, 1995; Breen, 1998; Quinlivan & Town, 1999) did take up queer pedagogy rather more hopefully during the lesbian chic (Cottingham, 1996) 1990s,[1] and the "coming out" now of LGBTQ studies in music education, however belatedly, presents opportunities to explore potentialities of a queer pedagogy of companion-able species. Using felt—as opposed to sufficient—reason, I address how we might interact with each other in music education, how we might enact pedagogies based not on inclusion, but on holding in regard, meeting face to face, as significant others. Relinquishing our collective obsession with a pervasive discourse of inclusion that relies on bringing "others" to the profession as it currently exists, what I conceive as its pre-existing table, enables us to co-create together a contingent, dynamic table of potentialities deployed as a queer pedagogy for music education.

At the Children's Table

This particular discourse of inclusion demarcates a space in which to enter (articulated in music education multicultural discourses as "world music" and in equity discourses as "add women/queers/people of color and stir"), establishing an *inside* and *outside*. The terms are positioned dualistically not only because inside is preferred to outside, but because inside depends on outside in that outside is defined as not-inside, even while inside distances itself from outside by denying any similarity to outside and seeing all outsides as the same (Plumwood, 1993).[2] Based on a complex hierarchy of inferiorization that is not contingent and open to contestation or change, dualisms are never neutral, natural, or innocent. They are institutionalized by and through systems of power, accumulating historically so that "old" dualisms may be mobilized to form "new" ones. For example, Plato's reason/emotion dualism makes way for Descartes' mind/body dualism makes way for Marx's mental/manual dualism, "form[ing] a web or network" (p. 45) of interlocking and mutually reinforcing systems of domination held together by both common sense and philosophical assumptions. Inasmuch as they function in these systems in both cultural and material worlds, dualisms enjoin dualistic types of social structures supported by similarly dualistic ways of thinking. The discourses and practices of the dualistic space of music education privilege heterosexuality to the *exclusion* of dissident sexualities,[3] what I refer to here to as *queerness*.

A highly contested and extremely unstable term, I use *queer* in ways that are simultaneously sexual *and* political.[4] Related to sexuality, queer is "a refusal to inherit" (Ahmed, 2006, p. 178) all that compulsory heterosexuality bequeaths in the narratives and socioeconomic relations by which we live—for instance, kinship ties, inheritance laws, property and housing rights, compensation packages, public washrooms, musicianness and musicalities—and their effects "on those who refuse to be compelled" (p. 172). Politically, queer is performative, "an effect of how we do politics" that extends beyond making the "'familiar' strange, or even to allow that which has been overlooked . . . to dance with renewed life" (p. 177). As a hopeful politics of critique "shaped by the prior matter of simply how we live . . . queer [is] a commitment to an opening up of what counts as a life worth living" (p. 178), and hence opens potentialities of Donna Haraway's (2008) concept of *respecere,* to hold in respect and regard. My concept of queer is not synonymous with "gay" (Whitlock, 2010) or even "lesbian," "bi," or "trans," and cannot be juxtaposed dualistically with "straight," because to do so would strip it of its—queerness. Rather than claiming transcendental status for queer, I posit it as a contingent concept to open, in the Deleuzean (1994) sense, the problematic field of thinking beyond dualisms.[5]

Consistent with dualistic thinking and faithful to dualistic space, *inclusion* discourses in always already heterosexual music education pedagogies (and curricula) occur in one of two ways: by *devouring* queerness (Plumwood, 1993) or by *eating* it (hooks, 1992).[6] Devouring obliterates or incorporates queerness, which nevertheless

extinguishes it: "both in use (in commodification) and in non-use, as whatever cannot be made use of, commodified, represented in the market, whatever still dares to assert difference, is destroyed" (p. 193). This concept of commodification also implicates bell hooks's concept of "eating the Other."

As a form of thrill-seeking, eating queerness involves heterosexual music education consuming but not destroying aspects of queerness, such as its style and political aesthetic, so that the "intense pleasure," adventure, and political cache experienced by consuming it may be enjoyed again and again. hooks notes how this is expressed in advertising where

> encounters with Otherness are clearly marked as more exciting, more intense, and more threatening. . . . In the cultural marketplace the Other is coded as having the capacity to be more alive, as holding the secret that will allow those who venture and dare to break with the cultural [inability to experience pleasure] . . . and experience sensual and spiritual renewal. (1992, p. 26)

Similarly, just four years after she coined the term *queer theory* in an effort to unsettle the terms *lesbian* and *gay* and the theoretical studies to which they were attached as an "established and convenient . . . formula" (de Lauretis, 1991, p. iv), Teresa de Lauretis observed that the "marketing trend [of] 'queer theory' . . . has quickly become a conceptually vacuous creature of the publishing industry" (1994, 316).[7] Those who seek encounters commodifying—eating—the Other, however, do so not as a means of exploitation, according to hooks, but to "become the Other." Indeed, eating queerness not only became "hip" in the 1990s, but is now "all the rage" (Walters, 2001), demonstrated in the normalization of gay and lesbian life in Canada, the United States, and Europe. That "everyone wants the opportunity to be queer" (Brownworth, 1997) renders queer straight. The concept of *straight queer*,[8] "that testy love child of identity politics and shifting sexual norms" (Powers, 1993, p. 30), emerged as a signifier for heterosexuals who, intent upon so-called edginess (expressed most conservatively in the slogan "Straight But Not Narrow"), deploy queer signs that are then "neutralized by heterosexual signs, thus recuperating the ideological dominance of a heteronormative culture" (Rahman, 2004, para. 18).

The straight queer, "urban, bold, . . . postmodern . . . *can* be sexually transgressive" (Hawkins, 2006, p. 282, emphasis added), and challenges everything—sexual or otherwise—considered to be proper. As an all-purpose signifier of transgression, straight queer deploys "a romantic construction of the artist" as outsider situated in a so-called "queer/artistic nexus" (Mayhew, 2006, pp. 182, 169 respectively). Musicians, as a function of their deviance in Western society (Brett, 2006), and rock musicians in particular, with their "position as rebel and provocateur . . . [are] given artistic license and freedom to pursue taboo subjects and behave outside the norm" (Mayhew, 2006, p. 182). Having everything to do with generalized transgression and nothing to do with queer politics, however, straight queer musicians "heterosexualize

. . . the music industry" (Hawkins, 2006, p. 289) even as they present themselves as "vaguely gay" (Hall, 2005). Indeed, Pink comments without apparent irony, "I should be gay by the way that I look and the way that I am. I just happen to not be," as she takes ownership of her fans, those "adorable little gay girl couples and gay boys," declaring, "I've had a lot of my gay boys around, but my gay girls are my rootstalk" (Pink, quoted in Anderson-Minshall, 2012, p. 5). Like the so-called "White Negro" of the 1950s, white people who wanted to be black, straight queers, including those writing so-called straight queer theory (Heasley, 2007; Thomas, 2008), "want to be part of the gay culture, expatriates from the straight world" (Kamp, 1993, p. 78).

> What are the implications involved in claiming "queerness" when one is not gay or lesbian? And would we tolerate this passing . . . in another context, say the context of race or ethnicity? If it is clearly co-optive and colonizing for the white person to claim blackness if she or he "feels" black (or even feels aligned politically with the struggles against racism), then why is it so strangely legitimate for a heterosexual to claim queerness? . . . The white academic says she is working on antiracism and on issues of race and ethnicity; the straight (most often white) academic says she (or he, more often) is queer. (Walters, 2005, pp. 10–11, emphasis in original)

Neither innocent, nor without consequences, constructing queerness "in order to define straightness" (Hawkins, 2006, p. 282) dis-embodies musicians rather more literally than Philip Brett (2006) could have imagined with his now-famous declaration, "*All* musicians, we must remember, are faggots" (pp. 17–18, emphasis in original)—or dykes.

Dualistic spaces depend upon the active participation of everyone they affect, implicating all of us in heterosexism. There is no oppression, no discrimination without those who enforce it and those who experience it—whether as acceptance or resistance. The former is achieved by taking on characteristics of heterosexual society as an illusion of security. By making lesbians safe, or at least nonthreatening, Ellen DeGeneres is perhaps the most obvious example of acceptance. Resistance, by contrast, brings into stark relief the very terms by which dualistic spaces are defined and sustained. My own self-described acts of resistance, such as this philosophical essay, legitimate music education as "open" to LGBTQ studies even as the profession marginalizes and ignores it, or at the very least, tolerates it without taking it seriously. Like the indifference of the sexual difference of hommo-sexuality that renders difference as sameness for Bredbeck, the exclusive desire for the discourse of inclusion in the context of acceptance or resistance renders queerness as straightness. Rather than inclusion on these terms, I suggest that we, in ways that are outrageously queer—in the sense of *outrage* that "engag[es] the Other and ourselves . . . substantively and meaningfully . . . based on difference and dissent" (Gould, 2008, p. 41), confront what terrifies

us: exclusion—at the children's table. Haraway's concept of companion species provides a lens for examining this terror.

Messmates

Distinguishing *companion animals* from *companion species* as "messmates at table," Haraway (2008) underscores her concept of the latter as neither posthumanist nor postfeminist, but "rambunctious, . . . less a category than a pointer to an ongoing 'becoming with'"[9] in which the "partners do not precede their relating" (p. 16, p. 17), but are, in performative terms, effects of becoming. For *companion,* Haraway draws on the Latin *cum panis,* "with bread," and asserts, "Messmates at table are companions"—who "consort, . . . with sexual and generative connotations always ready to erupt" (p. 17). By comparison, political companions are *comrades,* while business and commercial associates form *companies.* For *species,* Haraway draws on the Latin *specere,* "to look" and "to behold." With usages in logic that conflate thinking with seeing, and in biology classifying individuals in "the dance linking kin and kind" (p. 17) even as biotechnology undoes those very classifications, what is at stake for Haraway is how we decide which "companion species will, and should, live and die" (p. 18). More relevant to this discussion, with usages related to extinction in environmental and conservation discourses that are also deployed in colonialist discourses of "the always vanishing indigene" (p. 18), as well as racialized discourses of African American men, juxtaposed with essentialist discourses of woman's reproductive imperative to carry on—the species, and postcolonial critiques of humanism's dualistically positioning all Others to rational man, the term *species* fairly "reeks of race and sex" (p. 18). In all of this bodily messiness, the relationality of messmates at table, Haraway notes the necessity of companion species to "learn to live intersectionally" (p. 18), joyfully playing a "game of response and respect" (p. 19) in which human exceptionalism, Haraway's primary concern, does not prevail. Consequently, "no one gets to be Man" (82)—which is to say, no one gets to set the rules by which everyone else must play—and live—in the world as well as in the profession of music education.

The game Haraway and Australian shepherd Ms. Cayenne Pepper play is the sport of agility. Played by paired canine and human participants running the course together side by side, agility requires high levels of skill and intense in-the-moment nonverbal, sight-based interaction between the players. This is achieved only through extended training—in which both players learn from and with each other. Haraway (2003) describes her and Cayenne's relationship in *The Companion Species Manifesto.*[10]

> We have had forbidden conversation; we have had oral intercourse; we are bound in telling story upon story with nothing but the facts. We are training each other in acts of communication we barely understand. We are, constitutively, companion species. We make each other up, in the flesh.

Significantly other to each other, in specific difference, we signify in the flesh a nasty developmental infection called love. This love is an historical aberration and a naturalcultural [*sic*] legacy. (Haraway, 2003, pp. 2–3)

The game I and orange tabby Mr. Hoback Canyon played was "catch the kitty," in which he would leap several feet straight up so that I would catch him, turn him on his back in my arms, and bury my face in his tummy. One of many games that he invented and taught me, "catch the kitty" quickly became our favorite and was certainly the most enduring. Hoback first admitted[11] Carol (my spouse since 1990) and me into his life 18 years ago when he was about four months old. Although spectacularly enthusiastic, his invitation was issued gradually. I cannot say with any certainty when or how he taught us "cat," but I do know that Hoback, "colonize[d] all my cells" (Haraway, 2003, p. 1), and that Carol's and my adoration for him most certainly "signif[ied] . . . a nasty developmental infection called love." His relationship with us was, I think, predicated on familiarity and pleasure, achieved through sight and touch. Our hands were mostly irrelevant. Beyond scratching and petting, curling up in my lap, or even sleeping every night in my arms, what Hoback clearly wanted most was to touch our faces with his. Rubbing faces was integral to our greeting ritual, mutual grooming activities, and bedtime routine. We beheld each other in regard and respect, unmediated by language in "our oral communication" as companion species—not one *to the* other, Hoback to Elizabeth, but one *and each* other, Hoback and Elizabeth.

A Queer Pedagogy

Haraway's concept of companion species acknowledges and accounts for difference in the conjoined processes of bodily worldly entanglements. In the context of music education, I add the suffix *-able*, creating *companion-able species,* to underscore underlying affection and active participation required for the "optic/haptic/affective/cognitive touch" (2008, p. 164) constitutive of this *"dance of relating"* (p. 25, emphasis in original) in which we take part as music educators "in the company of significant others. . . . This is not romantic or idealist but mundane and consequential in the little things that make lives" (p. 93). Mundane in their affect yet consequential in their effect, "the little things that make lives" are integral for a queer pedagogy that seeks to create music-al lives worth living. This queer pedagogy of companion-able species is not "seduced by the emphasis on Otherness, by its commodification, because it offers the promise of recognition and reconciliation" (hooks, 2002, p. 26) through, I suggest, discourses of pity and pathology as currency for acceptance and assimilation. Refusing normalizing practices, and beginning

> with an ethical concern for one's *own* reading practices, one that is interested in exploring what one cannot bear to know, one interested in the imagining of a sociality unhinged from the dominant conceptual order [a queer peda-

gogy of companion-able species] is built from the possibility that reading the world is always already about risking the self, and about the attempt to exceed the injuries of discourse so that all bodies matter. (Britzman, 1995, p. 165, emphasis in original)

It is not a project to "include" queerness or queer perspectives in the form of LGBTQ studies in straight music education. Instead of including, gathering in, a queer pedagogy of companion-able species opens up spaces for co-creating a vital, always in process table, where all are guests and no one is host, a table where music education messmates commit to practices of regard and response, *respecere,* in ways that compel us to learn from and about each other in the context of humility and doubt. Lesbian desire, as described by feminist musicologist Suzanne Cusick (2006) in her "serious attempt not to think straight,"[12] seems to me to provide a way of thinking about the play integral to co-creating a continuously self-evolving table.

Asserting that all relationships are negotiated in terms of power, Cusick argues that women, because they are constructed in Western society's sex/gender system as non-power-full, are more likely to create with women relationships in which power flows freely between partners, as "no one [is] in the position—power full, worth full—[un]marked 'man'" (p. 72).[13] Enacting sexuality's "power/pleasure/intimacy triad" in ways that subvert the man/woman dualism, lesbians mix and alter both categories,

> *playing* with them in a game in which everyone can play every position, everyone is expected to pay the closest possible attention to how everyone else is playing, and no one (if you play it well) accumulates the power of a social man. [Indeed], the pleasure of the game is living in a world free of fixed categories. (p. 73, emphasis in original)

As a queer pedagogy for music education, a queer pedagogy of companion-able species, lesbian desire expresses potentialities of play itself made—endlessly—queer.

Radical lesbians of the 1970s, singer-songwriters such as Meg Christian, Cris Williamson, and even Holly Near, provide examples of a queer pedagogy actualized. Grappling with unmitigated discrimination in all facets of their lives, but particularly in their forced exclusion from the rock music scene and recording industry, they co-created within community their own record labels (Kearney, 1997).[14] Composing, producing, and performing their own (mostly) acoustic music initially in women-only spaces that were themselves predicated on access, they were among the first performers to place American Sign Language interpreters on stage. They also made arrangements to provide free child care, and insisted on wheelchair ramps, and accessible seating and washrooms in the venues where they rehearsed and performed together and with lesbians of color such as Linda Tillery and Mary Watkins, as well as the iconic feminist, straight-identified, African American a cappella ensemble Sweet Honey in the Rock. Although their attempts to cross over to the so-called musical mainstream

almost uniformly failed (Holly Near, having achieved success in the antiwar and human rights movements, is perhaps the most well-known exception), their musical and political activities carried far-reaching effects that inspired the activism of younger women, and helped open the game of performing and recording popular music to 1980s lesbian performers Melissa Etheridge, Tracy Chapman, and Suzanne Vega (Gaar, 2002) and, I would argue, Ellen DeGeneres.

That lesbian performers can serve as models for a queer pedagogy in music education is provocative but appropriate, because the ethics of presence by which they appear signals the urgency for co-creating a transitioned and transitioning table in music education that would not only enable music-al lives worth living, but queer lives worth living musically in the world, as it expresses outrage to confront the terror of gender nonnormative students in all of our classrooms who are quite literally dying. While we often know the names of white queer people who die, I call the names of queer people of color which are, by comparison, almost unspoken in the mainstream press. For example, Aiyisha Hassan, previously a biology student at historically black Howard University, struggling with expressing her sexuality (Najafi, 2010), committed suicide in 2010 less than a month after violinist Tyler Clementi's well-documented suicide. Sakia Gunn, an African American student attending Newark, New Jersey's Westside High School, was murdered in 2003 while waiting for a bus—reportedly for rebuffing the attention of two African American men by stating the obvious, that she and her girlfriends were lesbians. Not only was her murder minimally and inaccurately reported by the mainstream press (Cogswell & Simo, 2003), Charles Bennett Brack's documentary, *Dreams Deferred: The Sakia Gunn Film Project* (2008), distributed by Third World Newsreel, like Sakia Gunn herself, is virtually unknown—particularly in comparison to Moisés Kaufman's HBO film (2002) of his play *The Laramie Project* (2000), written in response to the widely reported 1998 murder of Matthew Shepherd. Shepherd's very name is now synonymous with hate crimes committed against (white) queer people.

This terror demands our outrage as music educators as a queer pedagogy, all the more so because in adulthood it clearly does not "get better." The hommo-sexual table just gets bigger, providing more seats for cover, from where, we "like good late-capitalist consumers, . . . persuade ourselves that deciding what we like or don't like about what's happening is the same thing as actually intervening in its production" (Sedgwick, 1993, pp. 132–133). Prevalent in education discourse generally and music education discourse specifically, the claim, "It gets better"—without ever articulating exactly what "it" is—is patently false, as demonstrated not only by Matthew Shepherd's murder, but by the 1988 murder of Rebecca Wight, a lesbian of Iranian and Puerto Rican descent, whose death again is practically unknown to the general public, despite publication of the book *Eight Bullets: One Woman's Story of Surviving Anti-Gay Violence* (1995), written by Claudia Brenner, Wight's lover who survived

the attack, and Brenner's subsequent gay rights activism (Graf, 1995). Moreover, the implicit racism of the "It Gets Better" project (Grisham, 2012) speaks specifically to an upwardly mobile, able-bodied, white male "exceptional class of aspirational gay citizens at the expense of others" (Puar, 2010, para. 4), most notably those who are "queer people of colour, trans, genderqueer and gender nonconforming, . . . and lesbians" (para. 5). Defining the issue exclusively in terms of a masculinist version of bullying, "as if every queer child is sad, alone and isolated and pondering a hard choice between everyday violence and suicide" (Halberstam, 2010, para. 2), is overly reductive. In addition to glossing the myriad of factors contributing to suicide, particularly for students of color, survivors of sexual abuse, and teenage mothers, "it gets better" discursively reinscribes sexual and gender norms.

Those of us who perpetuate the bullying narrative—"media, anti-bullying groups, teachers, university professors—deal the final blow" (Whitlock, 2010, 100), metaphorically, of course, as we attempt to "make it better."[15] Perhaps most relevant and important, "it gets better" is constructed dualistically, and locates bullying as a matter of personal responsibility—that of bullies and bullied, placing the burden of survival on the latter in a pedagogy that is decidedly not queer, no matter how it is defined. Ignoring systemic racism, sexism, homophobia, discrimination, and violence in society and music education generally, directed against nonnormative bodies specifically, contributes to the normalizing function of "it gets better," ensuring that it gets better only for those who can *be* better, which is to say, "normal."

Central to any queer pedagogy, particularly one for music education in which performance is integral, are various forms of political activism carried out publically, in the street. Self-described "queer activist writer" Eve Sedgwick (1993)—not queer-identified, but performatively queer, and companion-able—describes a "sedate" demonstration in which she took part against the University of North Carolina PBS television station because of its refusal to broadcast Marlon Riggs's film *Tongues Untied*, a semi-documentary about racism and homophobia faced by black gay men. The demonstrators' goals consisted of shaming the public station for deliberating excluding a constituent part of the public, while smuggling those very bodies into public space—if mostly referentially, as the majority of demonstrators were not black themselves, and many, like Sedgwick, also were not gay or male—through placards and chants such as "'We're here, we're queer, and we won't pledge this year,' or, better, 'Snap! Snap! Snap! What is this racist crap?'" (p. 124). These "complex acts" of speech and visibility constituted a queer pedagogy that has been

> incalculably powerful in the politics of the electorate, of the media, of the space of the streets—powerful *for* us; powerful when used *against* us; powerful in ways we can never expect fully to control; but to which, for a politicized body of queer, queer-loving, and anti-homophobic citizens, scholars, teachers, there is very starkly no alternative. (p. 134, emphasis in original)

Politicizing the body of music education to move thinking beyond identities on which inclusion depends may initiate the play of a queer pedagogy of companion-able species co-creating a table at which all are present as a matter of our ethics and safe as an effect of their materiality.

Author's Note

An earlier, shorter version of this paper was presented at the conference, The Second Symposium on LGBT Studies and Music Education held at the University of Illinois-Urbana/Champaign, October 18–19, 2012.

Notes

1. For a succinct review of that research in education, see Whitlock, 2010.

2. For a detailed discussion of this in music education, see Gould, 2008.

3. As I will argue, the material reality of exclusion provides the impetus for a discourse of inclusion that includes homosexuality only to the extent that it excludes it.

4. Alexander Doty (1993) describes in detail rhetorical struggles with the concept of queer that to this day remain largely unresolved. For an extended discussion in music education, see Gould, 2009.

5. For a detailed discussion of this in music and music education, see Gould, 2007.

6. For an extended discussion of this in terms of democracy and music education, see Gould, 2008.

7. Criticisms of queer theory summarized as "male-centered, anti-feminist, and race-blind" (Sullivan, 2003, p. 48) are salient, but beyond the scope of my argument. Rather than engaging them directly, I argue that may be deployed in ways that address these concerns.

8. Although she reverses the terms as "queer straight," Annette Schlichter (2007) provides an overview of what she calls "the discourse of queer heterosexuality" (p. 189).

9. See Vinciane Despret (2004). This is unrelated to Gilles Deleuze and Félix Guattari's (1987) concept, *becoming*.

10. To be clear, Haraway is neither sentimental nor romantic about her relations with any animal. She most emphatically does not anthropomorphize Cayenne's behaviours, and she is not a vegetarian. She is deeply concerned with catastrophic effects of human exceptionalism—for animals, the world, and not incidentally, humans.

11. As opposed to dogs who submit themselves to our lives (a characterization with which Haraway, I believe, would not disagree) I argue that cats admit us into their lives. This is not to imply, however, that one way of interacting is preferable to the other, or that this is voluntary or a matter of choice for all three species.

12. For a more complete discussion, see Gould, 2005.

13. As a function of the concept, *whiteness*, all social groups in Western society who deviate from the expected, hence unmarked, white, Christian, heterosexual man, are marked as a function of their difference. See Chambers, 1997, for a more complete discussion, and Gould, 2005, for a discussion specific to music and music education.

14. Wax Records released Alix Dobkin's *Lavender Jane Loves Women* in 1972, while Olivia Records, founded the next year, was "the most famous and longest-lasting of lesbian

separatist businesses" (Kearney, 1997, p. 219). Holly Near's label, Redwood Record, also founded in 1973, was always inclusive of men and human rights issues generally.

15. The good intentions of these efforts, one of which I participated in at the University of Toronto, are not to be discounted, but they represent an example of doing something—anything—regardless of its effectiveness.

References

Ahmed, S. (2006). *Queer phenomenology: Orientations, objects, others*. Durham, NC: Duke University Press.

Anderson-Minshall, D. (2012). The truth about Pink. *The Advocate*. Retrieved from http://www.advocate.com/print-issue/current-issue/2012/10/16/truth-about-pink?page=0,0

Bredbeck, G. W. (1995). Anal/yzing the classroom: On the impossibility of a queer pedagogy. In G. E. Haggerty & B. Zimmerman (Eds.), *Professions of desire: Lesbian and gay studies in literature* (pp. 169–180). New York, NY: The Modern Language Association of America.

Breen, M. S. (1998). "Falling into a place": Reading for renewal as queer pedagogy. *International Journal of Sexuality and Gender Studies, 3*(3), 233–244.

Brett, P. (2006). Musicality, essentialism, and the closet. In P. Brett, E. Wood, & G. C. Thomas (Eds.), *Queering the pitch: The new gay and lesbian musicology* (2nd ed., pp. 9–26). New York, NY: Routledge.

Britzman, D. (1995). Is there a queer pedagogy? Or, stop reading straight. *Educational Theory, 45*(2), 151–165.

Brownworth, V. A. (1997). On publishing: Opportunistically queer. *Lambda Book Report, 5*(8). Retrieved from http://proquest.umi.com.myaccess.library.utoronto.ca/pqdweb?did=582263641&sid=2&Fmt=3&clientId=12520&RQT=309&VName=PQD

Chambers, R. (1997). The unexamined. In M. Hill (Ed.), *Whiteness: A critical reader* (pp. 187–203). New York, NY: New York University Press.

Cogswell, K., & Simo, A. (2003, June 6). Erasing Sakia: Who's to blame? *The Gully Online Magazine*. Retrieved from http://www.thegully.com/essays/gaymundo/030606_sakia_gunn_murder.html

Cottingham, L. (1996). *Lesbians are so chic . . . that we're not really lesbians at all*. New York, NY: Cassell.

Cusick, S. G. (2006). On a lesbian relationship with music: A serious effort not to think straight. In P. Brett, E. Wood, & G. C. Thomas (Eds.), *Queering the pitch: The new gay and lesbian musicology* (2nd ed., pp. 67–83). New York, NY: Routledge.

de Lauretis, T. (1990). Sexual indifference and lesbian representation. In S.-E. Case (Ed.), *Performing feminisms: Feminist critical theory and theatre* (pp. 17–39). Baltimore, MD: Johns Hopkins University Press.

de Lauretis, T. (1991). Queer theory: Lesbian and gay sexualities: An introduction. *differences: A Journal of Feminist Cultural Studies, 3*(2), iii–xviii.

de Lauretis, T. (1994). Habit changes. *Response*. In E. Weed & N. Schor (Eds.), *Feminism meets queer theory* (pp. 315–333). Bloomington, IN: Indiana University Press.

Deleuze, G. (1994). *Difference and repetition*. (P. Patton, Trans.). New York, NY: Columbia University Press. (Original work published 1968)

Deleuze, G., & Guattari, F. (1987). *A thousand plateaus: Capitalism and schizophrenia*. (Brian Massumi, Trans.). Minneapolis, MN: University of Minnesota Press. (Original work published 1980)

Despret, V. (2004). The body we care for: Figures of anthropo-zoo-genesis. *Body and Society, 10*(2), 111–134.

Doty, A. (1993). *Making things perfectly queer: Interpreting mass culture*. Minneapolis, MN: University of Minnesota Press.

Gaar, G. G. (2002). *She's a rebel: The history of women in rock and roll* (expanded 2nd ed.). New York, NY: Seal Press.

Gould, E. (2005). Desperately seeking Marsha: Music and lesbian imagination. *Action, Criticism, and Theory for Music Education, 4*(3), Retrieved from http://www.maydaygroup .org/articles/Gould4_3.pdf

Gould, E. (2007). Thinking (as) difference: Lesbian imagination and music. *Women and Music: A Journal of Gender and Culture, 11*, 17–28.

Gould, E. (2008). Devouring the other: Democracy and music education. *Action, Criticism, and Theory for Music Education, 7*(1). Retrieved from http://act.maydaygroup.org /articles/Gould7_1.pdf

Gould, E. (2009). Dis-orientations of desire: Music education queer. In T. Regelski & J. T. Gates (Eds.), *Music education for changing times: Guiding visions for practice* (pp. 59–72). Dordrecht, The Netherlands: Springer.

Graf, E. J. (1995). Safe is nowhere. *The Progressive, 59*(8), 42–43.

Grisham, K. (2012, February 28). From one white gay male to another: Calling out the implicit racism in Dan Savage's "Liberal" politics and the "It gets better" campaign. *The Feminist Wire*. Retrieved from http://thefeministwire.com/2012/02/from-one -white-gay-male-to-another-calling-out-the-implicit-racism-in-dan-savages-liberal -politics-the-it-gets-better-campaign/

Halberstam, J. J. (2010). It gets worse. . . . *Social Text*, Periscope, Queer suicide: A teach-in. Retrieved from http://www.socialtextjournal.org/periscope/2010/11/it-gets-worse.php

Hall, D. E. (2005). A brief, slanted history of "homosexual" activity. In I. Morland & A. Willcox (Eds.), *Queer theory* (pp. 96–114). New York, NY: Palgrave Macmillan.

Haraway, D. (2003). *The companion species manifesto: Dogs, people, and significant otherness*. Chicago, IL: Prickly Paradigm Press.

Haraway, D. (2008). *When species meet*. Minneapolis, MN: University of Minnesota Press.

Hawkins, S. (2006). On male queering in mainstream pop. In S. Whiteley & J. Rycenga (Eds.), *Queering the popular pitch* (pp. 279–294). New York. NY: Routledge.

Heasley, R. (2007, August 11–14). But you're so queer for a straight guy! Affirming complexities of gendered sexualities in men. Paper presented at the 102nd meeting of the American Sociological Association, New York, NY.

hooks, b. (1992). *Black looks: Race and representation*. Boston, MA: South End Press.

Irigaray, L. (1985). *Speculum of the other woman*. (G. C. Gill, Trans.). Ithaca, NY: Cornell University Press. (Original work published 1974)

Kamp, D. (1993, July). The straight queer. *Gentlemen's Quarterly, 63*, 94–99.

Kearney, M. C. (1997). The missing links: Riot grrrl—feminism—lesbian culture. In S. Whiteley (Ed.), *Sexing the groove: Popular music and gender* (pp. 207–229). New York, NY: Routledge.

Mayhew, E. (2006). "I am not in a box of any description:" Sinéad O'Connor's queer outing. In S. Whiteley & J. Rycenga (Eds.), *Queering the popular pitch* (pp. 169–184). New York, NY: Routledge.

Najafi, Y. (2010, October 13). Mourning at Howard [updated]. *Metro Weekly*. Retrieved from http://www.metroweekly.com/news/?ak=5654

Plumwood, V. (1993). *Feminism and the mastery of nature*. New York, NY: Routledge.

Powers, A. (1993, June 29). Queer in the streets, straight in the sheets. *Village Voice*, p. 30.

Puar, J. (2010). In the wake of It Gets Better. *The Guardian*. Retrieved from http://www.guardian.co.uk/commentisfree/cifamerica/2010/nov/16/wake-it-gets-better-campaign

Quinlivan, K., & Town, S. (1999). Queer pedagogy, educational practice and lesbian and gay youth. *International Journal of Qualitative Studies in Education, 12*(5), 509–524.

Rahman, M. (2004). Is straight the new queer? David Beckham and the dialectics of celebrity. *M/C Journal, 7*(5). Retrieved from http://journal.media-culture.org.au/0411/rahman.php

Schlichter, A. (2007). Contesting "straights": "Lesbians," "queer heterosexuals" and the critique of heteronormativity. *Journal of Lesbian Studies, 11*(3/4), 189–201.

Sedgwick, E. K. (1993). Socratic raptures, Socratic ruptures: Notes toward queer performativity. In S. Gubar and J. Kamholtz (Eds.), *English inside and out: The places of literary criticism* (pp. 122–136). New York, NY: Routledge.

Sullivan, N. (2003). *A critical introduction to queer theory*. New York, NY: New York University Press.

Thomas, C. (2008). *Masculinity, psychoanalysis, straight queer theory: Essays on abjection in literature, mass culture, and film*. New York, NY: Palgrave Macmillan.

Walters, S. D. (2001). *All the rage: The story of gay visibility in America*. Chicago, IL: University of Chicago Press.

Walters, S. D. (2005). From here to queer: Radical feminism, postmodernism, and the lesbian menace. In I. Morland & A. Willox (Eds.), *Queer theory*, (pp. 6–21). New York, NY: Palgrave Macmillan.

Whitlock, R. U. (2010). Getting queer: Teacher education, gender studies, and the cross-disciplinary quest for queer pedagogies. *Issues in Teacher Education, 19*(2), 81–104.

Wittig, M. (1971). *Les Guérillères*. (D. Le Vay, Trans.). New York, NY: Viking Press. (Original work published 1969)

Zerilli, L. (2005). A new grammar of difference: Monique Wittig's poetic revolution. In N. Shaktini (Ed.), *On Monique Wittig: Theoretical, political, and literary essays* (pp. 87–114). Urbana, IL: University of Illinois.

(Re)Constructing Cultural Conceptions and Practices in Art Education: An Action Research Study

Joni Boyd Acuff
The Ohio State University

It is heavily argued that art educators should consider the various ways racism, classism, and heterosexism work to shape consciousness and produce identity, as these constructions shape what content is privileged in the art classroom. This examination of power and privilege is what critical multicultural art education calls for. Unfortunately, K–12 art teachers continue to struggle to enact critical multicultural art education curriculum. This paper seeks to identify what personal pedagogical changes I can make to help pre-service and practicing art teachers transfer concepts and practices derived from social justice-oriented teacher education into their art classrooms. I assert that art teachers, practicing and prospective, must first establish positionality and recognize the implications of their position in order to facilitate equitable educational experiences for all their students.

In my pedagogy and curriculum development, I work to merge the goals of critical multicultural education theory[1] with the practices of art education. I guide students in critically examining issues of oppression, cultural subjugation, unequal resources, and the systemic disparities that sustain economic inequity via art. In spite of my efforts to include discourse about multiculturalism in my courses, students continue to ask: "Why do we need to discuss diversity in art?" (Acuff, 2013, p. 88). Pre-service students and practicing teachers openly admit that they fear they may "say the wrong thing" to a group of students who do not share their racial and/or socio-economic background. Their comments force me to consider what I might be missing as I

From *Visual Arts Research*, Vol. 40, No. 2 (Winter 2014), pp. 67–78.

guide future art teachers to become multicultural pedagogues. Am I skipping a step in the educative process?

Instead of instituting critical multicultural art education, it is my impression that K–12 art teachers continue to utilize a liberal multicultural art education framework[2] in which students create artifacts like Native American dream catchers and African masks, and they eat ethnic foods, read folktales, sing, and dance. These celebratory activities do not call for a critique of power, nor do they recognize how racism, heterosexism, and other discriminations are "enmeshed in the fabric of our social order" (Ladson-Billings, 1999, p. 213). These practices trivialize art and perpetuate racist beliefs and misinform people about culture and art (Delacruz, 1996). Alden (2001) states: "Although reproducing the existing power structure may not be a conscious motive of art teachers in the 21st century, many of their actions replicate conditions necessary for domination by the Euro-White culture" (p. 25). Many prospective and practicing art teachers lack foundational knowledge about the ideas and goals at the core of critical multicultural education that would facilitate the acquisition of knowledge about critical multicultural *art* education. I have come to believe that in order for art teachers to comprehend, become invested in, and enact effective critical multicultural art education, they must first understand how they are affected by and implicated in maintaining oppression.

To investigate if critical multicultural education should be a precursor to critical multicultural *art* education, I conducted an action research study that asked: Would the comprehension, perceived significance, and future implementation[3] of critical multicultural art education be more effective if art education students had a foundational understanding of critical multiculturalism? This study was completed in a graduate level art education course titled "(Re)Constructing Cultural Conceptions and Practices in Art Education" at a major southern university.[4] The course was built around reading and discussing literature related to systems of race, class, gender, and sexual orientation. While the literature and discussions anchored the students' investigations, there were intermittent in-class writing and art-making activities that assisted students in further developing knowledge around these issues. The course culminated with the students critiquing various freely accessible multicultural art lessons found online,[5] then creating critical multicultural art education lesson plans and submitting them to those same websites.

Methodology: Action Research

Action research, a qualitative methodology,[6] is "teacher-conducted, classroom-based research whose purpose is to measure the effects of new instructional strategies, activities or techniques; the overarching goal is to improve student learning" (Glencoe/McGraw-Hill, 2011). Action research is an iterative process that asks teacher researchers to plan-act-observe-reflect (Anderson, 2005) repeatedly in order to create the best

learning experiences possible for students. Using this methodology, I reflected on my teaching practice and curricular decisions, tried new strategies in the classroom, and assessed the effectiveness of these new initiatives. This research involved eight graduate students[7] in my "(Re)Constructing Cultural Conceptions and Practices in Art Education" course, and me. The students engaged in daily journal writings, in-class discussions, and art-making activities. I utilized the students' daily journals and visual artworks as research data, and I also kept a course journal in which I wrote observation notes as the students exchanged ideas and knowledge during class discussions.

Grounded in critical multicultural education, my "planning" and "acting" for this action research centered around two goals: (a) students establishing positionality, and (b) students realistically assessing their environment. These goals fostered students' proficiency in talking about issues of race, class, gender, and sexuality as a precursor to examining issues of equity in art education. For data analysis, I used these two goals as preconceived categories in which to codify data. While there were emergent themes,[8] this paper details only the results as they relate to the two aforementioned categories because I believe these actions are critical to the groundwork needed to foster critical consciousness in our educators, thus helping them be more effective multicultural art pedagogues. I gathered data that demonstrated the students' efforts to understand and acknowledge their various identity categories and to apply these categories to their future teaching pedagogy and practices, and I illustrated the students' struggle to implicate themselves in the cycle of oppression on the micro and macro level.

In narrative form, the following sections detail the results of this action research study. I further expand on the theoretical constructs that informed this art education course, and I provide examples of student insights and learning in evidence as the course unfolded. The data reflects the experiences and perceptions of the students in my course. Therefore, I do not claim transferability of the results of this research to other groups of students, as this action research was site- and population-specific. Nevertheless, I do believe that readers will find that this action research is informative and provides useful insights into teaching critical multicultural art education.

Race Talk and the Identification of Positionality

Art educator Elizabeth Garber (2003) asserts: "Positionality derives from relating mastery, authority, and voice to the position of the speaker. Gender, race, class, sexuality, nationality, ability, age, and a host of other descriptors can come into play in understanding this relationship, as well as prior knowledge, education, experiences, and emotions" (p. 59).[9] Desai (2000) adds that it is imperative that teachers "acknowledge [their] own social position within matrices of domination and subordination in relation to the culture [they] intend to represent" (p. 127). Teachers

must take into account "the powerful political, cultural, and social forces that have shaped [them]—often without [their] knowing it" (Cosier, 2011, p. 43). With this in mind, the initial goal for the first half of the course was an attempt to initiate the type of reflexive self-analysis Cosier (2011) refers to and establish the positionality Desai (2000) and Garber (2003) suggest.

I began the course with Lois Mark Stalvey's 1960 novel, *The Education of a WASP*.[10] In the novel's introduction, Chisolm (1960) writes: "This book is a straight-forward account of the education of one American white woman to both the real and the potential dangers contained in the day-to-day life of every American, dangers that may indeed preclude an American future" (pp. xi–xii). Stalvey's book inspired frank discussions about race, and in this class of mixed races and ethnicities, the students could make connections with the characters in the book. Helping students make personal connections with characters in books can enliven and strengthen discussions regarding inequality (Duncan-Andrade, 2008). One consequence of these connec-tions was that students were able to comment about racial and economic privilege (or lack thereof) through the voice of someone with whom they identified in vary-ing ways. For example, the following comments, made by a White female student in this course, exemplify how the text led her through an inquiry into positionality and privilege, specifically racial privilege.

> I am a WASP and I think this influences much if not all of my teaching. I
> think my strong identity as a WASP means that I assume any number of
> things about students who look like me and about students who don't look
> like me. I try very hard to overcome these preconceived ideas about myself
> and others, but I think it is difficult when you cannot pinpoint where the
> preconceptions come from. (personal communication, February 1, 2012)

The Education of a WASP guided this student to "discover just how racialized [her] own [identity] and viewpoints have been" (Singleton & Hays, 2008, p. 20). The above student's phrase "cannot pinpoint where the preconceptions come from" reveals that she has come to understand that identities are socially constructed; however, she struggles to identify the mechanisms of this process. Students take for granted that their life experiences are "'normal' and, most often, do not recognize that their worldviews have been shaped by stories passed down from family and community members and through media and popular culture" (Cosier, 2011, p. 42). The student recognized that she is and always will be a beneficiary of White privilege. Helms (1997) identifies this acknowledgement as a crucial aspect of White racial identity development.[11] Understanding the correlation between past oppressive systems like slavery and segregation and the contemporary struggles for those in minority groups is important when working within the contemporary educational system.

The Education of a WASP also guided the students of color in recognizing their positionality. These students realized that they must consider their physical appearance as they make pedagogical and curricular decisions. They also began to understand how they must continuously consider how to negotiate the imposed, essentialized racial perceptions that their future K–12 students may place on them as teachers. The Korean American female student wrote:

> As a teacher I acknowledge the fact that my ethnicity is the minority. My students will look at me with questions and expect different things of me rather than a White female. I might have to address who I am physically. I might come into conflicts with my fellow teachers. (personal communication, February 1, 2012)

This student claimed to have never considered before how her physical appearance would influence her teaching efficacy. Tatum (1992) states: "Students of color often enter a discussion of racism with some awareness of the issue, based on personal experiences. However, even these students find that they did not have a full understanding of

Figure 1. Korean American student artwork. The student created a Korean female dressed in stereotypical Hello Kitty apparel and singing karaoke.

Figure 2. Saudi student artwork. The student created a Saudi male with headdress portrayed as a suicide bomber/terrorist.

Figure 3. Kuwaiti student artwork. The student created a Kuwaiti male riding a camel in the desert with his four veiled wives trailing behind him on foot.

the widespread impact of racism in our society" (p. 7). This disconnect was unpacked in classroom discussions and reflective art-making activities. Figures 1–3 are visual artworks, created by three art education students of color, post-discussion. The images communicate what they believed K–12 students might "see" as they stand in front of a classroom to teach. The art education students of color had to negotiate the fact that regardless of how educated, well-spoken, and nicely dressed they are, others' perceptions of them as a leader are skewed by skin color (Carter-Black, 2008) and by the socially constructed stereotypes that have been imposed upon their entire cultural/ethnic group.

A Realistic Assessment of Our Environment

Weber (2010) asserts: "A first step toward understanding oppression is to make visible the processes that obscure and deny its existence" (p. 21). We need to engage in a "realistic assessment of our environment. . . . Realistic expectations also foster our ability to interact with a diverse range of people, to see their economic and social needs as being as legitimate as our own, and to work together to redress the injustices we face" (Weber, 2010, p. 16). A realistic assessment involves implicating oneself in the act of oppression. Therefore, I encouraged my students to do just this, which helps to legitimize issues of racism, classism, and heterosexism (Weber, 2010). Such legitimizing makes students see the issues as important enough to invest in their pedagogy and classroom teaching.

To guide the students through this self-implication, I utilized Steinberg and Kincheloe's (2009) book chapter "Smoke and Mirrors: More Than One Way to Be Diverse and Multicultural." They state; "Critical multiculturalists are concerned particularly with the power blocs formed by the axes of power associated with class, race, and gender: class elitism, white supremacy, and patriarchy" (Steinberg & Kincheloe, 2009, p. 10). Power blocs—The Class Elitist Power Bloc, The Patriarchal Power Bloc, and The White Supremacist Power Bloc—refer to the social formations around which power politics function. Individuals rest either inside or outside of these three blocs.[12]

I asked the students to draw the three blocs—The Class Elitist Power Bloc, The Patriarchal Power Bloc, and The White Supremacist Power Bloc—and align themselves on a spectrum that represented their distance between the center of the power bloc (most powerful) and the farthest point they could visually represent. The power bloc activity facilitated a very intimate self-assessment in which the students visually placed themselves on a power continuum in relation to other people. It forced students to visualize how while they might exist outside of one power bloc, their proximity to the center of other blocs helped to negotiate their overall power and privilege.[13] For example, exploring Steinberg's Patriarchal Power Bloc, which focuses on the pervasiveness of gender inequality, led the students into inquiries

about the normativity of privilege as it relates to gender and sexual orientation. Patriarchy's push for "traditional" gender roles privileges heterosexual relationships and supports heterosexism. I asked my students to reflect on heterosexual identity and forced gender roles and consider how heterosexism plays a role in education today. Through the evaluation of the students' journals, it was clear that all eight students agreed that, overwhelmingly, schools reflect a heterocentric worldview. Teachers must be cognizant of the internalized heterosexism that influences varying dimensions of life such as language, education and curriculum, social media, and literature. Steinberg and Kincheloe's (2009) power bloc framework effectively facilitated this learning. As students focused on accurately presenting themselves on the axes of race, class, and gender, they began to see how they were implicated in projecting, maintaining, and furthering oppression such as heterosexism.

Adding Art Education to the Conversation

After seven weeks of investigating race, class, gender and sexuality, and the systemic oppression that targets specific categories of people, the students and I began to consider the roles that artists, art, and art education play in challenging or maintaining systems of oppression. Students in this course who were practicing art teachers or had taught prior to entering the university art education program began to question and critique curriculum choices that they had made in the past. One student shared: "My attempts at diversity and multiculturalism have almost always been fruitless. They start with good intentions, but almost always dissolve into an 'othering' of a culture" (personal communication, February 1, 2012).

Hegemony[14] is an important concept for a critical multicultural educator. At the start of the class, students did not know the definition of hegemony and could not have conceived of trying to create the counter-hegemonic art curriculum that critical multicultural art education requires. Class discussions during the later weeks of the course demonstrated that students had come to understand hegemony and the way it presents itself through classroom texts, artwork used in the curriculum, instructional practices, and even behavioral management strategies (Adams, Bell, & Griffin, 2007). With an understanding of hegemony and its connection to racial and cultural subjugation, the students identified how "the art classroom [can be] a space in which discriminatory values from the dominant culture are reinforced by privileging the artworks and traditions of the economic and political elite" (Kraehe, 2010, p. 163). If my art education students had not identified and comprehended their positionality and actively implicated themselves as oppressors on a macro-level, I am not sure if they could have authentically understood how they exist as oppressors on the micro-level (in the classroom). As a consequence, they would not have seen the urgency or relevancy in developing a critical multicultural art education curriculum that attends to power and cultural subjugation.

As a course project, the students were required to critique various multicultural art lesson plans found online. In the students' critiques, I observed how the preliminary work that we had done strengthened their ability to identify and articulate problematic aspects of the online lessons. The students advocated for the need to move Othered cultures out of the historical, "exotic" category, and to see these cultures as valuable in their present-day form. The students identified the "power of designation" as hegemony that is often maintained in attempts of multicultural art teaching.

While it is a struggle to comprehend how larger structural conditions directly impact learners' daily experiences in the classroom, this knowledge is imperative for "catalyzing preservice teachers' critical consciousness and commitment to educational equity and social justice aims" (Kraehe & Brown, 2011, p. 489). The result is that teachers develop a multicultural art education curriculum that fosters critical consciousness and examines power and the subjugation of knowledge.

Conclusion

This action research study found that the comprehension, perceived significance, and future implementation of critical multicultural art education is more effective if art education students have a foundational understanding of critical multiculturalism. Understanding the underpinnings of critical multiculturalism can help art teachers comprehend and become invested in enacting critical multicultural art education. Students recognized the need for a critique of power that parallels the critical multicultural art education curriculum.

Preliminary internal, reflective work about privilege, hegemony, and power will produce better prepared, more knowledgeable, effective multicultural art educators. For me, this action research study confirmed that with a lack of foundational understanding about systems of race, class, gender, and sexuality, art teachers might continue to produce curriculum that fails to interrogate power and privilege (Lee, 2009). Investigative, reflective dialogue about systemic oppression is required before art teachers are able to see themselves as capable of creating art curriculum that is truly critical and attentive to difference, and that challenges systems of dominance.

Notes

1. Critical multicultural education theory seeks to investigate the maintenance of authentic cultural history, the subjugation of non-dominant cultural knowledge, and the continuous movement, fluidity, and evolution of culture (May & Sleeter, 2010).

2. Liberal multiculturalism essentializes and de-politicizes culture. "The focus is on getting along better, primarily via a greater recognition of, and respect for, ethnic, cultural, and/or linguistic differences, while the approach adopted is a problem-solving one" (May & Sleeter, 2010, p. 4). It fails to recognize power and privilege as key concepts of interrogation.

3. Because this was not a longitudinal study, and I could not guarantee that I would stay in touch with students after the course in order to get a report on their teaching, I could not attend to this aspect of the research question.

4. The graduate level art education students enrolled in this course had art teaching experience that ranged from prospective teachers with no experience in the art classroom to practicing art teachers seeking a master's or doctoral degree. The course's main objective was to facilitate students' inquiries into the political and social aspects of identity development, including privilege and systemic oppression. Upon developing knowledge around their identity, the students were then charged with discovering the art educational implications of these constructions.

5. The students critiqued multicultural lesson plans from kinderart.com and dickblick .com. See Acuff (in press) to read more about the results of this final project.

6. Qualitative research allows a researcher to examine everyday social life and interpret it through rich descriptions, providing less abstract and more functional solutions to my research questions (Denzin & Lincoln, 2000).

7. Eight enrolled students: four White Americans (three female, one male), one Korean American female, two Saudi males, and one Kuwaiti male.

8. Some emergent themes included lack of critical language, misunderstandings of critical concepts (like empathy, racism, hegemony, multiculturalism), micro-aggressions, failing to connect oppression to oneself, and not moving beyond the micro-level oppressions.

9. I assume the understanding of positionality designated by Linda Alcoff (1988), that race, class, gender, and other aspects of our identity are markers of relational positions, not essential qualities. "Knowledge is valid when it includes an acknowledgment of the knower's specific position in any context, because changing contextual and relational factors are crucial for defining identities and our knowledge in any given situation" (Maher & Tetreault, 1993, p. 118).

10. White Anglo-Saxon Protestant (WASP).

11. Additionally, Helms (1997) writes:

 If one is a White person in the United States, it is still possible to exist without ever having to acknowledge that reality. In fact, it is only when Whites come in contact with the idea of Blacks (or other visible racial ethnic groups) that whiteness becomes a potential issue. . . . Thus, if the Black (in this instance) presence "intrudes" into the White person's environment, and the intrusion cannot be ignored or controlled, then the White person is likely to be forced to deal with White racial identity issues somewhat. (p. 54)

12. Steinberg and Kincheloe (2009) write:

 Along the lines of race, class, and gender, individuals can simultaneously fall within the boundaries of one power bloc and outside another. While no essential explanation can account for the way an individual will relate to power blocs vis-à-vis their race, class, or gender, such dimensions do affect people's relationship to power-related social formations. In most cases individuals are fragmented in relation to power. An African American male may be disempowered in relation to the racial category of white supremacy yet may enjoy the political benefits of being a male in a patriarchal power bloc or an upper-middle-class male in the economic power bloc. Thus, individuals move in and out of empowered and disempowered positions. (p. 9)

13. Critical race theory (CRT) readers may recognize this activity as CRT work, as it works to unmask the various permutations of oppression, in addition to racial oppression (Ladson-Billings, 1999).

14. Hegemony, brought forth by Antonio Gramsci, is a term that refers to the way in which "a dominant group can project its particular way of seeing social reality so successfully that its view is accepted as common sense, as part of the natural order, even by those who are in fact disempowered by it" (Bell, 1997, p. 11).

References

Acuff, J. B. (2013). "How will you do this?" Infusing multiculturalism throughout art teacher education programs. *Journal of Cultural Research in Art Education, 30*, 1–19.

Acuff, J. B. (2014). (Mis)Information highways: A critique of online resources for multicultural art education. *International Journal of Education through Art, 10*(3).

Adams, M., Bell, L. A., & Griffin, P. (Eds). (2007). *Teaching for diversity and social justice.* New York, NY: Routledge.

Alcoff, L. (1988). Cultural feminism versus post-structuralism: The identity crisis in feminist theory. *Signs, 13*(4), 405–435.

Alden, D. (2001, April). Multicultural art education's illusion of equity. *Journal of Social Theory in Art Education, 21*, 25–46.

Anderson, K. (2005). *The action research dissertation: A guide for students and faculty.* Thousand Oaks, CA: Sage Publications.

Aveling, N. (2006). "Hacking at our very roots": Rearticulating White racial identity within the context of teacher education. *Race Ethnicity and Education, 9*(3), 261–274.

Bell, L. A. (1997). Theoretical foundations for social justice education. In M. Adams, L. A. Bell, & P. Griffin (Eds.), *Teaching for diversity and social justice* (pp. 3–15). New York, NY: Routledge.

Bequette, J. (2009). Tapping a postcolonial community's cultural capital: Empowering Native artists to engage more fully with traditional culture and their children's art education. *Visual Arts Research, 35*(1), 76–90.

Blanchett, W. (2006). Disproportionate representation of African American students in special education: Acknowledging the role of white privilege and racism. *Educational Researcher, 35*(6), 24–28.

Cain, R. (1996). Heterosexism and self-disclosure in the social work classroom. *Journal of Social Work Education, 32* (1), 65–76.

Carter-Black, J. (2008). A black woman's journey into a predominately White academic world. *Affilia, 23* (2), 112–122.

Chisholm, S. (1970). Introduction. In L. M. Stalvey, *The education of a WASP* (pp. xi–xii). Madison, WI: The University of Wisconsin Press.

Cosier, K. (2011). Girl stories: On narrative constructions of identity. *Visual Arts Research, 37*(2), 41–54.

Delacruz, E. M. (1996). Approaches to multiculturalism in art education curriculum products: Business as usual. *Journal of Aesthetic Education, 30*(1), 85–97.

Denzin, N. K., & Lincoln, Y. S. (Eds.). (2000). *Handbook of qualitative research* (2nd ed.). Thousand Oaks, CA: Sage Publications.

Desai, D. (2000). Imagining difference: The politics of representation in multicultural art education. *Studies in Art Education, 41*(2), 114–129.

Duncan-Andrade, J. (2008). Teaching critical analysis of racial oppression. In M. Pollock (Ed.), *Everyday antiracism* (pp. 156–160). New York, NY: The New Press.

Garber, E. (2003). Teaching about gender issues in the art education classroom: Myra Sadker Day. *Studies in Art Education, 45*(1), 56–72.

Glencoe/McGraw-Hill. (2011). Teaching today. Retrieved from http://www.glencoe.com/ps/teachingtoday/index.phtml

Helms, J. (1997). Toward a model of White racial identity development. In P. Altbach, K. D. Arnold, & I. C. King (Eds.), *College student development and academic life: Psychological, intellectual, social, and moral issues* (pp. 207–224). New York, NY: Garland Publishing.

Kincheloe, J., & Steinberg, S. (1997). *Changing multiculturalism.* Buckingham, England: Open University Press.

Kraehe, A. (2010). Multicultural art education in the era of standardized testing: Changes in knowledge and skill for art teacher certification in Texas. *Studies in Art Education, 51*(2), 162–175.

Kraehe, A., & Brown, K. (2011). Awakening teachers' capacities for social justice with/in arts-based inquiries. *Equity & Excellence in Education, 44*(4), 488–511.

Ladson-Billings, G. (1999). Preparing teachers for diverse student populations: A critical race theory perspective. *Review of Research in Education, 24*(1), 211–247.

Lee, E. (2009). Taking multicultural, anti-racist education seriously: An interview with Enid Lee. In W. Au (Ed.), *Rethinking multicultural education: Teaching for racial and cultural justice* (pp. 9–15). Milwaukee, WI: Rethinking Schools.

Maher, F. A., & Tetreault, M. K. (1993). Frames of positionality: Constructing meaningful dialogues about gender and race. *Anthropological Quarterly, 66*(3), 118–126.

May, S., & Sleeter, C. (2010). *Critical multiculturalism: Theory and praxis.* New York, NY: Routledge.

Singleton, G., & Hays, C. (2008). Beginning courageous conversations about race. In M. Pollock (Ed.), *Everyday antiracism* (pp. 18–23). New York, NY: The New Press.

Stalvey, L. M. (1970). *The education of a WASP.* Madison, WI: The University of Wisconsin Press.

Steinberg, S., & Kincheloe, J. (2009). Smoke and mirrors: More than one way to be diverse and multicultural. In S. Steinberg (Ed.), *Diversity and multiculturalism: A reader* (pp. 3–22). New York, NY: Peter Lang Publishing.

Tatum, B. D. (1992). Talking about race, learning about racism: The application of racial identity development theory in the classroom. *Harvard Educational Review, 62*(1), 1–24.

Walton, G. (2012). Eating cake: The paradox of sexuality as a counter-diversity discourse. In S. Steinberg (Ed.), *Diversity and multiculturalism: A reader* (pp. 211–222). New York, NY: Peter Lang Publishing.

Weber, L. (2010). *Understanding race, class, gender, and sexuality: A conceptual framework.* New York, NY: Oxford University Press.

Art, Native Voice, and Political Crisis: Reflections on Art Education and the Survival of Culture at Kanehsatake

Elizabeth J. Saccá
Concordia University, Montreal

Native culture and art and the education of children are essential to the community of Kanehsatake, near Montreal. Also important is nonnatives' understanding of native culture. Following the historic and summer-long armed confrontation called the "Oka Crisis," Longhouse People who are artists explain the relation of their art to the political crisis their community faces. They also describe the relation of their art to the ancestral and spiritual trust to protect the land. Throughout the government and military opposition they faced, they maintained the cultural values which continue to guide their art, teaching, and community life, and they see hope in the education of children and in increased understanding among nonnative people. Our challenge is to understand the cultures of students and to continue to invent ways of teaching that support their various cultures. Another challenge is to teach our students to understand and appreciate the cultures of others. Art teachers who recognize the political forces working against art, community, environment, and creative work provide a great hope for the survival of all cultures.

My main interests in art have always been things that relate to my own cultural identity, whether it's legends or just symbols or political messages inside them. Part of my work used to be just fantasy and my ideas of what things would look like in old legends. It's part of my attempt to try and get people educated into my own culture, my nation, because I don't think that it should be lost. I try not to go into abstract, because people don't understand it; I mean, the ordinary person doesn't appreciate it. I'm trying to appeal to everyone and even if it's people who are art connoisseurs; the aesthetic value, its own value as a form of expression to convey a message, those things are important in my work. (Gabriel, 1991)

The nation Ellen Gabriel is referring to is the Mohawk Nation. Her community, Kanehsatake, 45 miles northwest of Montreal, is one of the four communities that make up the Mohawk Nation of the Iroquois Confederacy. A month after Ellen's 1990 graduation with a B.F.A. in painting, her community was plunged into a historic confrontation which Canadian television and newspapers covered daily throughout that summer and fall.[1] Even though the Oka Crisis disrupted community life and painting, Ellen, who had become a spokesperson, sees her political work as closely related to her art. Both are based in the history of the community which she understands through the stories she has heard from elders:

> They are powerful stories, and a lot of those stories are based on what our traditions are. I grew up hearing stories, just from the area; and I've always been interested in the other dimension that lives with us, that we don't see. Growing up in a family where our spiritual beliefs were mixed up with Christianity, it was a mixture of the two cultures, and then to finally find out the other part, I found that fascinating. And the storytelling itself is something I feel very close to, like Deganawida,[2] when he founded the Great Law, a lot of people believed he came in this area and spoke to the people here, so we feel that this particular area is of great importance. And the cost, the magnitude of opposition against us makes us believe that it probably was true, that it is an area that has a lot of power in it. So that's where my interest comes in for political, for political messages being conveyed, because it's still an integral part of our life. (Gabriel, 1991)

In contrast to Ellen, the author has a personal involvement with Kanehsatake which is recent; it began a few years before the Crisis when I found an intriguing pine and hemlock forest. The eerie way the light reflected through the branches fascinated me, and I had the sense of being not alone, but being very comfortable and safe. I returned to this forest regularly to escape the pressures of city work and to draw, and I found that I was counting on the forest's calm to restore me. Occasionally someone would walk through the clearing, and I noticed what seemed to me to be a manner respectful of the land.

A sign identified a small, crowded cemetery as Mohawk. The cemetery was surrounded by a highway, a golf course, and a road to the golf clubhouse which other signs indicated were private. It seemed odd to have a golf course and clubhouse, symbols of wealth and development, built right into this natural forest and surrounding a small cemetery.

Local newspapers reported the mayor of the town of Oka had plans to expand the Oka Golf Course, cutting further into the forest. Papers also reported native protests. My concern grew as I wondered if the rampant development in adjoining areas would also obliterate this forest, known locally as The Pines. As discussions and

Figure 1. Ellen Gabriel, *Spirit Guide*, acrylic on canvas, 152 × 119 cm.

protest proved unsuccessful, some natives parked cars across the dirt track to block any expansion of the golf course into The Pines.

One day, I went near the parked cars to draw and was met by two people watching the area. One of them, Joe David, was an artist who had studied art education. We talked for a long time, and he told me how the entire region had once been occupied by the ancestors of the People of the Longhouse. As Europeans arrived and converted the natives to Christianity, Longhouse People's land was taken piece by piece, until only a few square kilometers remained including the pine forest and cemetery. According to the traditional Longhouse religion in which Joe grew up, the people are to protect the land, but they found the government was still refusing to talk with them.

Later I was told more history. Parents, grandparents, and great-grandparents had resisted commercial or outside development of the area. Joe's grandmother had confronted loggers who were attempting to set up a sawmill in the pine forest I was so attached to. She had been badly beaten and was later charged with assault. His great-grandfather had ridden on horseback with 40 others to scare off workers constructing a railroad that was to run into their community. They stopped the railroad, which has not been completed to this day, but the great-grandfather spent the remainder of his life hiding from the police.

I also learned that the Creator had put these native people in this place called Kanehsatake.

At Onondaga, a community near Syracuse, New York, a man named Deganawida—the Peacemaker—had planted a Great White Pine, the Tree of Peace. The pine's white roots extend in four directions, so that people wanting peace can find their way to the great tree for protection by the Iroquois Confederacy. When Deganawida visited Kanehsatake, he met the ancestors of these Longhouse People. I came to realize that the forest I loved existed only because native people had been protecting it from development.

In July 1990, police attacked the main entrance to The Pines, which was being blocked by the natives. When the police met resistance, they sealed off the entire community.

Eventually the Canadian army was brought in to break the native defense of the pine forest. Thousands of army personnel, armored vehicles, machine guns, helicopters, and miles of razor wire were used against the native community (D. David, 1991; Gabriel, 1992; Maclame and Baxendale, 1990; York and Pindera, 1992). It was a summer of anger and torment.

Most of us were cut off from the community and had to rely on the media for news of what was happening inside army lines. Those unacquainted with Kanehsatake

Figure 2. Elizabeth Saccá, *The Pines*, October 1989, watercolor, 18 x 29 cm.

had to rely on the media for an explanation of why this was happening. Although natives kept explaining the meaning of the land and their need to defend it, their words did not reach politicians, private interests, or the general public. The natives' message did not match popular preconceptions and stereotypes. Media personnel who did not understand the culture behind the Longhouse People's actions could not explain; instead, they portrayed the confrontation by demonizing individuals and playing on unsavory stereotypes of aboriginal people. In failing to explain this native culture and why people had to defend the land, the media helped support government action against the people and their culture, confirming Chomsky's persuasive argument (1989) that in spite of surface disagreements, representations in the media support those holding power.[3]

When I saw television images of armored vehicles rolling through the clearing where I had painted, I felt overcome and enraged. How could military power be brought into such a tranquil and sacred place? I could imagine pictures of a tank rolling through a cathedral, past a votive light, and into the tabernacle. Such disregard for the sacredness of a cathedral would disgust believers and nonbelievers alike. They would understand what was happening, and they would find such a violation repugnant.

The army, under the direction of politicians, encircled the natives and closed them into a smaller and smaller area. They encircled them with razor wire and insisted on unconditional surrender.

The army banned journalists from the area of confrontation, but a number of journalists refused to leave. Cutting off journalists' cellular phones and supply of film and videotape, the army provided their own version of events to the public through an army spokesperson (Collier, 1991; Roth, 1992).

After 78 days of confrontation, the natives decided their point had been made and they would leave their entrapped camp, allowing the army to take custody of them and the police to arrest them. The government laid criminal charges against these natives and their supporters. Joe David, the artist I had met, was charged, and a conviction could have led to 10 years in prison.

But the intense alienation these people face and the overwhelming power brought to bear against them have not weakened their convictions or their solidarity, which are based in their culture. In spite of what they are subjected to, they persist; and they have told me their traditions and their art sustain them. Chickie Etienne, a member of the community who was in The Pines when the police raided, told me that her commitment to the land had always been there.

> I was raised with my mother always saying that was our land, the stories of
> my grandmother. My mother was very political: the relationship between us
> and the earth. When my daughter was a newborn, her bellybutton cord fell
> off. And I was standing there and "Now what do I do?" and my grandmother

says, "You bury it. That goes back into the earth; you're part of the earth; she's part of the earth." So this was part of my upbringing. (Etienne, 1991)

After the summer crisis, Chickie beaded and feathered golf clubs to turn them into native symbols:

> The golf club itself represents the struggle, the government's attempt at relocating us or displacing us, taking our land, encroaching once again on our sacred grounds. And the reasoning for dressing them with the feathers and the beadwork and everything is I've turned it into a war club, which is what happened and the fact that we'll always be here. Birds will always have feathers, we'll always have birds. Fur, animals will always have fur, we'll always be here. As many golf clubs as there are, there'll always be a native here to stand up, even if there's only five of us, we'll always be here.
>
> That's what the club represents, and it rubs it in their face, too. I get my own little personal enjoyment out of seeing the white people when they see our clubs. (Etienne, 1991)

Many natives grow up with constant messages from the media and authorities that they are no good. Chickie told me about the pain of growing up alienated from her own identity.

> When I was young, when I was a little kid, I was watching a [TV] show, some cowboy movie, and these two cowboys found this dead Indian, and

Figure 3. Robert Galbraith, *Army and Razor Wire*, photograph. From C. MacLame and M. Baxendale (1990), *This Land Is Our Land: The Mohawk Revolt at Oka* (plate opposite p. 96) Montreal: Optimum Publishing International. Reprinted by permission.

one cowboy went to turn him over. The other cowboy says, "No, no, don't touch him, don't you know when they're dead they turn to poison?" And I was terrified, I didn't even know I was an Indian, right. To me, there was no difference, and then I was scared of the Indians.

And then the day I found out I was a native, I was so overwhelmed, I was so upset. I found out I was Indian when I went to school. I was terrified, it totally overwhelmed me. I couldn't believe it. That was the worst thing; I had never experienced "bad," you know what I mean? And all of a sudden I was bad, I was that poisoned Indian. And my parents, kind of [said], "Aw, come on." I guess they didn't realize the devastation; well, they didn't know about the TV show I had watched.

I went through that shame of knowing who I was till the age of about 11, and then I turned rebellious. I was a heavy drinker by the age of 12, but it was because of the pain. I couldn't deal with myself sober, like who I was.

Then, when I got into my late teens, when I was about 19, 20, when I had my daughter, and she's the joy of my life, I had my own little Indian baby. And I guess I had matured and I had seen that there was nothing wrong with my daughter, and there was nothing wrong with me. And I started taking pride in who I was and I started teaching her, I said, "She's not going to mess up like I did."

I looked at her as myself and tried to undo the pain and harm I caused myself, through her. When she started school here, right away Mohawk language. And I always told her, even when she was 4 or 5 years old, I'd tell

Figure 4. Chickie Etienne, Golf club with beads, leather, fur, feathers, 93 cm (length).

her, "Mummy's so ashamed because I lost some of my language." I said, "Don't ever lose your language." (Etienne, 1991)

Like Chickie Etienne, Ellen Gabriel also sees education as part of a solution:

> I think the fact that the culture is sort of taught in the schools is a beginning, because that's where we see the most hope, is in the kids, and the fact that people are interested in their culture, especially the younger kids, they're kind of thirsting for that kind of knowledge. The interest that last summer's events sparked in people trying to find out, "Well, I actually do have a culture that still exists and has been preserved, so what's it about?" And the interest in that is hopeful. (Gabriel, 1991)

As proof of the possibilities for preserving their culture she cites the traditional Longhouse religion, which continues to exist in spite of centuries of conversions by Christian missionaries:

> Out of fear, people have tried to destroy the Longhouse and the people who are associated with it. This fear of the unknown, about being pagans and burning in hell really scares people. The Christian beliefs of burning in hell really scares people, so for them to open the door to the Longhouse is scary. (Gabriel, 1991)

Figure 5. Joe David, *The Standoff* (1990), mixed media installation, 288 x 92 cm (diameter).

The government's refusal to recognize traditional Longhouse government or ancestral native land translates into oppression for native people. Chickie talks about resisting this oppression:

> And when the pressures really got hard, like during the Crisis, I couldn't deny it, I couldn't stay home. There was that compelling force, I had to be in The Pines. I stood my ground. And it's my land; it's been put into our hands. We've been given the duty of protecting it by the Creator and I couldn't deny that. I couldn't run home and hide and be safe. I lost the business, I lost a lot, but those are just material things. If I lost the land, I lost my identity, and that to me is more important. I've got grandchildren and great-grandchildren coming, and what I do today affects their lives even though they don't exist yet. I can go to my grave and say, "I did something, I tried, I stood in front of guns, I didn't run."
>
> I've seen a lot of brave people last summer, I've seen a lot of brave children.[4] It was bad, the fact that they brought an army against a handful of people, people deprived. The Elders suffered a lot, deprived of their medication and food.
>
> But then, too, it relit something inside our people. Something that has been so dormant that it was on the verge of being extinguished. (Etienne, 1991)

Each summer since the Crisis, the community has held a spiritual gathering and powwow to bring all cultural communities together in The Pines, and Ellen sees many more nonnative people taking an interest in native culture and respecting native culture. She considers this hopeful:

> I won't say it's too fate, but it's long overdue. The fact that they are interested and that there's all kinds of forums for native people to be speaking to the nonnative communities; I think that's one positive note. I see a type of revolution taking place within Canadian society when they see that their system of government is not perfect, that they don't have a voice the way they thought they did. (Gabriel, 1991)

Art and Preserving Native Voice

Joe David has represented these traditional ways and protection of the land in a piece of installation art:

> [One of] the elements in that piece is a tree, a pine tree from The Pines, with the dirt shaped liked the roots going off in four directions, that's our origin story. That's also a living thing being protected by a very flimsy feather shield and a wooden club which essentially is just symbolic war toys. And the

appropriated use of the trip flare, protecting that tree. That was something that we did this summer, is to go out and steal those trip flares from the army and put it up on our own perimeter too.

Essentially the weapons that were here are an appropriated weaponry and were very much a symbolic defense in the same way that the shield is a symbolic defense for the tree. And the idea that everything is ringed in by this deadly wire that looks flimsy and delicate when it's strung up in the vertical. Such a barrier, though, has just a menacing look to it, and that's what power's about. (J. David, 1991)

Joe is referring to the wire behind which he and the others were trapped for 26 days. He continues,

Essentially for us here in Kanehsatake it was about land and about the spiritual connection to the land, and for me personally, the fight is a spiritual fight. It's one where you need your spirit to continue this fight, so you have to keep paying attention to that whole world, that whole part of your experience, your reality; that there's the spirit world and that you're responsible for the protection of that spiritual and natural world. (J. David, 1991)

Joe criticizes the media and goes on to say that even Canadian museums reflect a shallow view of natives: "There's almost like a carny side-show element to the way the Museum of Civilization has mounted their 'Indian' element." Museums have broken Joe's trust that they will be fair and that they will promote understanding.[5]

Chickie, Ellen, and Joe's hope for an authentic exchange is shared by art teachers who consider cultures central to their teaching in art. Ellen explains how offensive it is to be categorized and misunderstood. She talks about the university where she earned her bachelor's degree:

First you're classified as a native artist and next you're classified as a political artist, native artist. And all these labels: I think that's what I had a problem with, because we don't have labels. You're just expressing an idea. I think the labels which are in institutions restrict you, and already tell you how to interpret a painting or a drawing or any kind of piece of work. They already tell you, "This is how you're supposed to interpret it." For myself and other people, I'm sure that doesn't apply. It's just however you want to interpret it; that's what it's there for.

When you come from a minority it seems that people seem to think that you should have "a look." Even when I did something the same as somebody else, the same kind of theme, it was always viewed differently as native art, and even when you didn't want a label. It's just a force of habit people have to label you right away, and not for its own merits. The teachers do it, subconsciously I think, but they do it. (Gabriel, 1991)

She said that she is sure that they did not mean to be insulting. When I asked, she gave me some examples:

> But it was stuff like "You should draw, you should paint things about your native culture." I have my own way of expressing myself, and there's certain costumes that we wear, and there's certain legends that we have. Some of my professors found it sexist; because there's a collar that the women wear, she found that it was strangulating the women. Like the creation stories, some found it sexist. The whole belief of harmony with nature that, you know, "Oh, that's a myth." Just the attitude that it couldn't possibly have happened, whereas for us it did happen. We do have this dual world that lives with us, but it's classified either as occult or superstition. (Gabriel, 1991)

A number of people have told me stories of the racial slurs and racist insults they have endured at the nonnative secondary schools they attended. One of the teachers whom native students did trust was an art teacher. They felt she was interested in their culture and supported them and their ideas, and art class became a refuge where ideas not tolerated by racist individuals were accepted. With some understanding of native culture, a teacher can respond constructively to students' work and avoid judgments of their culture. She would not consider a religious belief a superstition, and she would not presume to interpret cultural symbols. In such a classroom, teacher and students learn that their cultures can exist together, even within a hostile school and a hostile society. At the primary school level, art taught by such a teacher can be an antidote for the poison in the mind of the child who thinks she is the poison Indian.

Valerie Alia (1991) teaches ethics, arts, and communication; she has written about her deliberate effort to overcome the superficiality of her own understanding of native cultures and traditions. She describes a "humbling (and belated) awakening" to the intricacies of native ceremonies (p. A7). Criticizing media coverage of powwows as secular displays, she wonders about how those of Judeo-Christian backgrounds would respond to such secular treatment of their ceremonies. Her comments remind me of my own reaction to the army's sacrilegious advance into The Pines.

Alia sees hope in the conscious efforts of nonnatives to understand native cultures. She envisions a multicultural journalism of the future, and in so doing, she shares the hopes of Chickie, Ellen, and Joe. Following Chomsky (1989), I see prospects for survival of society in deep-rooted popular movements dedicated to the values he calls "community and solidarity, concern for a fragile environment, creative work under voluntary control, independent thought, and true democratic participation" (p. 136), values also shared by these artists.

Art teachers who recognize the political forces working against art, community, environment, and creative work provide a great hope for the survival of all cultures.

In conclusion, numerous trials have resulted from the criminal charges the government laid against these native people. A number of people have been convicted. Of those who resisted the army and were trapped behind the razor wire, 40 people including Joe David based their legal defense on their right to defend sacred land against the golf club expansion, and a jury acquitted them of all the charges.

To date, the Oka Golf Club has not been expanded, but the mayor continues to claim land that the natives also claim. The government, now holding another portion of the land, has not reached an agreement with the native people. Police helicopters still pass over Kanehsatake, and extra police keep the area under surveillance.

In spite of all the things that have happened to them and continue to happen, Chickie, Ellen, and Joe continue with their art and their political work, even as very powerful forces work to erase the pine forest and the Longhouse People's culture.

Our challenge as art teachers is to understand the cultures of students and to continue to invent ways of teaching that support their various cultures in spite of political pressures. Another challenge is to teach our students to understand and appreciate the cultures of others. With this basic understanding, we could avoid cultural conflict like the one at Oka and Kanehsatake in the summer of 1990. Even though an art teacher's work is painstaking and sometimes discouraging, it is clear that art teachers play a vital role in the survival of cultures threatened with extinction.

Notes

The author thanks Joe David, Chickie Etienne, and Ellen Gabriel for their recorded interviews, and Anna Gabriel Nelson for her conversations with the author. The author also appreciates the assistance provided by Miriam Cooley, Anne Whitelaw, Amasi Jumbani, Kathy Adams, and Madeleine Lajambe.

1. For an overview, see E. Gabriel (1992).

2. For an account of Deganawida and the founding of the Great Law of Peace by the Iroquois Confederacy, see *The White Roots of Peace* by Paul A. E. Wallace (originally published by the University of Pennsylvania Press, Philadelphia, 1946), copyright 1986 by John Fadden Kahionhes, Saranac Lake, NY: Chauncy Press (Library of Congress Number 84-72986).

3. Lorna Roth describes the absence of native people in regular media work, the cultural bias of the media reporting the Crisis, and changes needed in the media. See L. Roth (1992).

4. For community members' perspectives on the traumatic effect of the Crisis on the community, especially the children, see D. David (1991).

5. For discussions of these issues see R. Hill (1992). One part per million: White appropriation and native voices. *FUSE* 15(3), 12–22; G. McMaster (1990). Problems of representation: Our home BUT the natives' land | Problemes de representation: la terre de nos aieuls, OU de l'Autochtone. *MUSE* 8(3), 35–38 (English) | 39–42 (French); L. Todd (1990). Notes on appropriation. *Parallelogramme* 16(1), 24.

References

Alia, V. (1991, July 16). The powwow is more than just a carnival of color. *London Free Press*, London, Ontario, p. A7.

Chomsky, N. (1989). *Necessary illusions: Thought control in democratic societies*. Boston: South End Press.

Collier, S. (1991, April). At war with the army. *Ryerson Review of Journalism*, pp. 16, 18–20, 22–23.

David, D. (1991, March). After Oka: The tortured healing of Kanehsatake. *Nativebeat* 1(8), pp. 14–15.

David, J. (1991, May). [audiorecording made by Elizabeth J. Saccá, Concordia University, at Kanehsatake].

Etienne, C. (1991, July). [audiorecording made by Elizabeth J. Saccá, Concordia University, at Kanehsatake].

Gabriel, E. (1991, July). [audiorecording made by Elizabeth J. Saccá, Concordia University, at Kanehsatake].

Gabriel, E. (1992). Kanehsatake: The summer of 1990. In D. Engelstad and J. Bird (Eds.), *Nation to nation: Aboriginal sovereignty and the future of Canada* (pp. 165–172). Concord, Ontario: Anastasi Press.

MacLame, C., and Baxendale, M. (1990). *This land is our land: The Mohawk revolt at Oka*. Montreal: Optimum Publishing International.

Roth, L. (1992). Media and the commodification of crisis. In M. Raboy and B. Dagenais (Eds.), *Media, crisis and democracy: Mass communication and the disruption of social order* (pp. 144-161, refs. 181–190). London: SAGE Publications.

York, G., and Pindera, L. (1992). *The people of The Pines*. Toronto: Little, Brown.

Affinity, Collaboration, and the Politics of Classroom Speaking

Kirstin Hotelling and Alexandra Schulteis

In *Simians, Cyborgs, and Women,* Donna Haraway defines a political organization by affinity which recognizes "permanently partial identities and contradictory stand-points," where "struggle is to see from both perspectives at once because each reveals the dominations and possibilities unimaginable from the other vantage point" (154). Affinity politics, as an alternative to identity politics, is driven by the choice of shared concerns and strategies rather than by fixed identificatory markers. It exists only through conscious, committed, and voluntary participation; it cannot outlast nor pre-date its members, nor claim the support of the uninvolved. These characteristics make affinity an apt model for a classroom devoted to the exploration of how identities are constructed and deployed through language and representation. In the Women's Studies and English literature and composition classes we have designed and taught together at the University of Rochester, we have used Haraway's concept of affinity as a foundation for structuring both our collaborative pedagogy and feminist syllabi. In sharing some of our experiences here, we suggest that affinity politics encourages an unusually open and frank classroom environment, which forces participants to be responsible for their contributions and silences. Our goal as teachers is neither to direct nor censor student comments, but continually to ask our students (what it means) to be accountable for their words.

Pursuing affinity as a pedagogical model means addressing, if not overcoming students' expectations of and desire for traditional classes. Of our nine collaborative classes, for example, eight were required freshman and sophomore English classes (the ninth was an upper-level Women's Studies course). Required courses challenge

From *Feminist Teacher,* Vol. 11, No. 2 (1997), pp. 123–132.

a fundamental principle of affinity politics—that of voluntary engagement. In order to meet that challenge, we spent the first day of class, during students' "shopping period," articulating our own goals and expectations for the semester: our emphasis on student participation, grading based on critical and analytical skills rather than on mastery of the subject, and the need we will all face of applying those skills to our own writing and thinking. Also on the first day, we tell students about the other options they have for fulfilling their English requirement. We describe the themes and approaches of comparable courses offered that semester, and we encourage students to find the course that is right for them. While we cannot drop the student whose goal for the semester is "to get my four credits," we can provide students with the information they need to make an informed choice of courses. Once the semester is underway, we use student-led discussions and our collaboration to shift students' focus from asking "what the teacher wants" to participating in a communal investigation of our various subject positions vis à vis our interpretations of the texts.

The distinction between individual identity and political identity is never fixed—in our teaching we acknowledge it as constantly blurred and always historically and socially situated. At the same time, we believe that maintaining a distinction promotes a continual dialogue between identity and politics, ensuring that neither is privileged over or subsumed within the other. Identity and politics emerge from this dialogue as contingent but not conflated, and it is this tension that enables a class both to validate and move beyond claims of "experience" that can foreclose class discussion as easily as open it. "It is the unspoken law of the classroom," Diana Fuss notes in *Essentially Speaking*, "not to trust those who cannot cite experience as the indisputable grounds of their knowledge" (116).[1] The effects of this law often include a hierarchical ordering of identities (usually conceived of as oppressions) according to the topic at hand and a corresponding scale of legitimacy of participants' speech. Accountability thus becomes a question conforming to the political standards set by the most-valued speaker, a curious rearticulation of the very formula identity politics seeks to contest.

Our affinity-based pedagogy seeks to redefine accountability and authority in relation to the common goals we set for our classes. These goals emerge out of our class theme of "constructions of identity/identity as constructed." In contrast to a definition of identity based upon experience and physical markers, we work from an interrogation of identity as a nexus of language, power, and community. Asking class members to think critically about their private and political choices locates accountability in the interstices of their simultaneous identities. In a discussion of the film *Philadelphia,* for example, we focus on how the way we define ourselves as spectators dictates our responses to the film. While some class members read the Denzel Washington character's acceptance of the AIDS discrimination case as a

symptom of class status, others find his motivation in the common racial and sexual discrimination he and his client respectively experience. Comparing these readings allows us as a class to ask not only how race and sexuality overlap within the movie, but more importantly how we can trace our various responses to the identities we each privilege and exclude as spectators. Difference becomes, then, in Christina Crosby's words, "a problem for theory and not a solution" (139). It is in looking at the difference between differences, finally, that we define responsibility as the conscious ranking of those differences. "Otherwise," as Crosby notes, "differences will remain as self-evident as identity once was, and just as women's studies once saw woman everywhere, the academy will recognize differences everywhere, cheerfully acknowledging that since everyone is different, everyone is the same. Such is the beauty of pluralism" (140).

Trying to unpack the relationship between our identifications and our readings of class texts helps us to recognize how this same relationship operates in our own writing. In an early composition assignment, for example, we ask students to write two short autobiographical essays, one "true" and one "false," and to try to make each equally believable to the class. Sharing these essays in class leads to a discussion of the ways in which we try to present ourselves to others, the voices and identities we assume, and what we hope they convey. Since this is the first work students share, it serves as a personal introduction to the class as a whole and to the link between language use and identity that is the focus of the semester. The assignment has the added benefit of equalizing us all in relation to the student whose work we are discussing. Students are most proud of their work when they trick us as their teachers; and it is in participating in the process of analyzing these essays that we reveal our own assumptions about students' identities and language use.

We designed our collaboration to emphasize jointly our shared commitment to responsible language use and contingent identities and our differences in approaching and working through these concepts. While we appear in front of the class as white, middle-class women at the start of, we hope, our careers, we differ in the kinds of writing and texts we favor and in our political and academic backgrounds. In college Kirstin majored in English, with additional coursework in Psychology and Women's Studies. Her current work employs psychoanalytic and feminist theory to focus on twentieth-century American poets. Alexandra's undergraduate and graduate work in history, literature, and public policy informs her research on the intersection of psychoanalytic and postcolonial theory in contemporary literature. While our feminist perspective has grown out of a mutual theoretical interest, we use that perspective to different, though complementary ends. In both our research and our classrooms, Kirstin's emphasis is more often on internal psychic processes, whereas Alexandra's is on the social contexts of those processes. Clearly, these approaches are mutually dependent and constitutive, but their differences constantly remind us of

the foundational nature of any methodology. Beyond the philosophical interests we share, our collaboration is made possible by a strong friendship developed over the course of graduate school. The stimulation collaboration provides, whether in our graduate seminars or in our classes, more than compensates for the added financial burden and course load of collaboration. In the English Department, collaboration means teaching four courses per semester rather than two. In Women's Studies, while we are heartily encouraged to teach collaboratively, we are not compensated for doing so, and we share one instructor's salary for the course.

Our pedagogy of affinity is founded upon an interrogation of political foundations combined with a belief that such foundations are necessary. At the same time, our differences, openly stated in class, disrupt the student-teacher opposition without suggesting that authority is not an issue in the class dynamic. The structure of our collaboration in the English Department corresponds to this relationship: each of us maintains final responsibility for the conduct of her separate classes, and we collaboratively teach both classes regularly, though not necessarily every period. (In Women's Studies, the class is fully collaborative, from the syllabus to attendance to grading.) That each of us grades her own students' work and outlines the goals for every session means that students do have a place to turn to in negotiating their own progress. At the same time, we collaborate as equal partners in designing syllabi, deciding on the format of each class, and interacting with students in order to emphasize our shared investment in this project. Because the class structure is dynamic—depending on whether we jointly teach that day—students can't come to rely on a single style of direction. On the days we collaborate in class, the typical student-teacher trajectory is fractured by the other teacher's presence; eye contact and questions are dispersed, and we encourage students to address each other and not just one or both of us. Class format varies from both of us sparking discussion to one of us presenting material, to both of us working with small groups of students. Our collaboration in class is not scripted. In interrupting one another to redirect conversation or questioning each other about our statements or questions, we make our own positions available for scrutiny and interrogation.

We decide when to attend each other's classes based on our relative strengths and weaknesses (ranging from every day to once a week), a strategy that works to further contest traditional classroom authority by exposing the teacher's knowledge as partial and in process. In order to give our students a variety of tools for analyzing cultural texts we frequently combine literary or artistic texts with social or political concepts. Such pairings in the past have included selections from Marx's *Capital, Volume I* alongside Salman Rushdie's "At the Auction of the Ruby Slippers," and Freud's work on the unconscious with Charlotte Perkins Gilman's *The Yellow Wallpaper*. These texts reflect the individual backgrounds and approaches we bring to our collaboration. We alternate in presenting certain schools of thought while we

simultaneously ask questions designed to unravel the assumptions that lie behind those schools. Juxtaposing Marx and Rushdie, for instance, allows us to challenge the belief that desire is instinctual or pure: Marx's writing on commodification helps students understand the relationship between social and economic value and desire. At the same time, Rushdie's blurring of the lines between fiction and reality combined with his whole-hearted embrace of aesthetic pleasures checks the tendency to apply Marxist theories absolutely. We often present texts in this way not to promote a particular political program, but to encourage students to examine the link between authorship and identity in new ways. Here again the textual readings become a springboard for looking at how our own word choices, metaphors, grammar, and subject matter reveal our values and identities.

Collaboration also serves as an invitation to students to join with us in the common, semester-long project of the class itself. The structure of the class enables students to express viewpoints in a variety of formats, formal and informal, individually and as a group. Opening up channels of communication outside the traditional essay, individual conference, and class discussion allows us to investigate, at the level of our shared classroom experience, how context and content of speech are related. In addition to formal essays required throughout the semester we ask students to write one-page, informal, typed responses to each reading assignment. While these responses may be directed to a particular question we pose or they may be open, in all cases they are informal in terms of technical writing in order to encourage students to think critically in whatever grammatical terms they can. This temporary lifting of technical rules, rather than divorcing clear thinking from its expression, frequently provides a forum for otherwise intimidated students. As teachers, we share these responses with each other and evaluate them—with a check, check-plus, or check-minus—as an additional form of class participation, rewarding critical, invested thought that turns to the text for evidence. We tell our students to use short responses to show us how they have begun to interpret readings, not that students have read them. Our written comments to the students on these mini-papers often expand into on-going dialogues spanning several texts and class discussions. In addition, short responses allow students to question the assignment at hand while simultaneously acknowledging its relevance for the class.

Beyond the formal essays and short responses, we require students to write responses to the lengthy comments we give their formal essays. We encourage students to use these responses to our comments as a space to confront, challenge, explain, defend, praise, question, or otherwise interact with the grading process. It is essential to our project to know how our comments are received, if they are valuable to students, and where they fall short. These responses, too, may result in lengthy correspondences which force both students and teachers to re-examine their criteria for and expectations of the grading system. For example, a student in one of our

composition sections used this opportunity to question our "right" as teachers to demand he engage with a text he found "offensive": a speech by Malcolm X. Forced to explain our choices, we were simultaneously able to use this exchange to explore the nature of the "offense." This correspondence, lasting from the middle through the end of the semester, ultimately led the student to take responsibility for the racist overtones of his language, even as we were made to articulate the strategic necessity of offense.

Although usually one of the more vocal participants in this class of thirteen, this student, a white man in a class which was half white, initially preferred in this case to express his views privately to us. While class composition undoubtedly contributes to the comfort level of each student, we hesitate to proffer this as the sole explanation of this student's written responses; he frequently chose the classroom as a forum in which to encourage discussion about sensitive issues. The written exchange began with his response to Civil Rights speeches by Malcolm X, Martin Luther King, Jr., and Thurgood Marshall. While the assignment was to evaluate the different strategies presented in these texts, this student took this opportunity to express his outrage with what he termed "Malcolm X's racism." In direct response to our comments in which we asked him to consider the possible differences between Malcolm X's separatism and white racism, he focused on the role of the "victim" in our contemporary culture. His reply is worth quoting at length:

> Unless things have changed drastically, a year of welfare is more expensive than a cheap boat ticket to Africa. Be that as it may, my point was that we do not see any groups of blacks asking to go back to the place where (as they say) their culture and identity was founded. They seem to be enjoying the mother of all pity parties. We are bankrupting the country to keep these people on welfare, and they are still demanding more. . . .
>
> Blacks are the victims of welfare money handed to them with no strings attached, victims of our charity in the form of wildly inflated test scores, victims of the generosity of affirmative action institutions.
>
> We will never be able to sink our differences as "blacks" and "whites" until we can learn to take people as individuals instead of members of an ethnic group. It is ridiculous that we are discriminating against ourselves in the name of equality. True equality is that we do not ask what color our skin is on tests, job applications, college applications, or anything else—it just doesn't matter. It is time we start acting like citizens of the earth instead of self-pitying, ethnic, victims.

This student's concluding argument, for individualism with the presumption of equal opportunity, motivated a response based on several levels of affinity. As a pedagogical approach, affinity both exhibits and demands a belief in collectivity. We used the occasion of the student's remarks on individualism and racism to answer both

his concerns and his choice to write them to us rather than share them in class. The following excerpts are from Kirstin's written response:

> I agree with your statement that "we will never be able to sink our differences as 'blacks' and 'whites' until we learn to take people as individuals instead of members of an ethnic group." However, I disagree just as emphatically with your following assertion that skin color "just doesn't matter". . . .
>
> The question then still remains: what is the best way to rid our nation of racism altogether? . . . As I have said, I am also wary of dividing society into "dominant" and "victimized" cultures. However, I think it is just as erroneous, and perhaps more harmful, to go ahead with discussion and legislation as if racism didn't exist at all. . . .
>
> If you don't agree with Malcolm X's assertions and "promotion of racial hatred," then say so! Say so loud and clear so that you may open someone's eyes who is otherwise asleep! If you really care about these issues, as your emotionally invested responses suggest, then you must be willing to say what you think, even if it means being non-politically correct. People will learn from what you have to say, whether by seeing things in a new light or articulating an opposing point of view. Although you find Malcolm X's approach to be a wrong one, you certainly can't say he was apathetic or unwilling to put his life on the line for his beliefs.

By asking the student to engage with the class as a whole and to re-examine Malcolm X's strategy in the context of the other two readings, Kirstin's response prompted the student to join in the collective project of defining the "social good" from the standpoint of race. Back in the classroom, we were able to use our different approaches to the three texts to work from the student's initial outrage with Malcolm X to analyzing how these texts define their constituencies and their associative "rights."

In our attempt to advocate a politics of affinity, we see this kind of confrontation as vital; invested in the overall benefits of a traditionally graded system, we are likewise devoted to questioning the standards of that system. This assignment allows for discussion that moves outside the usual realm of student/teacher interaction; it opens up both positions to critique, thereby forcing each participant to take responsibility for his/her standing in the class.

Filmmaker Sally Potter ends *The Gold Diggers* with the words, "I know that even as I look and even as I see, I am changing what is there." It is that kind of self-awareness, hopefully leading to self-questioning, which we hope our assignments and class texts will foster. In choosing texts, we ask ourselves the following questions: How do we negotiate the line between honoring students' backgrounds and opinions and maintaining a "safe" classroom? How do we enlarge the chorus of voices both allowed and heard in the classroom? And, do students ever have a legitimate right to refuse to engage with a text on the basis of its language, images, or overall content?

While we remain committed to the principle of a "safe" classroom, we believe it is only by taking risks implicit in broadening the range of class discussion that issues of language and identity become immediate to students and available for closer analysis.

We taught Nella Larsen's *Passing* in an effort to examine the ways in which we all negotiate membership in various social groups today, and to examine the relationship between bodily specificities and one's ability to use language in different contexts. We want to focus here on how this text has encouraged student use of personal disclosure to "authorize" specific speech acts and foreclose potential responses. In each of our sections, a student of mixed race has openly identified with the character Clare and used that identification as a basis for directing discussion. One example involved a "white" male student (one of whose parents, he later told us, is black) who in the midst of a discussion about Clare's "real" race announced "Well I'm black!" Discussion halted. Rather than illustrate the constructedness of race, his comment was designed to authorize his own reading of the text at the expense of all others. His peers, none of whom were black, were able to reenter the conversation only by questioning his strategy of privileging a heretofore hidden identity, a strategy that clearly revealed his assumption of their own "obvious" races. In another class, a self-identified light-skinned black student shared his interracial background as a way of making the dynamics of passing contemporary. While with his father's family he identified himself as black, he privileged his whiteness when with his mother's. By telling his story he enabled the class as a whole to see how race is both constructed and real. This fostered a class-wide affinity based on a common interrogation of race, rather than a narrowing of discussion along lines of racial authority.

At the center of our feminist pedagogy lies a commitment to challenging normative representations of identity. Examining these most naturalized representations involves a questioning of ontology itself and, as such, necessarily entails a willingness to risk the security it provides. Risk, then, becomes a pedagogical goal, one we sometimes approach through overtly controversial texts. Two examples include a campus exhibition of world-wide AIDS awareness posters and the film *Paris is Burning*. The poster exhibit provided a forum for establishing a network of affinity between the classroom and other communities to which we belong; at the same time, the recognition of this network broadened the scope of sanctioned expressions within class. Holding class in the gallery, particularly during this sexually-explicit exhibition, undermined boundaries between the classroom and the wider campus community: the gallery remained opened during our classes, and others often joined our discussions. Some students went beyond the limits of the class to attend lectures on AIDS discourse which accompanied the exhibit. By enlarging the confines of the traditional class in terms of locale and content, we risked the expression of reactions we could not predict or control. In one session, a female student was clearly upset by the fetal images included in the exhibition; throughout much of the hour she sat

quietly, but openly, crying. Her decision to attend class—after we had briefed the students on the graphic and potentially disturbing nature of the images—reflected her sense of safety there. Most importantly to us as teachers, it was the class as a safe environment that allowed her to engage with material she may otherwise have avoided; her reaction also made it more difficult for her peers to dismiss their own discomfort. It is only by exposing this discomfort that we can begin to unravel and respond to it critically. At the same time, it is to the credit of the students that they were able to overcome their initial discomfort upon entering the gallery in order to share with one another and other visitors their interpretations of the images.

Discomfort surfaced immediately in students' reactions to *Paris is Burning*. The documentation of homosexuals, transsexuals, and transvestites in New York City in the 1980s, not to mention their configuration in family units, elicited reactions ranging from disgust to amusement to compassion. To begin one of our upper-level sections, a student, slightly older than the others and working full time in addition to taking classes, asked to read an outside text aloud. He was one of the quieter students in class and only spoke when he had seriously thought through his comments. He introduced a selection written by Ron Hubbard which describes homosexuality in any form as deviant and pathological. The student ended his reading with the comment, "And I agree with Ron Hubbard." This statement resulted in one of those moments when, as teachers, we realize how powerful our authority may be in directing class discussion. We were faced with the dilemma of responding viscerally to the content of his contribution versus legitimating his right to speak. The rest of the students also paused at this moment to gauge our reaction. While we don't hide our own positions in class, arguing from those positions here would have foreclosed a rich opportunity for critical rather than reactionary analysis. Our response, therefore, was to turn the student's comments back to the class as a whole, asking how one of the "house mothers" would respond to Hubbard. Students responded to this question by directly challenging the assumptions underlying Hubbard's rhetoric; consequently the initial student was called upon by his peers to investigate his own appropriation of that language. Moving beyond a willingness to tolerate the text to engaging critically with it required a collaborative effort. As each of us works hard to create a "safe" classroom forum, it sometimes takes the other's presence to risk the security of comfortable classroom discourse. We have consistently found that using our different rapport with individual students allows us to push them in ways one of us alone could not. This method of interrogation once again asks all of us to take responsibility for the choices we make in defining our spectatorial and discursive positions.

Risk in the classroom increases as we move from recognizing the constructedness of our positions towards defending or refiguring those positions. As a way of extending the accountability for our reactions that class texts demand, we incorporated

a student-directed symposium in our Women's Studies class. In the symposium, structured around the notion of gender as a problem—i.e., a concept in process, students chose to research and present contemporary issues where gender is most salient in their lives. The emphasis of this class project was on developing and sharing strategies for confronting gender as a problem, a goal which necessitates establishing foundations without recourse to essential identities. By discussing how gender is defined in these issues and the strategies that respond and potentially alter those definitions, the symposium as a whole underscored the malleability of gender as a concept as well as the need to use it. Student topics ranged from pornography to consent law in rape cases to the legitimization of homosexual marriages. Drawing on a plethora of research methods, students were able to offer concrete workable solutions to the dilemmas they outlined: "decriminalizing" rather than "legalizing" prostitution, rewriting legal language to expose and excise its masculinist bias, and creating a platform based on "human rights" as a way to avoid the biology versus behavior impasse when seeking civil rights legislation for homosexuals. As a way to synthesize the implications of these solutions on gender norms, we asked students to prepare a final response to the following questions: How do these strategies reconfigure, redefine, subvert, or leave untouched constructions of gender? Are those definitions of gender transferable from one symposium topic to another? How effective is "women" or "men" as a political category? What do you think are the benefits and drawbacks of a politics organized in these terms? And, finally, do your answers apply equally to racial, sexual, and class affiliations?

Because responses to these questions varied, our last class discussion became an example in and of itself of both the rewards and challenges of affinity politics. For instance, the student who advocated the re-writing of masculinist legal language found himself deconstructing the naturalized relationship between gender and language just as he was forced to recognize the material experiences that are shaped by that relationship. Consequently, the category "women" became both the problem and a part of the solution: while we need to expose the category "women" as inessential in order to rethink the masculinist bias of legal language, we must emphasize the brutal physical and psychic impact of rape in our culture as an experience almost exclusive to those marked as "women." At the same time, the student researching the legalization of homosexual marriages saw the overlap between the legal language surrounding rape and that of civil rights; in turn, she shifted the discussion by pointing out the heterosexual presumption that was ostensibly left unchecked by her classmate's analysis. The students working on pornography and prostitution brought class status to the center of the conversation as they asked their peers to focus on the relationship between legal agency and relative wealth. The students did not leave this final class discussion with clear answers to the questions we provided; indeed, they seemed to leave with more questions than answers. However, by presenting their individual

symposium solutions within a forum shaped by the advocacy of affinity, the students were motivated to challenge each other's assumptions as a means of strengthening their roles as responsible writers and thinkers.

Our collaboration has taught us how affinity may serve to relocate account-ability from de facto to constructed identities, to link ostensibly disparate texts and methods, and to bridge class goals with the greater social arena. By investigating the way language produces identities, we learn to take responsibility for the power of the language we use. That willingness to take responsibility and to risk translates into a classroom safety founded on a shared commitment to question what is most familiar to us. This process shifts the locus of authority from who says what to what one says in a given context.

Notes

1. Fuss goes on to offer an alternative to this law. She emphasizes both the inextricabil-ity of essentialist and anti-essentialist positions and the need to recognize the experi-ences students do bring to the classroom. Those experiences, she suggests, rather than standing as "the real," might instead "function as a window onto the compli-cated workings of ideology." She concludes, "'Essentially speaking,' we need both to theorize essentialist spaces from which to speak and, simultaneously, to deconstruct those spaces to keep them from solidifying. Such a double gesture involves once again the responsibility to historicize, to examine each deployment of essence, each appeal to experience, each claim to identity in the complicated contextual frame in which it is made" (118).

References

Crosby, Christina. "Dealing with Differences." Feminists Theorize the Political. Ed. Judith Butler and Joan W. Scott. New York: Routledge, 1992. 130–143.

Fuss, Diana. Essentially Speaking: Feminism, Nature and Difference. New York: Routledge, 1989.

Haraway, Donna J. Simians, Cyborgs, and Women: The Reinvention of Nature. New York: Rout-ledge, 1991.

Knitting as an Aesthetic of Civic Engagement: Re-conceptualizing Feminist Pedagogy through Touch

Stephanie Springgay

Introduction

We are in the midst of an explosion in the popularity of knitting. Shifting the traditional stereotype of what a knitter should be, the youth of today have taken up knitting as a tactile and embodied form of connectivity. In a rapidly changing and unpredictable world, characterized by, among other factors, the unprecedented expansion of global flows and patterns of social interaction, youth are increasingly involved in complex forms of interconnection. This has important implications for the ways that feminist pedagogy is re-conceptualized, lived, and practiced. Many feminist scholars, such as Leila Villaverde (119) and Sharon Rosenberg (234), have begun to unsettle pedagogy, seeking ways to create sustained engagements that rupture the limits of meaning making. My own "unworking" (Nancy 27) of pedagogy is tangled up with these new cartographies, as I attempt to bring the materiality of the body into the feminist classroom.

I arrived as a women's studies professor rather by chance, having practiced for many years as a feminist artist with a scholarly background in visual arts and education. It is from these intersecting perspectives that I embarked on a bit of a pedagogical experiment with my undergraduate students. I decided we would all learn to knit together. As the semester unraveled so did my thinking about feminist pedagogy and its relationship to the body. This paper grows out of this experience. It examines the embodied and tactile acts of visual culture and youth activism, and it re-conceptualizes globalization, collectivity, and feminist pedagogy from the

From *Feminist Teacher*, Vol. 20, No. 2 (2010), pp. 111–123.

perspectives of relationality and touch. Initial questions include: How might we understand collectivity, pedagogy, and globalization through visual culture? How might we understand the connective potential of the circulation, participation, and performance of visual culture in youth cultures? And how might such examinations bring about a re-conceptualization of feminist pedagogy—as pedagogies of touch—that enfolds bodies, tactility, and activism with changing global youth cultures?

In order to examine these questions, I will first analyze activism as art, and in particular theories regarding new youth subcultures of resistance. I then discuss two activist knitting projects and consider how they encourage interpersonal or political engagement that is embodied, tactile, and connective. These projects serve as contextual examples, highlighting the ways that youth are re-conceptualizing feminist pedagogy as embodied and relational. Following these examples, I focus my attention on an activist knitting project that emerged in my undergraduate women's studies course. While some scholars believe that today's youth resistance seems obscure, transitory, and disorganized (Harris 1) my examination of youth's lived experiences demonstrates that youth have new ways of taking on politics and culture that may not be recognizable under more traditional frameworks. It is in these unfamiliar and unrecognizable gaps, I argue, that an understanding of feminist pedagogy, as pedagogies of touch, takes shape.

Activism as Art

Many of us harbor an image of the knitter as a grandmother in a rocking chair. However, youth knitters and uncanny forms of knitting have gained in popularity in the twenty-first century, giving a twist to the traditional afghan, baby booties, and sweater. In Canada, for example, youth gathered for a "Rock and Knit" fest in a local bowling alley; there are countless blog sites attesting to the growing interest in knitting unusual patterns and objects, and stitch 'n' bitch clubs are increasing in popularity on university campuses. While the do-it-yourself (DIY) movement and third-wave feminism are contributing factors to the knitting revival (Wills 20) other reasons include a new approach to connectivity and resistance.

Youth resistance, although commonly framed around a "subculture" paradigm that posits a "heroic" notion of resistance and a static or fixed category of youth affiliation, has more recently been replaced with theories of neotribes, youth lifestyles, scenes, and new communities, which are more transitory, fluid, and not organized around a single resistant identity. Neotribes, argue Anoop Nayak and Mary Jane Kehily (13), are loose groups of young people who come together momentarily over shared interests and create moments of sociality. Moreover, the shift from subcultures to neotribes reflects the movement from locally bound to globally connected youth

cultures. These new perspectives on youth cultures, asserts Anita Harris, are examples of youth citizenship "in that they represent ways young people can get together and debate social issues, enact alternative social arrangements and create spaces for alternative transitions and alternative political forums" (4).

Third-wave feminists have also sought to expand notions of resistance. Broadening a sense of what "action" is, third wavers suggest that youth "have complex relationships with popular culture that require them to negotiate, infiltrate, play with, and undermine feminine cultural forms rather than simply reject them" (Harris 7). Cultural resistance becomes a mutable, creative, and negotiated space that is a political activity in itself.

In the arts, resistance has also taken on a new form. Activist art has commonly been understood to be an art form that carries political content. Today, however, a new form of artistic activism is taking shape. Inspired by the Situationists of the 1960s, activism *as* art often fails to look like art and might not involve any pre-existing form of creative activity (e.g., painting, sculpture, or theatre). Activism as art often harbors what Darren O'Donnell refers to as "an aesthetic of civic engagement" (26), whereby art is based on social relationships that make culture and creativity a central part of civic life. It is the processes of participation that *are* the works of art themselves. For instance, O'Donnell, a Toronto-based artist, is well known for his public "Q & A" sessions, where members of the public interview and ask strangers questions with the sole purpose being the asking of questions or the art of inquiry. It is not the answers to the questions or composite characters drawn from the Q & A sessions that become works of art, but the act of inquiry itself. Socially-engaged art, writes Claire Bishop (12), is concerned with the desire to create active subjects through participation, collaboration, and community-building. Activism as art focuses on the collective elaboration of meaning and aims to produce new social relationships and thus new social realities (Bourriaud 19). Such an understanding of civic engagement in and through the arts is evident in new youth cultures.

Growing up immersed in a consumer culture, many young people are discovering their own powers as producers, turning their media-saturated childhoods into media-literate action. Exploring new ways to subvert dominant codes and to express alternatives through emerging technologies and creativity, youth connect and learn from each other in previously unimagined ways. As Carly Stasko, a Toronto based zine artist, writes: "Through culture jamming I was able to express my own resistance and critical awareness so that as I traveled through my environment I could feel authentically engaged and empowered" (207). As a form of culture jamming, knitting involves youth in performance, experimentation, evaluation, reflection, and interpretation, or what Elizabeth Ellsworth refers to as a pedagogy in the making, "harboring and expressing forces and processes of pedagogies as yet unmade, that provoke us to think or imagine new pedagogies in new ways" (6).

The theories and methodologies emerging in critical youth studies and relational art practices need to be reflected in the ways we theorize, understand, and practice feminist pedagogy. Pedagogy then becomes an ongoing event—a lived experience articulated with, in, and through the body. Such an understanding shifts our thinking from youth as *having* bodies that pedagogy acts on, toward a re-conceptualization of pedagogy *as* bodied. In developing pedagogy as bodied, I turn my attention in the following section to two activist knitting sites, examining them in relation to embodiment, connectivity, and pedagogy.

Knittivism

"knittivism: *n* 1 a doctrine emphasising vigorous or militant knitting activity, e.g., the use of knitting in mass demonstrations, urban interventions, in controversial, unusual or challenging ways, *esp* political, causes. 2 the systematic use of knitting for political ends. knittivist *n* and *adj.*"[1]

Knitta is a Houston-based graffiti knitting crew who combine the idea of a knitted tea cozy with gestures of street graffiti. They tag street lamps, public statues, handrails, gates, and other public and private property with impractical hand-knit cozies. Advocating knitting as an adventurous experience, Knitta encourages knitted tags as acts of pleasure, confusion, and surprise. Handmade and irreverent, their work engages in transforming the modern city with an aesthetic that is both alarming and cozy. Speaking about their work, the Knitta members say: "We go beyond simply wanting attention. We prove that disobedience can be beautiful and that knitting can be outlaw" (http://www.knittaplease.com/KNITTA_PLEASE.html). The uselessness of their actions—some critics have suggested they should focus their energy on knitting blankets for the homeless—is intended as an examination of the "thingness" of things. The "thingness" is not the object itself per se but its excess, its temporality, and its sensuousness. Bill Brown, in theorizing things, writes, "thingness amounts to a latency (the not yet formed or the not yet formable) and to an excess (what remains physically or metaphysically irreducible to objects)" (5). Thingness, he suggests, points towards the objects'/things' materiality, while simultaneously naming something else. Tags become a re-examination of mundane objects as signifiers for sensory information, knowledge, and memory while highlighting the interwoven nature of our perception and the interplay between art and life. Thingness asks questions not about what things are, but about their "subject-object relation in particular temporal and spatial contexts" (Brown 7). Knitting as a relational and embodied activity invites thingness to interconnect and intertwine subjects through various bodied encounters. If we consider knitting as a place of learning that de-centers pedagogical practices, then bodies become implicated in the processes of meaning making. Knitted tags approach pedagogy as unsettled—as events that are "in the making"—open and never

fully achieved. This, suggests Ellsworth, "creates the opportunity for a pedagogy in which we come to know the world by acting in it, making something of it, and doing the never-ending work and play of responding to what our actions make occur" (56). Knitting becomes a pedagogy of interrelations.

Cat Mazza, the artist behind the knitting organization "microRevolt" (www .microrevolt.org), started knitting on her long commute to work at a nonprofit art and technology center in New York City. Interested in knitting and feminized sweatshop labor, she finds the intersections between textiles and technology compelling. Some of her work includes knitting corporate logos into garments, an act she says "simultaneously glorifies and assaults corporate logos' symbolic power" (Gschwandtner 121). Her website functions as a campaign against sweatshop labor by encouraging others to logoknit and by educating them about sweatshop labor. Since 2003 she has been collecting small knitted or crocheted squares that act as signatures on a petition for fair labor policies. As a tactile and embodied form of signing a petition, the fourteen-by-nine foot blanket in the shape of the Nike swoosh gestures towards an aesthetic of civic engagement, where art forms do not exist as static images but are experienced as processes and as movement. Learning becomes a means of participating in the world through movement. When we consider learning as being in motion, we are confronted with a pedagogical encounter imbued with forces, oscillations, intensities, and energies, exceeding the limits of knowing, being, and creating.

Drawing on Deleuze and Guattari's (190) molecular theories as small gestures of resistance, Mazza has since developed a computer program that automates knitting patterns. Knitpro lets users of her website turn any image into a chart that knitters can read and map into a pattern. Additionally she has designed a program that takes digital video and alters it into images of various stitches. Her documentary "Talking Stitch," in which she interviews people working in anti-sweatshop activism, turns talking heads into moving stitch patterns that are flat, pulsating, abstract textiles. Her site features a blog where posted links to projects made by other DIY activists and crafters are networked, providing a viable, sustainable alternative to mass production. This microeconomy is intended to create an alternative to sweatshops while also connecting people one stitch at a time. Collectivity, according to Michael Smith, is the foundation upon which the transglobal is based, and Smith proposes that in order to understand the future of urban change we must focus our attention upon communication circuits, no matter how complex, by which people are connected to each other, make sense of their lives, and act upon the worlds that they see, in which they dwell, and through which they travel (311). This collectivity occurs as we arbitrarily gather to take part in different forms of cultural activity. However, the performed collectivity that is produced in the very act of being together in the same space and compelled by similar activities produces a form of mutuality that is not always based on normative modes of shared beliefs, interests, or affiliation. In other

words, collectivity alters a hegemonic perception of community, where community is understood solely through roots of origin, and replaces it with a process of "becoming community"—a mobilizing force that has no end (Nancy 23). In a pedagogical sense, collectivity does not depend on dialogue where each person engages equitably in sharing her or his experiences and thoughts; rather, it acknowledges that collectivity is fragmented, unstable, and not given.

Collectivity in this sense is engaged with what Hannah Arendt calls the "space of appearance" characterized by speech and action or a coming together for a momentary expression and then coming apart again. Arendt's "space of appearance" is not a physical space demarcated by buildings, environments, or tasks, but one that comes into being through relational embodied understanding of actions and of the bodies/subjectivities created through these actions. Rather than an understanding of self and other as oppositional, community becomes imbricated and reciprocal, offering a reconceptualization of self and other in which these previously distinct parts constantly inform each other and their relationship. The potentiality of this "space of appearance," writes Arendt, "is that unlike the spaces which are the work of our hands, it does not survive the actuality of the movement which brought it into being, but disappears not only with the dispersal of men . . . but with the disappearance or the arrest of the activities themselves. Wherever people gather together, it is potentially there but only potentially, not necessarily and not forever" (qtd. in Rogoff 117). Collectivity, in this sense, implicates pedagogy "in the promise of an indeterminate, unspecifiable future and an unlimited open-endedness" (Ellsworth 122). This coincides with community-based artist and scholar Stephani Etheridge Woodson's consideration of art as a research methodology as well as a complex process of learning and identity formation. Artistic practice functions as both the object/subject of study and the interpretive space through which to explore collective and embodied ways of knowing. The arts, she argues, assist participants in "becoming aware of their own power as cultural makers and (re) makers" (291).

Attempting to bring together theories and practices of youth cultures, relational art, and embodied pedagogy, I gave my undergraduate students sets of knitting needles and yarn. I invited them to learn to knit alongside me as we discussed weekly readings, film clips, and contemporary feminist art practices. What emerged from this experience was a knitivism project and a re-conceptualization of feminist pedagogy as tactile, bodied, and collective. In the remaining section of the paper, I discuss the students' knit-in project and propose an experience of teaching and learning through pedagogies of touch.

Pedagogies of Touch

For the past five years I have taught at a large university in two departments—art education and women's studies (I have since moved to another institution). The joint

appointment allowed me to bring together my interests in a bodied curriculum and pedagogy with gender and youth studies and feminist visual culture. As a teacher, I desired to create a classroom space in which theory is lived not only in the classroom but also in relationships and encounters between people. Favoring classrooms that foster listening (Jones 57), accusation (Mayo 170), and critical dialogue (Ellsworth 297), I invited my students to experience bodily ways of knowing, through such things as performance art or media production.

One semester I arrived in my undergraduate women's studies class with a bag full of red and pink yarn and some inexpensive needles. My intent was simply to disrupt the normative ways that students shared and discussed common readings and other class-related texts. I wanted to insert the body into the classroom practice; to have us "do" something with our hands, not simply our minds. I also didn't know how to knit and thought it might be interesting for the class to work on something together where I was not perceived as the expert. The students, all women, were surprised that a feminist teacher, and in a women's studies class, was asking them to engage in what they saw as a stereotypical feminine pastime. Some were thrilled at the opportunity to learn to knit, while others were embarrassed, if not slightly incensed that their tuition was being put towards such frivolous and gendered acts. Not one of the students in the class had ever considered knitting as anything other than a gendered act. Through weekly readings, discussions, and presentations on the history of knitting, contemporary knitting, and activists, the students began to realize that knitting could in fact be done to challenge and subvert gender norms. One student reflected on this change:

> Knitting in a Women's Studies class created an interesting dynamic. Not recognizing the possibility of redefining the act of knitting, I originally thought that learning how to knit seemed somehow the antithesis of the progress of the feminist movement. However, once we learned how to knit, it became simply a peaceful activity in which we could all partake while discussing feminist pedagogy. Throughout our study of feminist pedagogy I came to view our knitting as an opportunity to redefine gender stereotypes and together, as a Women's Studies class, we were able to figure out a way to not only re-define the act of knitting but use it as a form of activism to support political issues.

She continued: "Knitting is stereotypically viewed as a gendered activity performed only by women within the private or domestic realm. By taking knitting into a public realm we were inevitably challenging this stereotype. Moreover, because knitting is often expected to remain within the private realm, it lends itself well to activism because it draws attention." Viewing knitting as a site of women's collective voice in action, another student noted: "Not only were we able to disrupt space by performing a private act in public but we were able to (somewhat) challenge gender roles and dynamics at the same time."

One student, however, refused to knit the entire semester, disinterested in the textile craft. She claimed she did not knit because she was not good at it. While many of the students embraced their dropped stitches and droopy tensions, this student was not able to move beyond the boundaries of perfection, a condition enforced through normative and disembodied education that focuses on memorization, standards, and the acquisition of skills. For most of the students, as the semester unraveled so did their thinking about knitting and its relationship to feminist pedagogy, and eventually the students created their own activist knitting project—a knit-in for Darfur (the above student did participate in the knit-in—she did not knit but made all of the publicity signs and posters for the event).

I had not imagined a student-organized activist project when I put the syllabus together, but toward the end of the semester the class asked if they could organize and participate in a knitivism project. The class brainstormed a number of "causes" including sweatshop labor and sexual violence. In the end the class decided to focus on Darfur because they had collected the most amount of research on the topic (something I had expected them to do on each of the causes they wanted to support); it brought together issues of sexual violence, human rights, and gender; two students in the class had personal experiences that related to the topic (they had taken classes that specifically addressed the genocide in Darfur and/or they had taken a service learning class from the women's studies department in Tanzania); and the class believed that the general student population at Penn State did not know very much about Darfur.

At the end of the semester I asked students to write a short critical reflection paper on their understandings of and experiences with knitivism. I informed the class that I would use these papers to develop my own understandings of feminist pedagogy and that I would also include segments of their writing in my academic writing on the subject. I have also continued to interview many of the students who continue to be involved with knitivism on campus. The theories and research I cite in the paper, and the two knitting activists referenced, were all introduced to the class throughout the semester, so while this paper is told from my perspective and theoretical analysis, it embodies the very acts and conversations that we shared in the class. For example, one student wrote:

> Contributing my time and energy to the knit-in for Darfur truly changed my life; it changed the way I look at the world. Through Women's Studies 401 and my research, I found that there is a significant relationship between feminism, art, and activism. The diversity of artistic methods, central ideas of feminist activist art, notions of public and private, notions about gender and the significance of feminist activist art are all themes worth reviewing, discussing, and responding to. These themes also directly relate to the experience of participating in the knit-in for Darfur.

At the end of the semester three students from the class formed an on-campus club for knitivism. The club, with over fifty active members, has organized a number of different knit-ins over the past year including one on sexual violence on campus (raising money and knitting scarves for the local women's shelter); a twenty-four-hour knit-a-thon for Darfur; and one to raise money for the local homeless shelter. Students in the class and in the knitivism club are interested in knitivism because it is "peaceful" and different from what they imagine "traditional" activism looks like. In the majority of their written reflections on knitivsm and in interviews students emphasize the peaceful nature of knitivism and state that they choose to be involved in this form of activism because it does not look like traditional forms of activism, which they associate with marches, protests, and angry voices.

In order to prepare the class for knitting in public I had the students engage in a variety of public knitting events, such as knitting on local buses, in the student union building, and tagging trees on the University campus. One student reflects:

> From the moment we began to knit on the Blue Loop I could feel myself taking up space. I actually felt uncomfortable (at first) because I was afraid other riders would resent me for taking up a seat. However, the longer we were on the bus, the more comfortable I felt, and the more I felt that I had a right to sit on the bus and knit. At the knit-in, I am sure that many passersby were baffled by the simple act of knitting. Many believe that knitting is something that is done in private by older women; however, we were able to change those assumptions. By knitting in public and peacefully disrupting a space, we brought a private act into a public setting. In doing so, we generated much attention and hopefully a greater awareness of the genocide taking place in Darfur.

Although not all witnesses to the public knitting knew about the feminist thinking behind knitivism, many people did stop and talk to the students because knitting in public was so unusual for the campus. It was through these informal conversations that the students were able to communicate their understandings of feminist pedagogy and activism to the public. In addition the students were featured in the campus paper and on the campus TV station, providing them with further opportunity to talk about knitivsm, feminist pedagogy, and their efforts for change in Darfur. The knit-in, which was held on the lawn outside the central library on campus, attracted knitters from the local community and students who wanted to learn to knit or join the knitting cause. There were twelve students in class, but often more than thirty people could be seen knitting on the grass at one time. The students raised enough money through dollar donations to send over a dozen solar cookers to Darfur.

The knit-in, writes one student, served as "an unconventional, non-confrontational way of disrupting and redefining space." The students contextualized their

actions as subtle, passive, and unobtrusive. Knitting, one student says, "embodies change and provokes thought by disrupting social and spatial norms." Many of the students began to understand activism as a "way of life," whereby "we didn't simply protest about the need for humanity to treat one another with more genuine care; rather we embodied that idea and acted upon it through knitting." Another student says, "Our knit-in worked on the 'lifestyle' level as we enacted the change we wished to see." Care in this instance refers to relational acts of being-with; an intercorporeal act that implicated self and other in the process. Similarly, the change that the student refers to here is the embodied relationality of knitivism that she hoped would transform other Penn State students' understandings of Darfur, activism, and knitting.

Materializing bodily experiences in the classroom initiates new possibilities, new ways for "bodies to matter" (Butler 12). This type of work may open up the possibility of pedagogical practices that attempt to work across the contradictions between self and other, private and public, body and image, bearing witness to these contradictions while inviting students to bring them together, to examine them, to experiment with engaging them differently in the world. Shifting the terms of representation, knitting and all of its tensions and contradictions may eventually produce transforming ideas—ideas that may work toward thinking about the world relationally, where "the goal is not to undo our ties to others but rather to disentangle them; to make them not shackles but circuits of recognition" (Gonick 185). Knitting as an active reworking of embodied experience involves *pedagogies of touch* (Springgay 124) where knowing is constantly interrupted and deferred "by the knowledge of the failure-to-know, the failure to understand, fully, once and for all" (Miller 130). It is the unthought that is felt as intensity, as becoming, and as inexplicable that reverberates between self and other, teacher and student, viewer and image, compelling a complex interstitial meaning-making process. Writing about pedagogical relations, Ellsworth states: "In excessive moments of learning in the making, when bodies and pedagogies reach over and into each other, the pedagogical address and the learning self interfuse to become 'more' than either intended or anticipated. In some cases, they become more than they ever hoped for. The instability and fluidity of pedagogy hold the potential for an unknowable and unforeseeable 'more,' and the actualization of that potential is what springs the experience of the learning self" (55).

This "more" shifts teaching and learning away from representation of something with a meaning, to an aesthetic assemblage, which moves, modulates, and resonates through processes of becoming that are imbued with bodily sensations such as touch. Western thought has always privileged vision as the dominant sense, equating it with light, consciousness, and rationalization (Vasseleu 21). The other senses, marked by the body, were understood as interior sensibilities and thus of lesser value (Classen 50). For instance the differences between the following two turns of phrase signify the ways in which Western thought has constructed knowledge as separate from and in

opposition to the body. "I see" has commonly connoted knowing or understanding, while "I feel" is often associated with intuitive knowing, which has historically been condemned as ridiculous and dismissed as trivial.

While vision is premised on the separation of the subject and object, creating a rational autonomous subject, touch, as a contact sense, offers contiguous access to an object. Touch alters the ways in which we perceive objects, providing access to depth and surface, inside and outside. Touch as a way of knowing can be understood through two modalities. First, touch is the physical contact of skin on matter. The second modality is a sense of being in a proximal relation with something. In visual culture this has often been addressed as synaesthesia. Synaesthesia refers to the blurring of boundaries between the senses so that in certain circumstances one might be able to say, "I can taste a painted image." A further understanding of proximity has been taken up by corporeal phenomenologists (e.g., Merleau-Ponty) and feminist scholars (e.g., Ahmed & Stacey; Grosz) who argue that knowledge is produced through bodied encounters (Weiss).

Inter-embodiment, an approach explored by feminist scholar Gail Weiss, emphasizes "that the experience of being embodied is never a private affair, but is always already mediated by our continual interactions with other human and non-human bodies" (5). Inter-embodiment, or relationality, poses that the construction of the body and the production of body knowledge is not created within a single, autonomous subject (body), but rather that body knowledge and bodies are created in the intermingling and encounters between bodies. Elizabeth Ellsworth maintains that a relational learning experience "acknowledges that to be alive and to inhabit a body is to be continuously and radically in relation with the world, with others, and with what we make of them" (4). How we come to know ourselves and the world around us, our subjectivity, is performed, constructed, and mediated in relation with other beings. It is this relationality that is crucial. Rather than knowledge formed through the rational autonomous I, knowledge is the body's immersion, its intertwining and interaction in the world and between others.

In proposing *pedagogies of touch* I draw on poststructuralist feminist pedagogies and theories of inter-embodiment and relationality. In her critique of critical pedagogy, Ellsworth reminds educators that pedagogies need to move away from "reason" and recognize that thought, knowledge, and experience are always partial—"partial in the sense that they are unfinished, imperfect, limited; and partial in the sense that they project the interests of 'one side' over others" (305). Shifting emphasis from "empowerment," "voice," "dialogue," "visibility," and notions of "criticality," poststructuralist pedagogies problematize partiality "making it impossible for any single voice in the classroom . . . to assume the position of center or origin of knowledge or authority, of having privileged access to authentic experience or appropriate language" (310). Rather, as Villaverde suggests, it is important that pedagog(y)ies engage

with "dangerous dialogues" in "order to expose the complexity of inequity and our complicity in it" (125). Deborah Britzman asks questions about the production of "normalcy" in the pedagogical encounter, creating the myth of the stable and unitary body/subject as the center from which all else deviates. Unhinging the body from such normalizing practices, how might *pedagogies of touch* "think the unthought of normalcy" (Britzman 80)? Unsettling and rupturing the limits of normalcy and representation *pedagogies of touch* help us "get underneath the skin of critique . . . to see what grounds have been assumed, what space and time have remained unexamined" (Roy 29). Furthermore, *pedagogies of touch* stress the need for an ethics of embodiment where transformations are connected to body and flesh and to a perception of the subject as becoming, incomplete, and always in relation (Springgay 153). Thus, ethical action becomes unpredictable and adaptive (as opposed to enduring and universal), and it is what happens when we venture into the complexities of the unthought.

Pedagogies of touch compel us into a place of knowing that is aware of how much it does not know, leading us to an elsewhere that is replete with what Barbara Kennedy calls an "aesthetic of sensation." An aesthetic of sensation "is not dependent on recognition or common sense" (110), but operates as force and intensity, and as difference. This, argues Kennedy, has significance for the way we approach perception. Visual culture then shifts from being "representation" to a material embodied encounter as sensation. Images/pedagogies do not exist as static forms, but are experienced as processes and as movement. An aesthetics of sensation is not based on "normalcy" or structuralist semiotics, but an aesthetics that vibrates and reverberates in modulation with, in, and through bodied encounters, shifting such concepts as "beauty" from form to a process—an assemblage. It is an aesthetic of civic engagement. Thus, in *pedagogies of touch* movement becomes an essential element.

For instance, the knitted tags that now adorn the University campus, attached to hosts such as trees, lamp posts, and stairwells, rest momentarily until they are set in motion once more; taken down, discarded, re-tagged, and transformed. The movement and sensation of knitting is not perceived outside of the body, but "rather [are] affections localized within the body" (Kennedy 118), thus materializing a pedagogical encounter imbued with forces, oscillations, intensities, and energies.

At the heart of *pedagogies of touch,* normalcy, the common, and representation become un/done, entangled again and again as difference. Says one student of the project:

> Knitting will not end the genocide in Darfur. Knitting will not stop 4.2 million native Africans from losing their homes and being torn from their families nor will it save 400,000 from death. Knitting allows for artistic and emotional expressions. Knitting is a peaceful outlet for individuals' opinions and voices. Knitting instills harmony through the tranquil move-

ments of two needles and a ball of yarn. Activism through knitting does not require enormous numbers and large crowds. Knitting provides an open door policy that many of the young women in our class have never seen. It offers a policy that is not often given by other forms of activism. Knitting invites young minds to create activism instead of "doing" activism. Knitting never demands much nor does it judge others. Knitting is believing you can make a difference one stitch at a time. Knitting involves being fearless and accepting of the notion that we do not have all the answers nor could we ever understand the complexities and horrors of genocide.

Knitting/knitivism is important for the ways it highlights how young people materialize their own bodied subjectivities, imaginations, and communities, and produce the new conditions for how they live their lives. Moreover, it embraces Nadine Dolby and Fazal Rizvi's arguments that the classroom is no longer the sole pedagogical site for youth (5). My call for pedagogies of touch is not for teachers all to bring knitting needles to class. Rather, to be relevant, responsive, and critically engaged we need to think about pedagogy as something in the making, as an embodied, experiential, and relational process that is irregular, peculiar, or difficult to classify only when viewed from the center of dominant educational discourses. As a student wrote in her class reflections,

> My experience with feminist activism has worked to open my eyes to how far reaching and indefinable activism truly is. My own stereotypes of what I viewed as activism have been interrupted and reconstructed to include the facets of feminist activism—embodying the changes as a way of life, disrupting space, and ultimately redefining social norms. Moreover, having learned about this idea of making activism a lifestyle has inspired me to incorporate my own individual forms of activism into my everyday life such as regularly knitting in public and periodically offering free hugs. Knowing now that to embody change is to create change in this world, it has become clear that feminist activism is at the heart of true change.

Whether knitting, hugging, or engaging in other relational encounters, pedagogies of touch enhance moments of knowing and being that are unfamiliar. Touch becomes a commitment to knowing that is engaged, emphasizing bodied encounters that are interrogative and unsettling. Pedagogies of touch open up feminist classrooms for other ways of understanding based on sensations and flows of interconnecting spaces, endowing education with contradictions and complicated knowledge.

Note

1. Definition from http://www.glittyknittykitty.co.uk.

References

Ahmed, Sarah, and Jackie Stacey. *Thinking through Skin.* London: Routledge, 2001.

Bishop, Claire. *Participation.* Cambridge, MA: MIT Press, 2006.

Bourriaud, Nicholas. *Relational Aesthetics.* Paris: Les presses du réel, 2002.

Britzman, Deborah. *Lost Subjects, Contested Objects: Toward a Psychoanalytic Inquiry of Learning.* Albany: State University of New York Press, 1998.

Brown, Bill. "Thing Theory." *Critical Inquiry* 28.1 (2001): 1–22.

Butler, Judith. *Bodies That Matter: On the Discursive Limits of "Sex."* New York: Routledge, 1993.

Classen, Christina. *Worlds of Sense: Exploring the Senses in History and across Cultures.* New York: Routledge, 1993.

Deleuze, Gilles, and Felix Guattari. *A Thousand Plateaus: Capitalism and Schizophrenia.* Minneapolis, MN: University of Minnesota Press, 1987.

Dolby, Nadine, and Fazal Rizvi, eds. *Youth Moves: Identities and Education in Global Perspective.* New York: Routledge, 2008.

Ellsworth, Elizabeth. *Places of Learning: Media, Architecture, Pedagogy.* New York: Routledge, 2005.

———. "Why Doesn't This Feel Empowering? Working through the Repressive Myths of Critical Pedagogy." *Harvard Educational Review* 59.3 (1989): 297–324.

Gonick, Marnina. *Between Femininities: Ambivalence, Identity, and the Education of Girls.* Albany: State University of New York Press, 2003.

Grosz, Elizabeth. *Volatile Bodies.* Bloomington: Indiana University Press, 1994.

Gschwandtner, Sabrina. *KnitKnit.* New York: Harry Abrams Inc., 2007.

Harris, Anita, ed. *Next Wave Cultures: Feminism, Subcultures, Activism.* New York: Routledge, 2008.

Jones, Alison. "Talking Cure: The Desire for Dialogue." *Democratic Dialogue in Education: Troubling Speech, Disturbing Silence.* Ed. Megan Boler. New York: Peter Lang, 2004. 57–67.

Kennedy, Barbara. *Deleuze and Cinema: The Aesthetics of Sensation.* Edinburgh: Edinburgh University Press, 2004.

Knitted Terrorists. Definition of "knittivism." Web. 3 August 2010. http://www.glittyknitty kitty.co.uk/.

Mayo, Cris. "Teaching against Homophobia without Teaching the Subject." *Curriculum and the Cultural Body.* Ed. Stephanie Springgay and Deborah Freedman. New York: Peter Lang, 2007. 163–73.

Merleau-Ponty, Maurice. *The Visible and the Invisible.* Evanston, IL: Northwestern University Press, 1968.

Miller, Janet. *Sounds of Silence Breaking: Women, Autobiography, Curriculum.* New York: Peter Lang, 2005.

Nancy, Jean Luc. *Being Singular Plural.* Stanford, CA: Stanford University Press, 2000.

Nayak, Anoop, and Mary Jane Kehily, eds. *Gender, Youth, and Culture: Young Masculinities and Femininities.* New York: Palgrave, 2008.

O'Donnell, Darren. *Social Acupuncture.* Toronto: Coach House Press, 2006.

Rogoff, Irit. "We—Collectivities, Mutualities, Participation." *Kein Theatre Weblog* 6 August 2004. 17 September 2007 http://theater.kein.org/node/95.

Rosenberg, Sharon. "A Few Notes on Pedagogical Unsettlement." *Turbo Chicks: Talking Young Feminisms*. Ed. Allyson Mitchell, Lisa Bryn Rundle, and Lara Karaian. Toronto: Sumach Press, 2001. 233–36.

Roy, Kaustuv. "Power and Resistance: Insurgent Spaces, Deleuze, and Curriculum." *Journal of Curriculum Theorizing* 21.1 (2005): 27–38.

Smith, David G. *In the Pedagon: Interdisciplinary Essays in the Human Sciences, Pedagogy, and Culture*. New York: Peter Lang, 1999.

Smith, Michael P. *Transcultural Urbanisms: Locating Globalization*. New York: Blackwell, 2000.

Springgay, Stephanie. *Body Knowledge and Curriculum: Pedagogies of Touch in Youth and Visual Culture*. New York: Peter Lang, 2008.

———. "An Ethics of Embodiment." *Being with A/r/tography*. Ed. Stephanie Springgay, Rita Irwin, Carl Leggo, and Peter Gouzouasis. Rotterdam, Netherlands: Sense Publishers, 2008. 153–65.

Stasko, Carly. "(r)Evolutionary Healing: Jamming with Culture and Shifting the Power." *Next Wave Cultures: Feminism, Subcultures, Activism*. Ed. Anita Harris. New York: Routledge, 2008. 193–220.

Vasseleu, Catherine. *Textures of Light: Vision and Touch in Irigaray, Levinas, and Merleau-Ponty*. New York: Routledge, 1998.

Villaverde, Leila. *Feminist Theories and Education*. New York: Peter Lang, 2008.

Weiss, Gail. *Body Image: Embodiment as Intercorporeality*. New York: Routlege, 1999.

Wills, Kerry. *The Close-Knit Circle: American Knitters Today*. Westport, CT: Praeger Publishers, 2007.

Woodson, Stephani Etheridge. "Performing Youth: Youth Agency and the Production of Knowledge in Community-Based Theatre." *Representing Youth: Methodological Issues in Critical Youth Studies*. Ed. Amy Best. New York: Routledge, 2007. 284–303.

The University of Illinois Press
is a founding member of the
Association of American University Presses.

———————————————————————

University of Illinois Press
1325 South Oak Street
Champaign, IL 61820-6903
www.press.uillinois.edu